The Crown Jewels

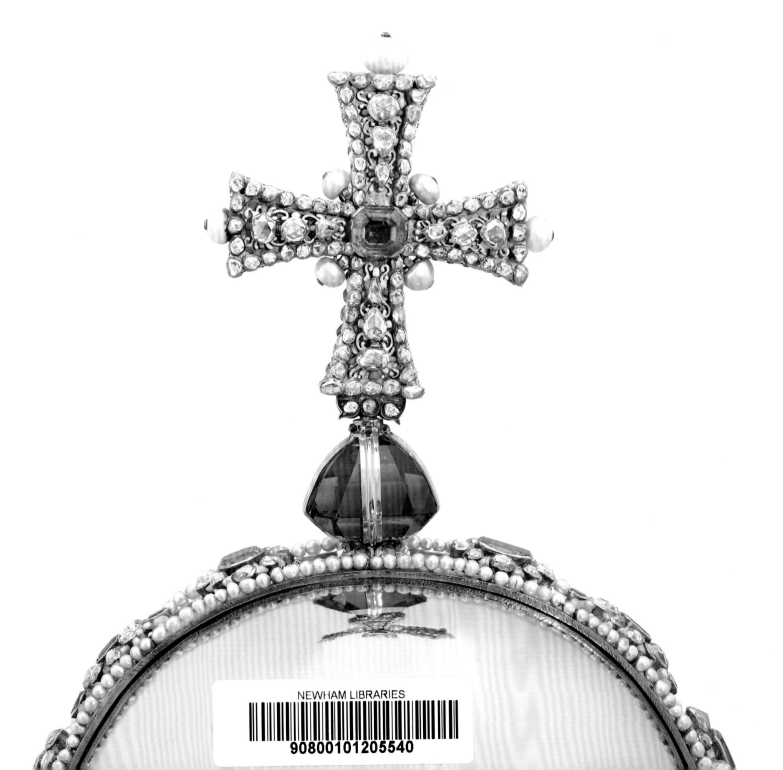

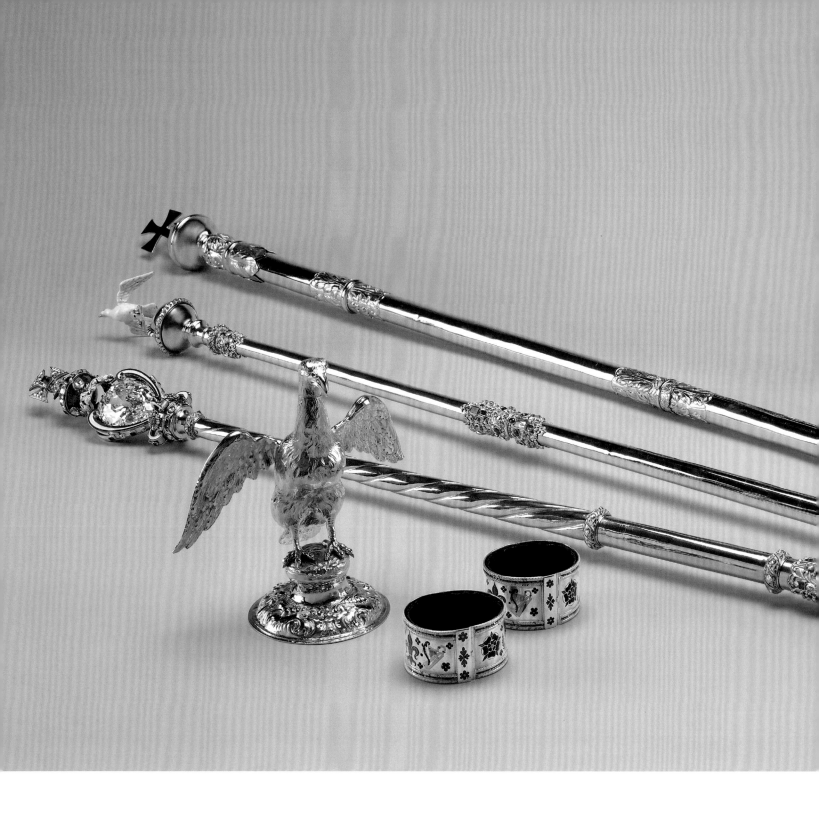

In association with

ROYAL COLLECTION PUBLICATIONS

HISTORIC ROYAL PALACES

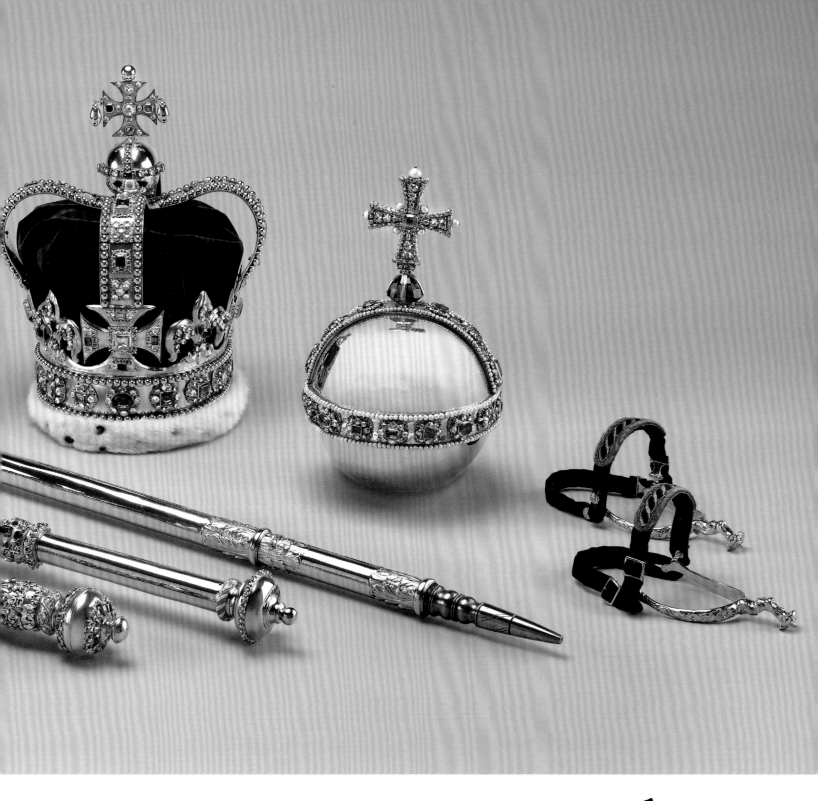

The Crown Jewels

THE OFFICIAL ILLUSTRATED HISTORY

ANNA KEAY

This abridged edition first published in the
United Kingdom in 2012 by Thames & Hudson Ltd,
181A High Holborn, London WC1V 7QX
in association with

ROYAL COLLECTION PUBLICATIONS
www.royalcollection.org.uk

and

**Historic Royal
PALACES**

www.hrp.org.uk

An expanded version of the text in this edition, with a
different selection of illustrations and with a different layout,
was first published in 2011.

Reprinted 2022

Original text by Anna Keay and reproductions of all items in
The Royal Collection © 2011 and 2012
Her Majesty Queen Elizabeth II

Design and typography © 2012 Thames & Hudson Ltd, London

Designed by Thomas Keenes

British Library Cataloguing-in-Publication Data
A catalogue record for this book is available from the
British Library

ISBN 978-0-500-28982-2

Printed and bound in China by C & C Offset Printing Co. Ltd

Be the first to know about our new releases,
exclusive content and author events by visiting
thamesandhudson.com
thamesandhudsonusa.com
thamesandhudson.com.au

Page 1 **THE SOVEREIGN'S ORB** (detail), 1661

Pages 2-3 **THE CORONATION REGALIA OF CHARLES II**, 1660-
61. Clockwise, from bottom left: the Armills, the Ampulla,
the Sovereign's Sceptre with Cross, the Sovereign's Sceptre with
Dove, St Edward's Staff, St Edward's Crown, the Sovereign's Orb
and the Spurs.

Page 5 **THE SOVEREIGN'S SCEPTRE WITH CROSS** (detail), 1661
and 1911.

Pages 6–7 **ST EDWARD'S CROWN** (detail), 1661.

All the Crown Jewels in the Tower of London are indicated by
caption headlines in **BOLD CAPITAL LETTERS**.

ACKNOWLEDGMENTS

For their advice and assistance during the composition of this
book, and over a longer period, I would like to thank Jeremy
Ashbee, Ian Balfour, Andrew Barclay, Harry Collins, Philippa
Glanville, Susanne Groom, Keith Hanson, Bruce Hunter,
Edward Impey, Tim Knox, Robert Lacey, Ronald Lightbown,
Keith Parfitt, Sir Hugh Roberts, Sir Roy Strong, David Thomas
and Simon Thurley. I am grateful to the staff of the English
Heritage Library and the London Library for supplying a stream
of printed books and to the Society of Antiquaries of London for
permission to consult the Sitwell Papers. The Crown Jewels has
been a collective effort, and looks as it does because of the hard
work of the teams at Thames & Hudson, Historic Royal Palaces
and the Royal Collection, and thanks to the patience of the
Crown Jeweller. Written in the year immediately following the
birth of our children, the book would not have been completed
without the support of Simon Thurley, and the help of Julia
Keay, Kay Smith, Rachel Smith and Eloise Gillow.

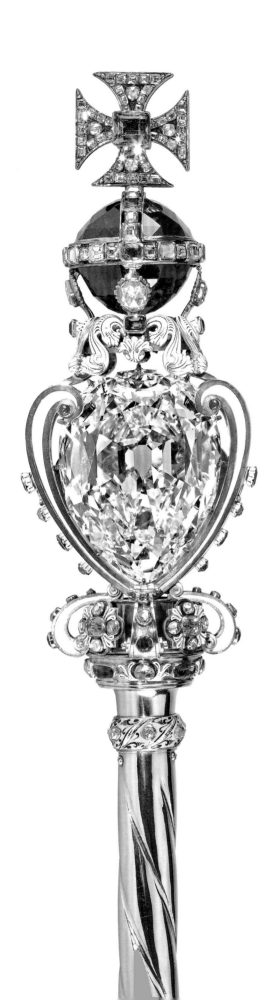

Contents

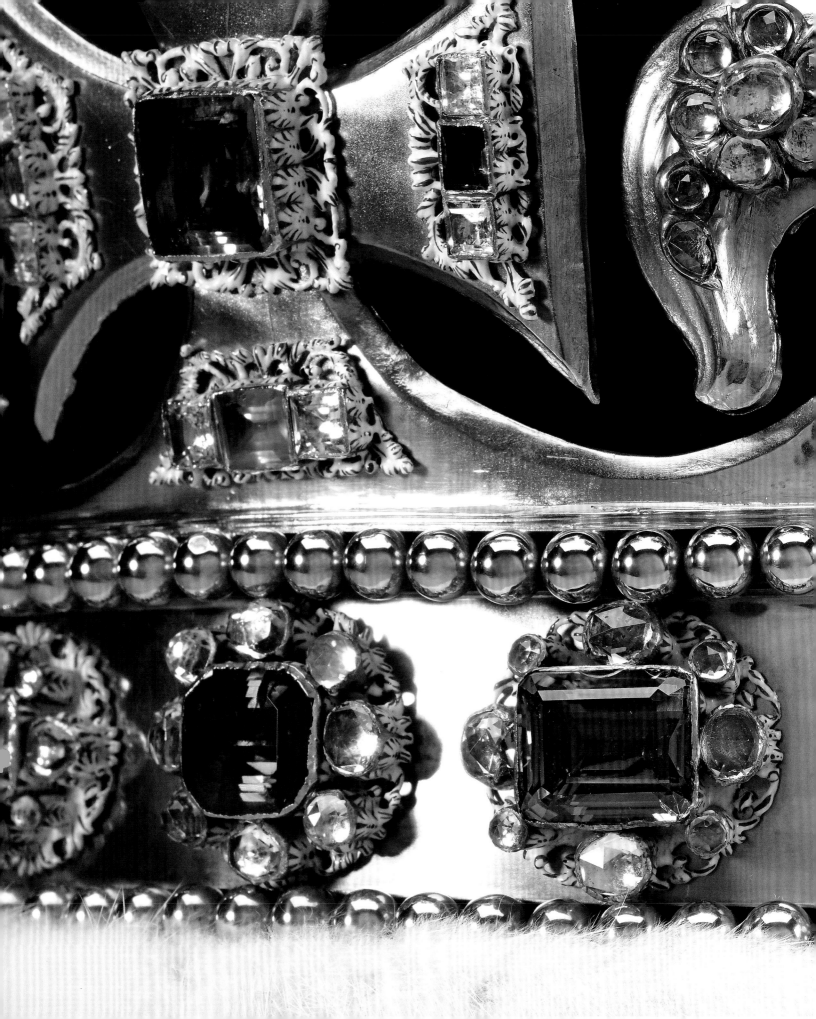

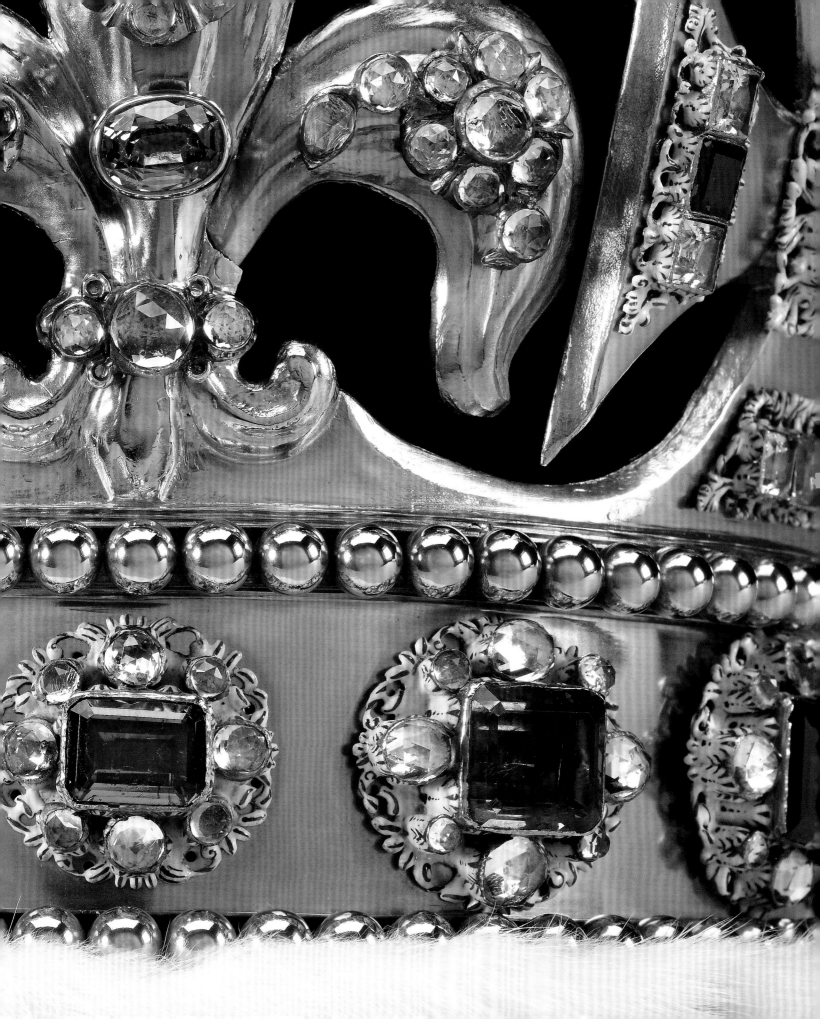

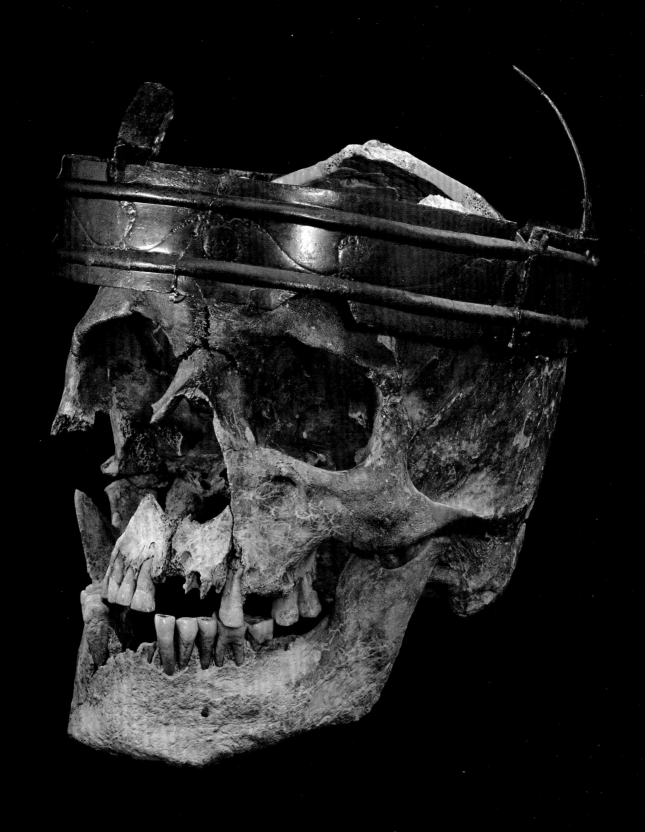

I

ORIGINS

In the fading light on 27 December 1988, the body of an Iron Age king was unearthed on a chalk ridge above the bleached sands of Deal in Kent. Still clinging to his fleshless skull, complete and unmistakable, was a bronze crown. This sensational discovery revealed the earliest known English crown, dating to between 200 and 150 BC [1]. It was not the only treasure in the tomb, however, but was part of a collection of precious objects. On the skeleton's right arm rested a long iron sword with a bone handle, still in its leather and bronze scabbard. At his knees lay a large decorative brooch, the fabric it had once clasped now long-perished, and over his body were the remains of a magnificent ceremonial shield.

Although this Kentish ruler was buried over two thousand years ago, the objects that he took with him to the grave are probably as recognizable to us today as any other aspect of his long-forgotten life. This is because, over the millennia that have since passed, the power of such precious, and perhaps sacred, objects has lasted.

Opposite 1 *The skull of the Iron Age ruler known as the 'Mill Hill warrior'. He wears the earliest known English crown, dating to 200–150* BC.

To this day more than two million people a year from across the globe come to the Tower of London to gaze at the collection known as the Crown Jewels. How this assemblage came into being, and how the power of the English regalia evolved and yet endured, is the story of this book.

While the arched Iron Age circlet found in 1988 is the oldest known English crown, its discovery was pure serendipity and it is highly unlikely that its wearer was the first man in England to own a crown. In fact, it is striking how many societies, over vast time periods, adopted special headdresses as a means of identifying authority, and supreme royal authority in particular. The use of crowns in the Near East in the centuries before the birth of Christ crops up frequently in the books of the Old Testament. When King David captured the city of Rabbah, he 'took the crown of their king from off his head and found it to weigh a talent of gold, and there were precious stones in it; and it was set upon David's head'. From Egypt to Persia, from China to Africa, rulers of the ancient world used special headgear to represent their regality.

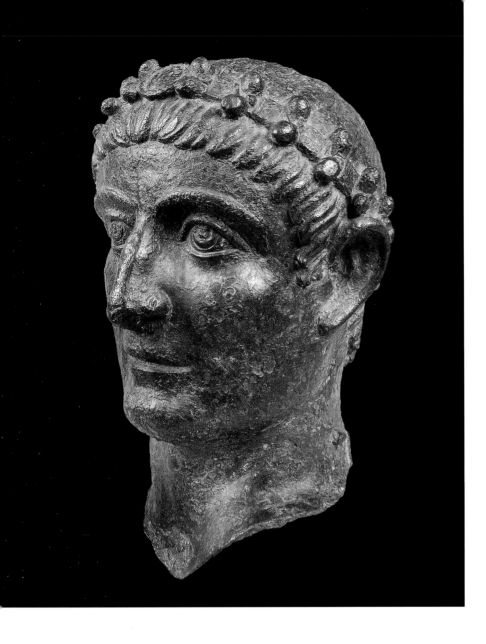

Left *2 Bronze head (325–30 AD) of Constantine the Great, the first Roman emperor regularly to wear a crown. The empire's republican roots made its rulers wary of explicitly royal insigna.*

Opposite *3 The ceremonial helmet probably belonging to Raedwald, 7th-century King of East Anglia. The famous Sutton Hoo treasure has at its heart a recognizable collection of regalia.*

The English regalia, that is to say the precious personal objects associated with and defining a sovereign, acquired its distinctive character from the three streams that converged on Celtic Britain: the Roman Empire, both in its heyday and, later, from its new eastern capital of Constantinople; the Germanic tribes who invaded the old Roman territories from around 400 AD; and the Christian church that came to dominate Europe in the early Middle Ages.

In many senses the most obvious source for the imagery of regal authority in Europe – the Roman Empire – was actually the exception rather than the rule. After the consulship of Julius Caesar the empire effectively became a

monarchy instead of a republic. The pretence remained, however, that the emperor was an elected official, and there was a reluctance to see him adopt explicitly royal insignia. It was not until the dying days of Rome that emperors wore anything comparable with medieval crowns. Constantine the Great (306–337 AD), who was both the first Christian emperor and responsible for abandoning Rome for Constantinople, was among the first regularly to wear a crown [2].

While the Roman emperors themselves had been slow to adopt crowns as emblems of authority, crowns had long been worn within their territories. As the Mill Hill warrior demonstrates, there was a tradition of crown-wearing in Britain before the arrival of the Romans and this evidently continued. Ploughing in a Norfolk field at Hockwold cum Wilton, in the 1950s, for instance, turned up an astonishing series of circlets and a bronze crown, all dating to the period of the Roman occupation of England.

The Roman armies were withdrawn from Britain at the beginning of the 5th century AD; the Angles and

Saxons arrived from the east filling the vacuum and a series of loose kingdoms emerged in the lands they invaded. As various dynasties struggled to establish themselves, successive warrior kings tried to entrench their authority and power more permanently. Crucial to this was the evolution of ceremonies and insignia of kingship, which set the ruler apart, defined his authority as timeless and inevitable, and so tried to perpetuate it in an otherwise bitterly military world.

The universe of these early kings is almost impossibly distant to us now. Nearly all the sources that might tell us how they lived have gone: they communicated without writing, traded without currency and the buildings they inhabited were demolished many centuries ago. But a unique and utterly dazzling picture of the mid-Saxon world was revealed with the excavation of the burial mounds at Sutton Hoo in Suffolk on the eve of the Second World War. The largest of the mounds was the tomb of a sovereign, probably Raedwald, King of East Anglia from 617 AD, whose military prowess brought almost the whole of England under his control. The richness of the objects with which he was buried is astonishing, among them a series of emblems of authority. Though Raedwald, as we will assume he is, was not buried with a crown per se, he had with him a priceless ceremonial helmet [3]. Covered in thin sheets of bronze that would once have been silvery in appearance, the helmet was adorned with facial features of cast bronze that would have looked golden. Though clearly a breathtaking object, it was also designed to be worn: a leather lining made it

comfortable on the skull while small holes in the nostrils allowed the wearer to breathe.

Every bit as extraordinary as the helmet was Raedwald's sceptre [4]. Like crowns, sceptres had a distinguished lineage. The Old Testament includes a number of references to sceptres as staffs denoting sovereign power, and they appear in many other ancient contexts as symbols of strength and authority. In the days of the Roman republic, ivory sceptres were part of the insignia of the consuls, the most senior officials of the government, and they were later adopted as part of the emperor's own regalia. As well as enjoying this distinguished imperial lineage, sceptres were part of the ceremonial equipment used by Celtic priests and a number of English sceptre heads survive from the time of the Roman invasion.

Raedwald's tomb, like that of the Mill Hill warrior, also included a highly decorated sword and shield. That swords should have special status in an age when power and physical force were so closely associated is not surprising. The sword as a piece of regalia – something with a ceremonial as much as a practical function – belonged more to the northern European tribes than the Roman or Greek empires, and a number of richly made early English swords and shields survive. The potency of the sword as an emblem, over and above its practical applications as a weapon, is perhaps best understood from its place in folklore. Swords of the great heroes were never mere weapons, but named companions with miraculous properties. To Beowulf, the warrior of the eponymous Anglo-Saxon poem, belonged the great sword Hrunting, a 'rare and ancient' weapon; to Charlemagne the magical Joyeuse, which changed colour thirty times a day; and to King Arthur, Caliburn or Excalibur.

So it was that in the years after the fall of Rome, these new English kings – some native,

Left 4 *The sceptre from the Sutton Hoo burial, early 7th century. Its cupped base allowed this heavy stone object to rest comfortably on its bearer's knee.*

Opposite 5 *Orders for the English coronation date back to the 9th century, but probably record the form of the ceremony from the 8th century. This, the 'Leofric' version of the coronation order, may date to as early as the first half of the 9th century.*

some invaders – developed collections of recognizable royal insignia, or regalia. Though the types of object would endure, and form the principal components of the Crown Jewels today, their meaning then must have been different. This is because 6th-century England was still a pagan land. The language of kingship, like so much else, began to find a new grammar when, in 597 AD, Pope Gregory I sent the monk Augustine to convert England. While Christianity would not fundamentally change the elements of the English regalia, in its liturgy they came to have an explicit and enduring meaning. Crucially, it was within a Christian context that the idea of coronation developed – a single ceremony in which the assumption of regalia defined the creation of a king.

The concept of a coronation, in which a king is anointed with holy oil and invested with royal insignia, became firmly established in Europe during the 7th and 8th centuries. It took its form from the collision of two traditions. One was the idea of a ceremonial crowning, which evolved in the Eastern Empire in the 6th and 7th centuries, the other was the use of holy oils to initiate priests and rulers into their offices, which was common practice in the kingdoms of Israel and Judah, as well as elsewhere, in the millennium before the birth of Christ.

Easily the most influential coronation of the Middle Ages was that of the emperor Charlemagne. On Christmas Day 800 the warrior

Hunc missalem Leofricys eps̄ dat ecclē
scī petri aptī in exonia ad utalitatem succes
sorū suorū · Siquis illū inde abstulerit · æternę
subiacere maledictioni · fiat · fiat · Confirma hoc
ds̄ qd̄ operatus es in nob·

Ꝛ Dað boc leofric biscop gef sce̅ petro · ⁊
tallū hi̅t æt cristgercum into exancestre
gode in to þeuienne · ⁊ gif ænig man ut
abredo̅ hæbbe · he godes curs ⁊ urꝛdde
talra halgena: halron hoce onexecsȝe þeode
hezelplæde hire piman þ hi bocū ⁊alde popl
þre samxoli cuist ⁊sce̅ petri ⁊ealle cuistes · h
hi iurizþe ynað þeli hærre ȝe þyrie · an

Her kyð on þisse bec þ æilȝiuu gode alysde
hiȝ ⁊ dunna ⁊ heora offspring · æt mauȝode
to · xiii · mancson · ⁊ æiȝnulf poit ȝerexa · ⁊ Godric
ȝupa namon þroll · on manleþer ȝe pꝛ
uþre · ⁊ on leoþesdes heakza · ⁊ on leopines hir
bpoþoꝛ · ⁊ on ælþuces maþhaꝛper · ⁊ on sperȝur
serbꝛipꝛea · ⁊ habbe he godes curs · þe hir æꝛuꝛ
un do · aon ecnysse · Amen ·

Right 6 *The Alfred Jewel, 871–899.*
Commissioned by the Anglo-Saxon King
Alfred, the jewel, only 5.2 cm (2 in.)
high, depicts the King holding a sceptre
in each hand.

Opposite 7 *The Coronation*
of Edward the Confessor, 1043,
from the Painted Chamber at the
Palace of Westminster. Henry III,
who had himself crowned in 1220
with what he claimed was Edward
the Confessor's crown, had this scene
painted within his bed enclosure. This
copy of the mural was made before the
paintings were destroyed in the fire
of 1834.

king was crowned in St Peter's basilica, Rome, by the Pope himself. Before long, coronations were happening across Europe. The English king Offa, ruler of the great Midlands kingdom of Mercia, had anointed his own son as his successor in 787, and at probably about this time the earliest English coronation order was being drawn up in the kingdom of Wessex. Several manuscript versions of the English coronation service from well before 1000 AD survive to this day [5]. The once-pagan rulers of England had now harnessed Christianity, and were using it to augment the strength and legitimacy of their power.

The earliest English coronation order, like all those that have followed, took the form of a special version of the Mass in which the Biblical description of the Israelite priest Zadok anointing King Solomon was read aloud as holy oil was poured on the king. After the anointing, the priests and the nobles presented the king with items of regalia. At least two versions of the coronation service had been formulated before the Norman conquest and four by the 14th century. These

early rubrics did not just specify what was to happen at a coronation, but explained the symbolism of each element of the regalia – which soon expanded to include a ring and rod or staff. The sword represented the strength the king would need to fight the enemies of his authority and of the Church; the sceptre denoted the sovereign power and the duty of the king to exercise justice [6]; the ring was the seal of faith, and the rod symbolized the king's obligation to promote equity and virtue in his people. The crown embodied the glory and righteousness with which God endowed the sovereign, to be exchanged in due course for the insignia of the kingdom of heaven. With only minor modifications, these explanations of the significance of the various elements of the regalia remain in the coronation service today.

Coronations were often dramatic occasions, marking the passage of power from one person or dynasty to another, and as a result they tended to be well recorded. But they were not the only, nor always the most important, occasions on which early kings

wore their crowns and swords, sceptres and rings. Charlemagne is described as donning his ceremonial insignia on the holy days of the church calendar and it is very likely Anglo-Saxon kings did much the same, wearing their magnificent and often jewelled regalia on ceremonial occasions throughout the year.

In 1066 Edward the Confessor, the last Anglo-Saxon king, died without an heir. A host of claimants swarmed on the kingdom, from which William, Duke of Normandy, emerged as the spectacular victor. An invader-king, William had to work hard to impress his authority on his reluctant subjects, and his regular 'crown-wearings' were a crucial part of this process. According to the contemporary Anglo-Saxon Chronicle: 'He was very dignified. He wore his crown three times a year as often as he was in England at Easter at Winchester, at Whitsuntide at Westminster, at Christmas at Gloucester. On these occasions the great men of England were assembled about him: archbishops, abbots, earls, thegns and knights. He was so stern and relentless a man that no-one dared do anything against his will.'

By the beginning of the Norman period the concept of the regalia – precious metal or jewelled objects borne by and identifying a king – was well established, but there was not yet any sense of these items as a sacred group that passed from one ruler to another. All this would begin to change in the 12th century when the monks of Westminster Abbey, the burial place of Edward the Confessor, made the bold claim that he had

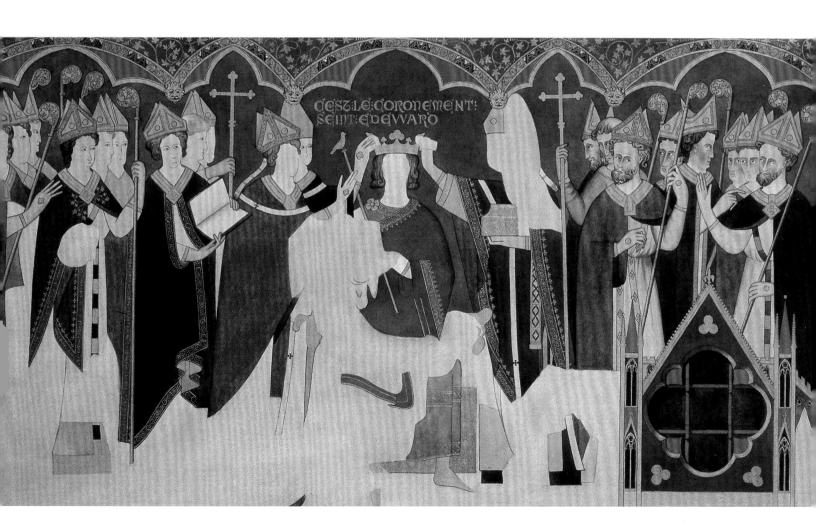

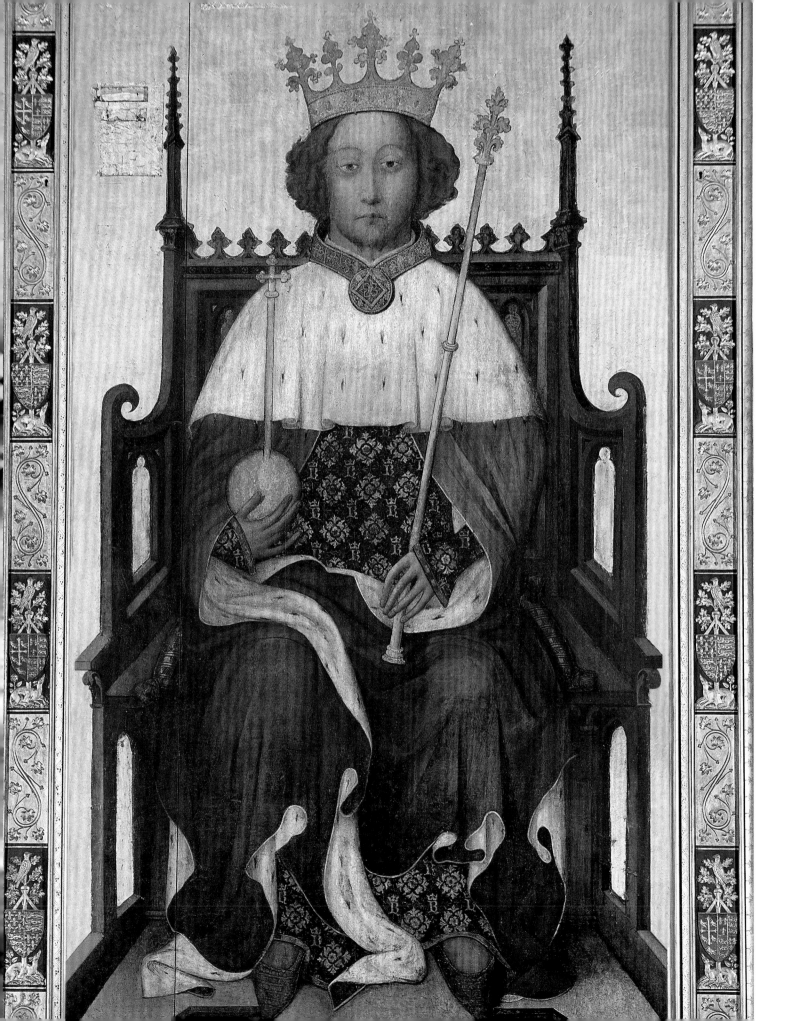

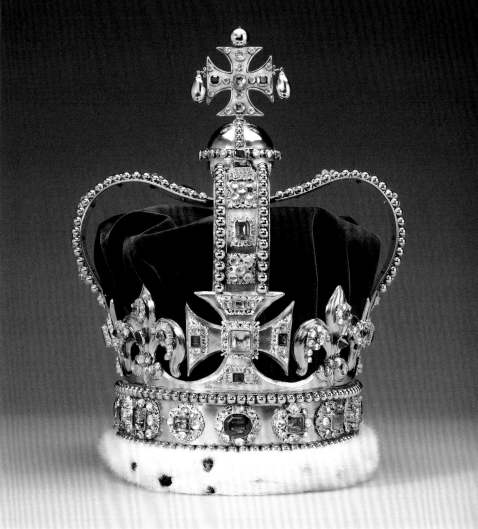

Opposite 8 *This portrait of Richard II, probably dating to the 1390s, is the earliest large painting of an enthroned English king. Richard marked his abdication by putting a crown into the hands of his deposer, Henry Bolingbroke.*

Right 9 ST EDWARD'S CROWN, *1661. The new crown was made as a replacement for its medieval namesake, and it may well be that it indicates the general form of the first St Edward's Crown at the end of the Middle Ages, but with the addition of many more gemstones than in the medieval crown.*

left his regalia in their safekeeping with the instruction that it should be used for the coronation of all future kings of England [7]. In 1161, a century after his death, Edward was recognized as a saint, and objects connected with him became holy relics, making this claim all the more audacious.

The probability is that the Confessor had left no such bequest, and that the story had been fabricated by the monks in a bid to draw pilgrims and patrons to their church. But the tale was potent, particularly as over the decades the Abbey acquired various precious objects that they claimed were those bequeathed by Edward. By the time of the coronation of the 13-year-old King Henry III in 1220, the crown used was described unequivocally as having belonged to his saintly forebear and as the one to be used by future kings. The concept of a hereditary collection of regalia had come into being.

Whether it was genuinely the crown of Edward the Confessor or a more recent creation, the object with which Henry III and his immediate successors was crowned would be called St Edward's Crown from 1220

until its destruction by English republicans four hundred years later. It was the defining symbol of English kingship: when Richard II was forced from power in 1399, he asked for it to be brought to the Tower of London so he could mark his abdication by passing the crown to his cousin and conqueror, Henry Bolingbroke [8]. The crown was made of gold, sparsely set with stones, and comprised a band decorated with simplified floral devices or fleurons, and – by the late Middle Ages at least – two arches crossing overhead. When completely new English regalia was made in 1660–61 it was modelled on that which had been destroyed in 1649 – and so the form of the present-day St Edward's Crown [9] is probably a reasonable guide to the overall appearance of its predecessor.

Because of the completeness of the destruction of the regalia at the end of the Civil War in 1649 no

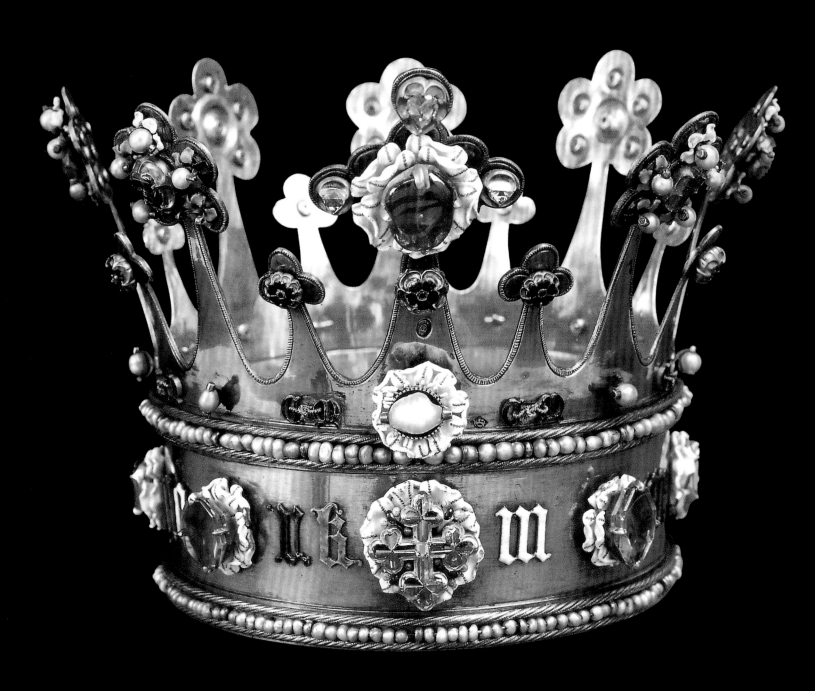

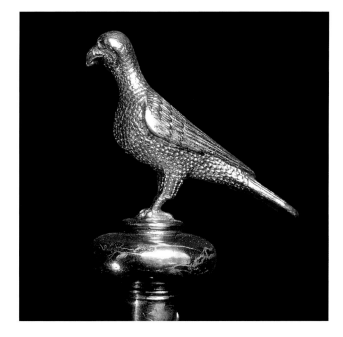

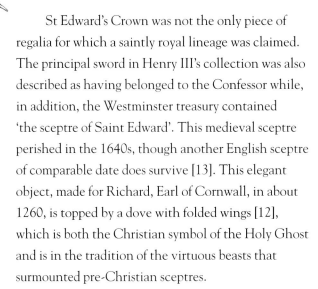

medieval crowns survive in England. However, two crowns had left the country in the packing cases of English princesses centuries before the English Civil War and they offer a glimpse of the glories of the medieval jewel house. In the Treasury at Munich can be seen the mid-14th-century crown [11] of Princess Blanche, daughter of Henry IV, and at Aachen Cathedral is the tiny crown [10] made for Margaret of York a century later.

Opposite 10 The Crown of Margaret of York, c.1461–74. This tiny crown, measuring just 12.5 cm (5 in.) in diameter, probably left England in 1468 when Edward IV's sister married Charles the Bold of Burgundy. Remarkably, its travelling case also survives.

Above left 11 Princess Blanche's Crown, c.1370–80. This dazzling object was in the Tower of London in 1399, but was taken to Germany two years later when Henry IV's daughter, Blanche, married Ludwig III of Bavaria.

Above right and right 12, 13 Sceptre of Richard, Earl of Cornwall, c.1260. Richard was elected King of the Romans, the junior title to the Holy Roman Emperor, and probably gave the sceptre to Aachen in 1262 for his and future investitures.

St Edward's Crown was not the only piece of regalia for which a saintly royal lineage was claimed. The principal sword in Henry III's collection was also described as having belonged to the Confessor while, in addition, the Westminster treasury contained 'the sceptre of Saint Edward'. This medieval sceptre perished in the 1640s, though another English sceptre of comparable date does survive [13]. This elegant object, made for Richard, Earl of Cornwall, in about 1260, is topped by a dove with folded wings [12], which is both the Christian symbol of the Holy Ghost and is in the tradition of the virtuous beasts that surmounted pre-Christian sceptres.

By the mid-15th century the 'Relics of the Holy Confessor' in the Abbey had multiplied to include two rods, a gold comb and spoon, and numerous robes and vestments, as well as an onyx chalice and gold paten. In addition to these treasures, which were associated with the Confessor and used only for the act of coronation itself, dozens of regal objects – including further crowns, rings and swords – were cared for by the royal household and used for all other events.

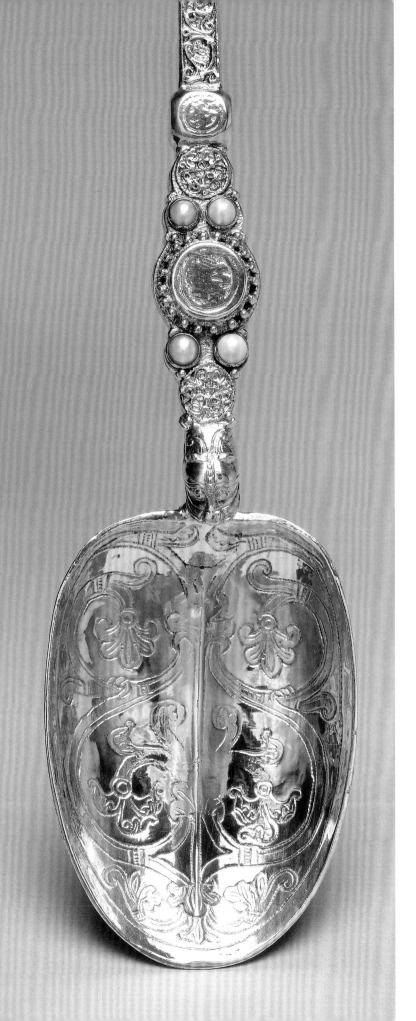

So there were, in effect, two collections of regalia in the Middle Ages: the coronation regalia in the Abbey and the state regalia housed in the royal palaces. The fate that awaited both in the 17th century was so drastic that only a single item of medieval regalia remains in the collection today, the modest yet fascinating Coronation Spoon [14].

Probably created for King Henry II, the spoon is the only piece of English royal goldsmiths' work to survive from the 12th century. Made of silver gilt, the whole object is decorated with engraved and chased foliage and a tiny monster's head holding the bowl to the stem [15]. The spoon is first recorded in an inventory in 1349, when it was housed in Westminster Abbey as part

of the coronation regalia, and even at this early date it was described as of 'antique forme'. Exactly what its purpose was in the Middle Ages is not at all clear. It is possible it was originally used in the preparation of the communion wine, or it may even have started life as a secular piece.

The Plantagenet kings gladly cashed in on the cult of St Edward, and no sovereign was more dedicated to the Confessor than Henry III, who called his first son Edward in demonstration of his devotion. King Edward I, whom the child would become, forced English influence outwards in the British Isles, conquering large parts of Wales and imposing his authority on much of Scotland. In annexing these territories he ensured he also seized those objects that symbolized their sovereignty. When he defeated the Welsh prince Llywelyn ap Gruffydd in 1282, Edward had the Welsh regalia, which was believed to have belonged to King Arthur, taken to London. The following decade, after his victory over the Scots at the Battle of Dunbar, he went in person to the Abbey of Scone and, 'in recognition of a kingdom surrendered and conquered', ordered the removal of the sandstone block on which generations of kings of Scotland had been inaugurated. A magnificent carved chair was made to house the stone and it was placed within the Confessor's shrine in Westminster Abbey [16]. Though Edward almost certainly had not intended it as such, the throne was soon being used for the investiture of kings of England – a role it has performed up to the present day, earning it the name Coronation Chair. The crown and sceptre of the kings of Scotland were also deposited in the shrine – the impounded regalia an eloquent expression of the captured kingdom.

Opposite 14, 15 **THE CORONATION SPOON,** *12th century. The spoon is the only surviving piece of the medieval regalia. The bowl is decorated with curling foliage and the end of the stem is in the form of a monster's head.*

Below 16 *The Coronation Chair. In 1296 Edward I captured the Scottish crown and sceptre, as well as the Stone of Scone – the inauguration stone of Scottish kings. The chair that was made to contain the stone has been used for the coronation of English monarchs since the 14th century. This photograph was taken before the Stone of Scone was returned to Scotland in 1996.*

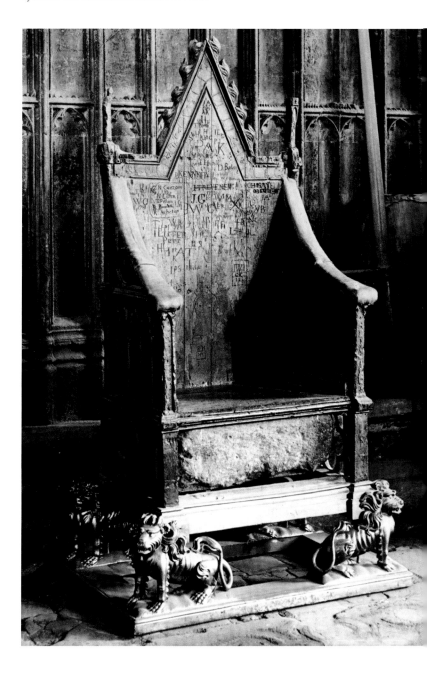

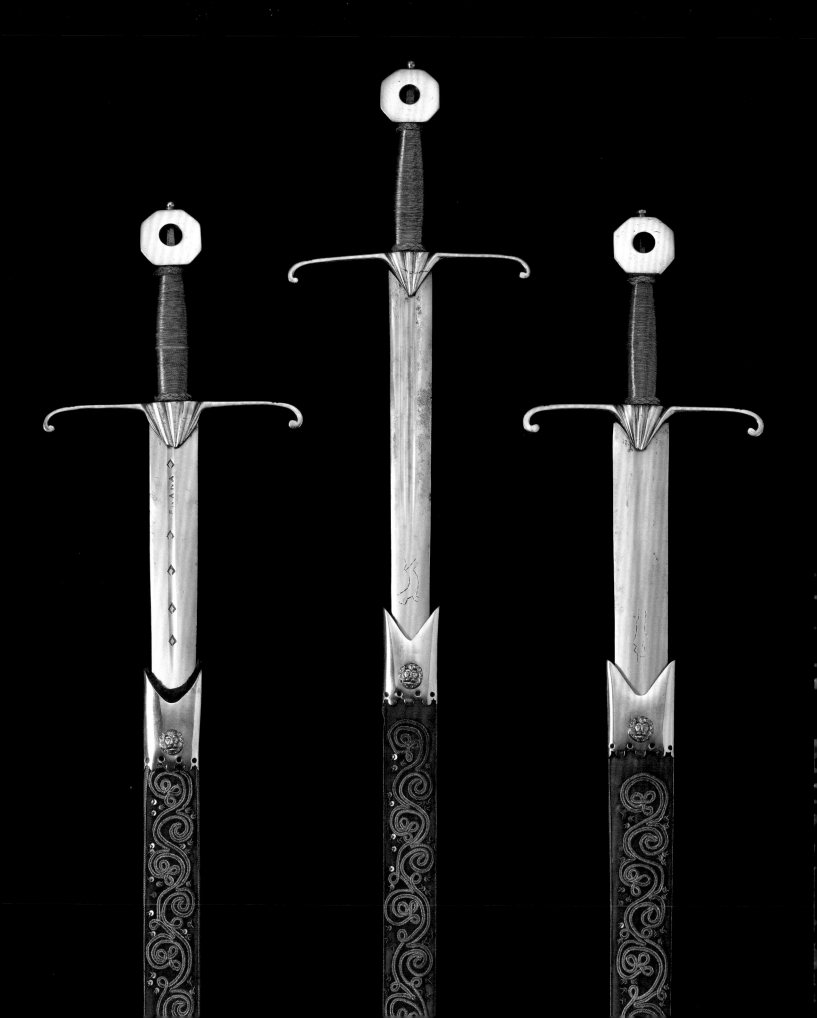

2

THE AGE OF MAGNIFICENCE

On the death of Henry VIII in 1547 an immense inventory was made of the possessions of this most regal of kings. Running to almost 20,000 entries, it catalogues a collection of astonishing range and richness. Topping the list is the regalia itself; but as well as the crowns and sceptres, the coffers of the royal household contained a blinding quantity of other jewels and plate. In just one of several strongrooms in the Tower of London was a series of huge chests, marked 'A' to 'X'. These in turn contained further individual boxes or coffers, as many as a dozen each, crammed with clasps, buttons, necklaces, brooches and rings, encrusted with diamonds, rubies and other gems. Just one box in one coffer contained sixty-five separate 'ropes' of pearls. All this in an age before the industrial mining of gems, when almost every diamond in Henry VIII's collection had been unearthed in the Golconda valley in India and made a 5,000-mile journey to Europe. This was truly the age of magnificence.

Opposite 17 THE SWORD OF TEMPORAL JUSTICE (left), THE SWORD OF SPIRITUAL JUSTICE (centre) and THE SWORD OF MERCY (right). The three swords, made of steel, silver gilt and gilt iron, were supplied for the coronation of Charles I in 1626 (see p. 26).

The need for jewelled objects in such quantities was largely the result of the ever-increasing importance of royal display. The English court was the focus of power, authority and conspicuous consumption, and since at least the end of the 14th century the rounds of royal ceremonies had grown ever more elaborate, involving regular ritualized acts of worship, charity, law-giving and peace-making. Great manuscript volumes were drawn up detailing the form of these occasions, how they should be staged, who should attend and what their rewards would be. The monarch was dressed in jewelled splendour for all of these events, but for only the very grandest and most august occasions would the most important objects, the regalia itself, be carried. Though waxing and waning with the various reigns, the early medieval tradition of crown-wearing continued through the Middle Ages and was still occasionally performed by the early Tudor kings. Then, as now, the opening of a new Parliament would bring the sovereign forth in sparkling regal splendour. Around the central figure of the monarch, processions formed which bore him to the event, and in which items of regalia were carried aloft [18, 19].

While the ceremonial cycle grew ever more elaborate, the coronation remained the single most lavish and magnificent occasion of all. The ceremony

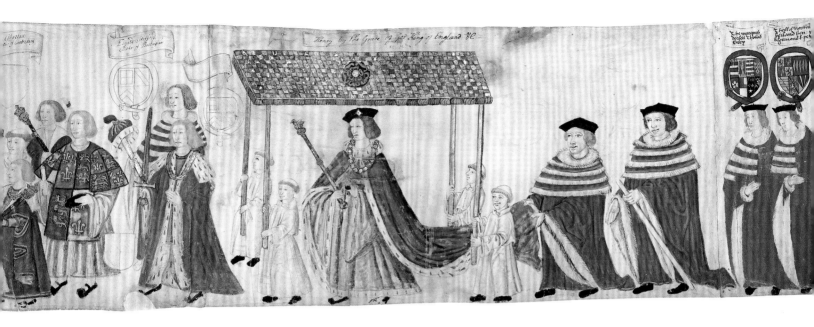

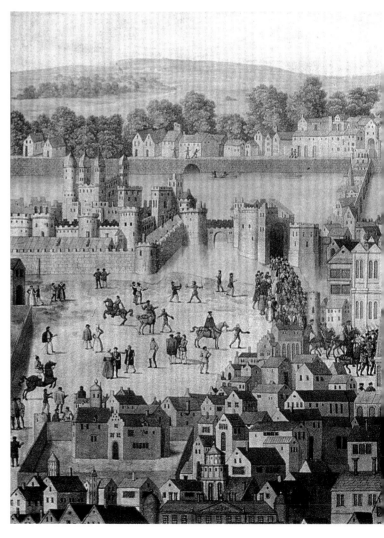

Top and above 18, 19 *Henry VIII processing to Parliament in 1512. He carries a sceptre surmounted by a bird, while the sword of state and Cap of Maintenance are borne before him. The Cap of Maintenance, one of the symbols of the sovereign's authority, is still carried on a short staff in the modern procession of the monarch to Parliament.*

Right 20 *The Coronation Procession of King Edward VI, 1547. These spectacular processions passed from the Tower of London to Westminster, allowing vast numbers to see the new sovereign.*

continued essentially unchanged by the Reformation, with the translation of proceedings from Latin into English for James I in 1603 perhaps the most conspicuous alteration. The day before the coronation a spectacular procession carried the sovereign through the capital from the Tower of London in the east to the Palace of Westminster [20]. On the coronation day itself he or she walked from Westminster Hall to the Abbey for the service. In this the sovereign was first 'presented' to the congregation, who shouted back (or 'acclaimed') their support, then the coronation oath was taken – in which the sovereign promised to rule according to God's law. There then came the anointing, following which

the regalia was presented, the crown being finally placed on the sovereign's head. After the service, the monarch processed back to Westminster Hall, where a lavish feast was held.

The processions and the feast were as magnificent as the service itself, and also required objects of splendour, of which a number survive today. Since the earliest times a sword had been one of the defining emblems of kingship, representing the physical strength and protective power of the ruler [21]. But by the end of the Middle Ages the meaning of the sword, and indeed the sword itself, had multiplied. Three swords, carried before the sovereign in the coronation procession, now

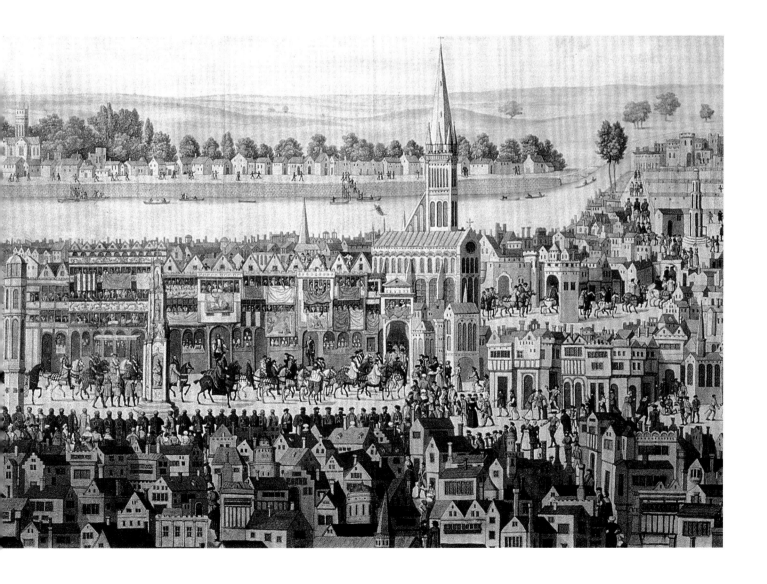

represented an aspect of the king's protective powers: his role in administering justice. They were the Sword of Spiritual Justice, the Sword of Temporal Justice and their memorable companion, Curtana, the Sword of Mercy, with its blunted end.

The three processional swords were generally provided new for each coronation until the early 17th century when Charles I deposited his swords with the regalia in Westminster Abbey. They can be seen in the collection at the Tower of London today [17, 22]. They were probably supplied by the royal cutler Robert South, and made use of existing blades – a common practice with high-quality steel. Bearing a running-wolf stamp and additional makers' marks, the blades were the work of the famed Italian swordsmiths Andrea and Giandonato Ferrara and were imported into England in the 1580s. The leather scabbards have been remade periodically; the current velvet covering was created for the coronation of King George VI in 1937.

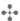

While the abbots, and later deans, of Westminster Abbey remained the guardians of the so-called 'St Edward's regalia' – used for the act of coronation itself – a much larger collection of bejewelled regal ornaments not associated with the Confessor was amassed by successive kings, and cared for by the royal household directly. This was the state regalia, worn for formal occasions other than the coronation. Until the end of the 15th century the objects that made up the state regalia were almost always the personal possessions of the king and, unlike the coronation regalia, did not normally pass from one to another. There were occasional exceptions, with the odd antiquated crown

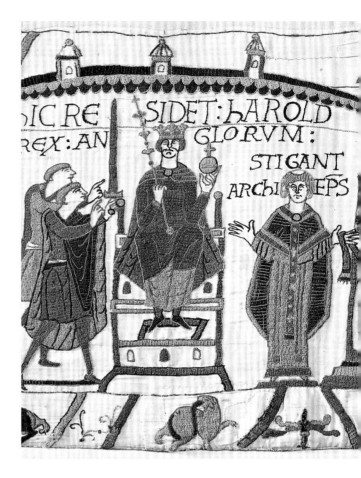

Above 21 *The coronation of King Harold in 1066 from the near-contemporary Bayeux Tapestry. Enthroned with his crown, sceptre and orb, Harold is attended by the Archbishop of Canterbury on one side while on the other attendants hold aloft a great sword.*

Left 22 **THE SWORD OF MERCY**. *One of the three swords supplied for the coronation of Charles I in 1626. It is also known as Curtana.*

Opposite 23 *King Charles I, 1631, by Daniel Mytens. The Tudor state crown is shown to the left of the King. Eighteen years later it would be destroyed by the new republican government.*

'of ancient manner', or pieces of special political significance, being retained. Among these was the crown of Richard III, which Shakespeare had Henry Tudor donning on the field of Bosworth, and which was genuinely part of the Tudor regalia, described as the crown 'which it pleased God to give us [Henry VII] with the victory of our enemy at our first field'.

Gradually, however, with growing political and dynastic stability a hereditary collection of state regalia started to accumulate. First among these items was the sovereign's state crown, the object he assumed immediately after the coronation (the coronation crown remaining in the Abbey) and wore on days of state. This was described in great detail in a number of 16th-century inventories and in 1649 was valued at the modern equivalent of about £1.5 million [23]. The crown was probably an early Tudor creation and had two crossing arches, following the fashion established by the Lancastrian kings in the 15th century – the arches representing the supreme, or 'imperial', nature of English royal authority. The gold frame was encrusted with pearls, rubies, sapphires and diamonds, and the band was adorned with alternating fleur-de-lys and crosses, as had been usual on English crowns since at least the reign of Henry VI. Also prominent and often shown in royal images was the orb, a golden globe representing the earth surmounted by the cross of Christ. By 1605 this state collection had become so valuable and important that James I decreed the items to be the inalienable property of the Crown.

As the royal ceremonial calendar filled up, so subsections of the royal household evolved with specific responsibilities for aspects of royal magnificence. By the end of the 15th century the office of the Jewel House had come into being, charged with managing all of the king's jewels and plate, other than the regalia in the Abbey. These included the state regalia itself, as well as all of the rest of the sovereign's personal jewellery and the substantial collection of royal plate.

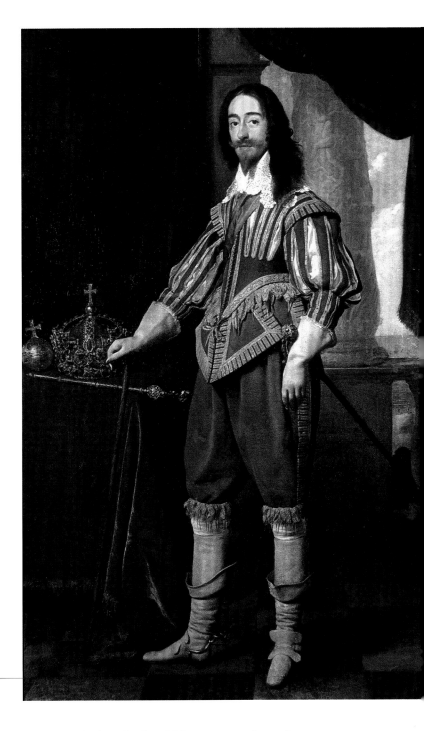

Long before the Jewel House emerged as a discrete department, the state regalia, royal jewels and plate had been housed in a variety of palace repositories. Small strongrooms were built at the major residences to store items regularly in use there. Until the catastrophic fire of 1512 the principal royal house had been the Palace of

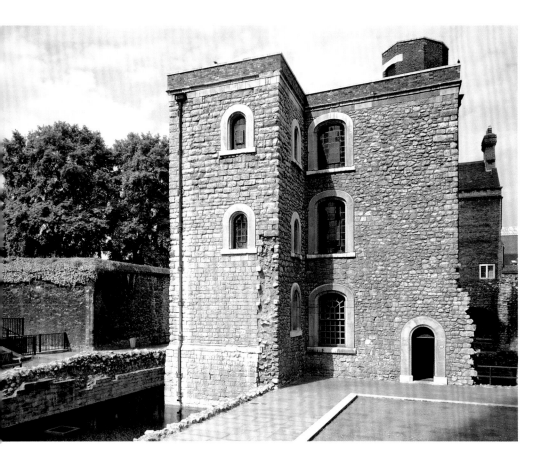

Westminster, and the Jewel Tower there, built in the reign of Edward III, stands to this day [24]. The work of the royal architect Henry Yvele, it was designed to be both beautiful and impregnable – stained glass bearing flowers and royal emblems adorned the windows, but wrought-iron grilles ensured no-one could gain unauthorized access. This care for security was a real necessity; only a few decades earlier, in 1303, a daring raid had emptied the contents of a royal treasury (luckily not that containing the coronation regalia) within Westminster Abbey. Despite the recovery of the odd piece dropped by the thieves – including a silver cup netted by a fisherman on the Thames, and plate discarded behind tombstones in St Margaret's churchyard – an extremely valuable collection was lost. It was the shock of this burglary that led crown officials to move the bulk of the royal ornaments and plate (other than the coronation regalia, which remained in the Abbey) to another home, where they have remained ever since – the Tower of London.

When the state regalia and plate moved en masse to the Tower in the 14th century, they were first stowed in the basement of the great White Tower. Here, within walls almost five metres (16 ft) thick, and secured by no fewer than forty-nine keys, the regalia was felt to be genuinely safe. As the collection grew, a series of new buildings was created for it in the early 16th century, including administrative offices [25]. Here special cupboards housed the department's ledgers and account books, while a collection of scales and some 400 weights were used to weigh everything that came in and out of the department. The whole complex was comfortable and well appointed, with staff and visitors even enjoying the benefits of a dedicated privy and waiting room.

The routine pageantry of the Tudor monarchy kept the officers of the Jewel House busy, but then as now a coronation saw activity rise to fever pitch. The state regalia, as well as jewels and plate, had to be ferried to where the king needed them, carefully wrapped in linen and then stowed in great trunks. They might be required at any one of Henry VIII's sixty or so royal palaces, or even overseas – as the mammoth collection taken to France for the royal event known as the 'Field of Cloth of Gold' shows. Items of the regalia were issued for rehearsals of state events, and even the velvet caps set within many crowns needed care – with special unguents being burnt to ensure they smelt as well as looked regal.

In addition to being used on the most august occasions of state, items of the regalia were, surprisingly, sometimes brought out for theatrical performances. Anne of Denmark, James I's wife, was an avid actress, and court plays and masques flourished under her patronage. In 1608 one of the sceptres was issued for the Queen to use as a prop, only to be returned broken, a note in the Jewel House account reading: 'Loste by Queene Anne at a maske the wing of a Septer of golde, which was delivered for her Ma^tes use.' With the benefit of hindsight, the casual carelessness revealed by these ledgers reads as a terrible augury of the catastrophe that was about to unfold.

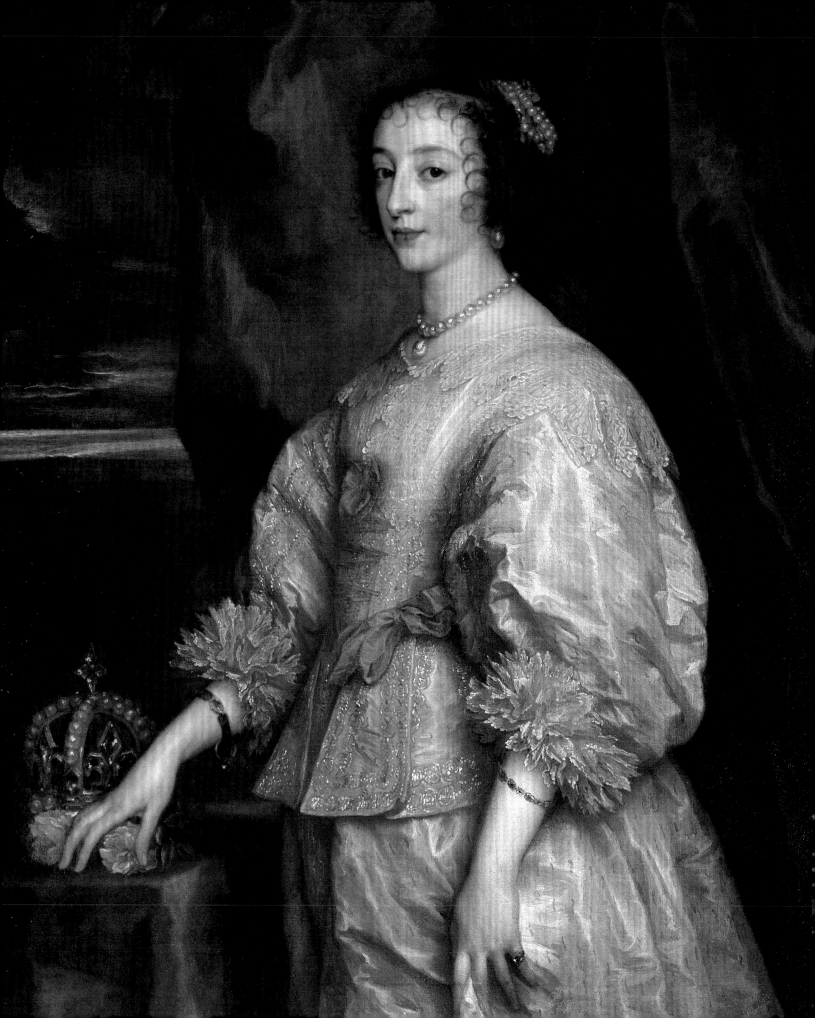

3

MELTDOWN

When King James I died and was peacefully succeeded by his 30-year-old son Charles, there was nothing to indicate that this shy young man of cultured tastes would bring down the English monarchy. Indeed, he instituted changes that might have cemented rather than collapsed the institution. It was 1625 and the age of exuberance was passing. The royal household was to be reformed and the showy excess of the Jacobean court replaced with a new sobriety. While portraits of Elizabethan worthies show jewelled objects dripping from every inch of their gorgeous gold and crimson dresses, those of the Caroline court show an altogether more sober scene. Grey and green eclipsed violet and vermillion, and a single string of pearls the menagerie of jewelled beasts [26].

The change in court culture brought about changes in the Jewel House. Many of the objects in the countless coffers now had limited appeal. The riches of the Tudor Jewel House – the spectacular jewelled cups adorned

Opposite 26 Henrietta Maria, *1632, by Anthony Van Dyck.*
By the 1630s tastes in jewellery had changed, and many of the most flamboyant objects in the Jewel House lay unused.

with the insignia of Henry VIII and his various wives, the enamelled ostrich eggs and engraved unicorns' horns – were no longer in regular use. Out of fashion in form and function, many items in the collection were unlikely ever to be needed again. Keen for the funds to allow him to intervene in European affairs, Charles dispatched his trusted friend, the dashing Duke of Buckingham, to Holland with a cache of treasures from the Jewel House. Among his cargo were some of the most gorgeous items of jewellery in the collection – though none of the principal items of the regalia – and in the teeming towns of the Low Countries they were pawned for tens of thousands of pounds.

Raising money against or selling objects from the royal collection was nothing new [27]. Jewels and plate were both portable and valuable, and they could be easily liquidated – sometimes literally – and so had always been an obvious source of ready money. An inventory of the reign of Edward III, for instance, describes the king's crown itself as having been recently redeemed from pawn in Flanders. But the times had changed; the relatively recent concept of the state regalia as inalienable, and a growing mistrust and resentment felt by many towards Charles I, caused the removal of items from the Jewel House to be eyed with

real suspicion. After this bout of pawning, the King started to sell chunks of his collection of jewels and plate outright. In 1629 Charles asked for most of the jewelled objects from the Tower Jewel House to be brought to Whitehall Palace. Over fifty items were identified for immediate sale. Meanwhile, the pieces that the Duke of Buckingham had pawned on the Continent were now also put on the market.

If the King's desire for disposable funds fuelled the sales of the 1620s, it was nothing compared to the urgency of the financial straits in which he found himself a decade later. His reign had taken a disastrous trajectory, and within fifteen years of his accession Charles I had managed to alienate the politically powerful classes by pursuing wildly unpopular religious and fiscal policies in his three kingdoms. His insistence on imposing his own brand of High Church Anglicanism on a largely Presbyterian Scotland brought him into armed conflict with the Scots, while relations with the Irish were no better, and by the end of the 1630s Charles was fighting his own subjects on two

fronts. As matters in England came to a head in 1642, Charles decided he had to dispatch his Catholic wife, Henrietta Maria, from the kingdom to ensure her safety. In February 1642 the Queen sailed for the Continent in the company of her daughter Mary, recently married to William II of Orange. When Henrietta Maria left, many of the most valuable items of personal jewellery – brooches, unset stones, necklaces and the like – were discreetly emptied from the coffers in the Tower and sent away with her. On his return to the capital from Dover, the King was terrified by the explosive political atmosphere he found, and within a week he abandoned London. By August the whole kingdom had dissolved into civil war.

As Charles departed, the capital fell into the hands of his Parliamentary adversaries and with it the offices of state based there. The lure of the regalia for the King's enemies was almost irresistible, both because of their sheer financial value and because of the royal authority that they represented. In 1643, less than a year into the Civil War, a motion was introduced into Parliament

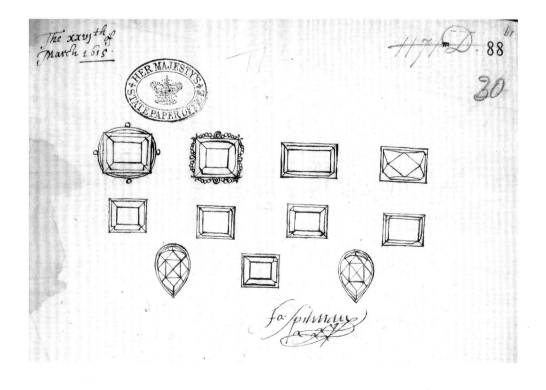

Opposite 27 *The custom of pawning royal jewels or raising money against them had been in practice since the Middle Ages. This drawing is of eleven royal diamonds offered to Sir John Spillman by Anne of Denmark as security for a loan, 26 March 1615.*

Above 28 *The strongroom at Westminster Abbey, known as the 'Pyx Chamber'. In the Middle Ages it served as an impregnable treasury, in which the coronation regalia was kept.*

proposing that the House of Commons should take possession of the keys to the Westminster Abbey treasury, where the coronation regalia had so far remained undisturbed, using force if necessary. Put to the vote, the motion was defeated. A new attempt was made the following day, with the qualifier that access to the chamber should be only for the purposes of making a comprehensive inventory 'and nothing removed till the House take further order'. It passed by one vote.

What happened next is described by Charles I's chaplain, Peter Heylyn; while Heylyn may or may not have been reporting fact, at the very least his vivid account illustrates the Royalists' worst fears. The Master of the Jewel House, Sir Henry Mildmay, who

had deserted the Royalist cause, led the delegation to the Abbey to inspect 'St Edward's regalia'. With him was the MP Henry Marten, a notorious lecher and future signatory of the King's death warrant, and the poet George Withers. When the Dean refused to relinquish the keys to the Pyx Chamber [28], the locks on the great doors were smashed. Once inside, in Heylyn's words, Marten 'made himself Master of the Spoil. And having forced open a great Iron Chest, took out the Crowns, the Robes, the Swords and Scepter, belonging anciently to K. Edward the Confessor, and used by all our Kings at their Inaugurations. With a scorn greater than his Lists and the rest of his Vices, he openly declared That there would be no further use of these Toys and Trifles. And in the jollity of that humour, invests George Withers in the Royal Habiliments. Who being thus crown'd and Royally array'd first marcht about the Room with a stately Garb, and afterwards with a thousand Apish and Ridiculous actions exposed those Sacred Ornaments to contempt and laughter.'

Mildmay's motley crew may have filled the Pyx Chamber with their simian screams, but the House of

Lords soberly refused to sanction any physical spoliation of the collection. They rejected a move in 1644 to melt the remaining royal plate for coin, remarking that its true value lay not in its gold content but what it represented, adding that 'Besides, it doth too much look like the Queen's Pawning and Selling of the Jewels of the Crown'. At this date, the Parliamentarians maintained the line that they were still loyal to the King – if only he could be persuaded to behave reasonably – and the Lords pointed out that 'the Parliament hath expressed Affection to the King; and to take care of his Children: And that this Act would be somewhat incongruous, now to sell his Plate'. But the House of Lords itself, like so many institutions of the old regime, would soon be deposed by the passionate progressives of the lower house, and their moderate words were not heeded.

At this time the Jewel House lost many of its treasures [29]. The jewellery had been greatly denuded by the King's own sales of the 1620s and by the quiet removal of pieces to the Continent in 1642, which were then sold off

by the Queen to keep the Royalist army in guns and ammunition. Concurrently, Parliament plundered the plate to melt down for coinage during the mid- to late 1640s. Despite all of this, the Jewel House still had in its care a substantial collection of gold plate and jewelled objects. Crucially, neither the King nor Parliament had dared to remove any of the principal items of either the state or coronation regalia, so the crowns, sceptres and orbs, which were the accumulation of half a millennium, remained intact.

On an icy day in January 1649 Charles I, defiant but defeated, was executed in the street outside Whitehall Palace [30]. A week later the monarchy itself was abolished and the republic of England was born. After six relentless years of civil war the new regime was almost bankrupt before it began. So it turned its attention to the infrastructure of the institution it had just brought down and on 6 July Parliament passed the 'Act for the sale of the goods and personal estate of the late King, Queen and Prince'. What followed was an unparalleled undertaking in every sense. Trustees were

Right 29 Standing Salt made for James I and presented by his ambassador to the Tsar of Russia in 1615. Such objects were part of the collection in the Jewel House at the beginning of the century and give a flavour of the riches that were sold or melted down in the 1640s.

Opposite 30 The Execution of Charles I, 1650, by an unknown artist. This took place outside Whitehall Palace on 30 January 1649. Six months after disposing of the King, the English republic put almost the entire royal collection, including the regalia, up for sale.

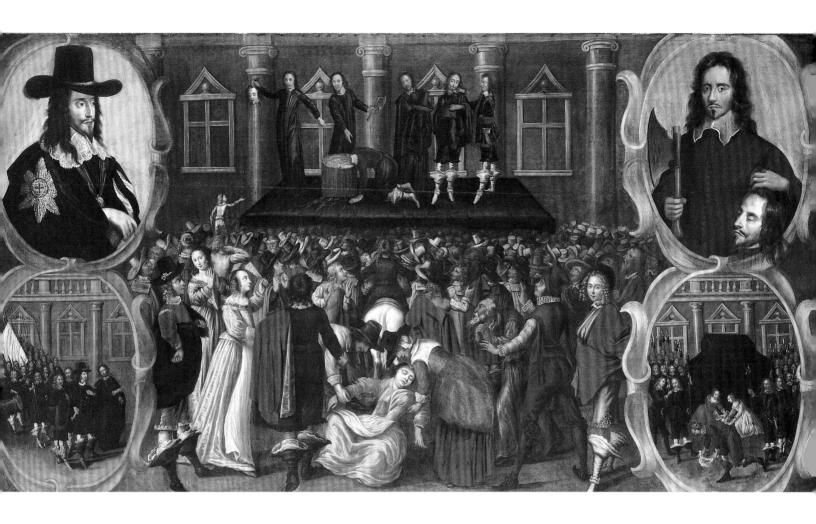

appointed who were to trawl through the royal palaces to create a vast inventory of every one of Charles I's possessions, decide upon a fair valuation for each, and then arrange their sale to the highest bidder.

At the Jewel House the Trustees had a challenge on their hands. The Master, Sir Henry Mildmay, was a confirmed Parliamentarian and posed no obstacle to their work, but his kinsman Carew Mildmay, the clerk who actually ran the office, was a different creature. The Trustees' first request, for the Jewel House ledgers to be handed over, met with blank refusal – an early sign of the stubbornness that would characterize all their dealings with the Jewel House clerk. Carew Mildmay did, however, co-operate with the creation of the inventory. Over the course of three days,

beginning on Monday 13 August, the contents of the Tower strongrooms were carefully catalogued. Much the most valuable item was the Tudor state crown [see 23], next in value to it was the queen's state crown, and a third small crown, perhaps that made for Edward VI in 1547. Also listed were the orb, weighing 600 grams (1lb 5½ oz), two sceptres and a silver-gilt rod.

These objects, and the numerous pieces of banqueting and church plate also in the collection, would have been well known to Carew Mildmay. Less familiar were the contents of the boxes that had arrived the previous Thursday from Westminster. For Parliament had ordered that 'St Edward's regalia' in Westminster Abbey be packed up and taken to the Tower to be included in their great catalogue.

As he unwrapped the sacred coronation regalia, Carew Mildmay did not disguise his disappointment with the fragile objects and their medieval workmanship. St Edward's Crown was described as 'of gould wyer-worke sett with slight stones', the queen's coronation crown was set with 'foule pearle[s] and saphires' and 'formerly thought to be of Massy gould but upon triall found to be of Silver gilt'. As well as the two crowns, he listed the ivory staff topped with a dove, a gilt staff also topped with a dove, two sceptres, the Coronation Spoon and a pair of gilt spurs.

Mildmay's valuations for the coronation crowns were modest compared to those for the state regalia. While he priced the Tudor state crown at £1,100, the queen's crown at £338 and the orb at £57, St Edward's Crown was marked at £248 and the queen's coronation crown at just £16. However, the regalia was valued more highly than almost any other category of object in the inventory. Most canvases in the King's famed collection of paintings were valued at between £20 and £50: Van Dyck's great painting of the King on horseback was given the price tag of £40, as was Andrea Mantegna's *Christ Carrying the Cross*, while a portrait of Henry VIII was priced at just £1. Only the vast ten- or twelve-piece sets of tapestries woven with gold and silver thread were valued more highly than the main items of the regalia.

It was one thing to catalogue the collection, but quite another to sell it. The great hall of Somerset House, the royal palace on the Strand, was to be the saleroom. The Jewel House plate was to make up the very first lots, and their sale was duly advertised. Things did not get off to a good start: the potential buyers who crossed the Somerset House courtyard found the great hall unexpectedly empty as the collection had not yet been released from the Tower – Carew Mildmay simply would not relinquish the keys. On 7 September Sir Henry Mildmay wrote sternly instructing him to hand them over and a fortnight later he went to the Tower himself to try and take them – but without success. Finally, on 25 September the stand-off ended: Carew Mildmay was arrested and imprisoned in the Fleet gaol, and the doors of the strongrooms broken down. Nothing now stood between the Crown Jewels and destruction.

In the event it took several months for most of the objects to be disposed of. The potency of the regalia – objects carried by the king that embodied sovereignty and were tinged with sanctity – was enormous and so while the rest of Charles I's collection was sold off largely intact, these items alone were to be 'totallie Broken and defaced'. So the king and queen's coronation crowns were sent to the Mint and melted down, as were the rest of 'St Edward's regalia' – the staff with a dove, the staff topped by a fleur-de-lys and the two sceptres. The state regalia was first stripped of its stones and then suffered the same fate [32]. The king's crown, denuded of its diamonds, sapphires, rubies and pearls, which were later sold as separate lots, was dropped into the Mint melting pots. With it went the queen's crown, Edward VI's crown, the orb, two sceptres and the coronation bracelets. The liquid gold was then pressed into hundreds of small blank discs. Sandwiched between engraved metal dies and struck by the mintmen's hammers, the once-hallowed gold became money, emblazoned with the simple words 'The Commonwealth of England' [31].

Above 31 *A gold 'unite' (worth £1), bearing the insignia of the Commonwealth of England, issued in 1649. This may be one of the coins minted from the melted gold of the medieval regalia.*

Opposite 32 *The Goldsmith's Workshop, c.1570, by Alessandro Fei. Gold and gems have always been recycled as times and fashions have changed. Those who bought the stones broken from the medieval crown jewels in 1649 would simply have had them re-set into new pieces.*

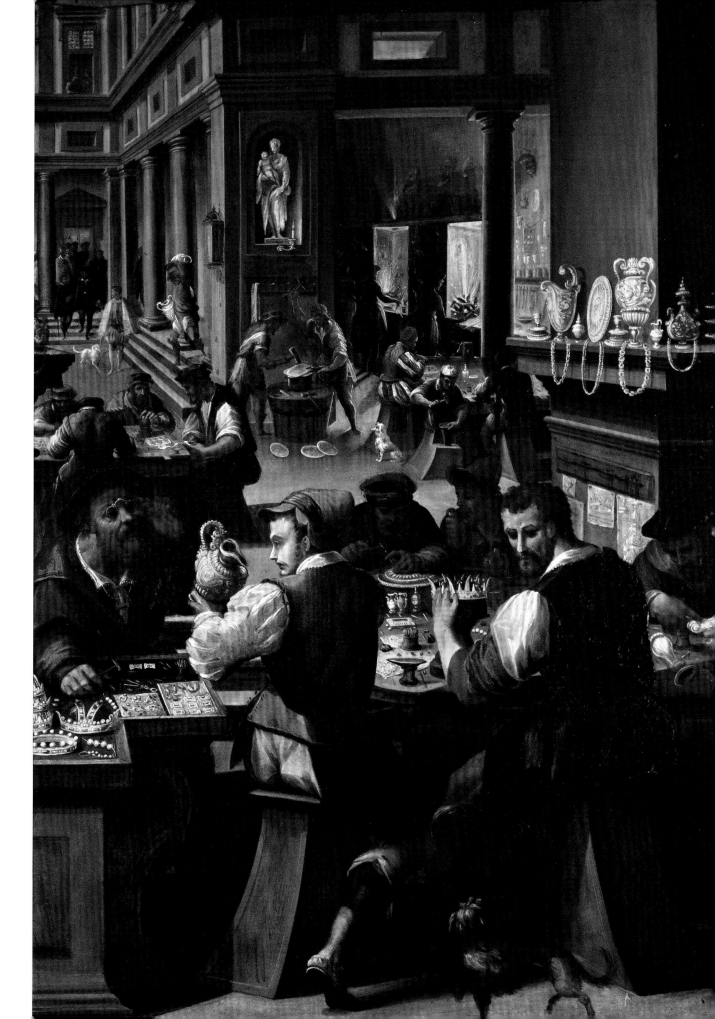

4

MONARCHY REMADE

O n 25 May 1660, after fourteen years of exile, Charles II landed on the Kent coast to scenes of wild rejoicing. The death of Oliver Cromwell in 1658 had caused the republican regime to dissolve into chaos, leaving England exhausted and craving stability. So complete was the popular delight when he set foot on English soil that Charles II himself remarked wryly that it had clearly been his own fault he had been absent so long, as there was not a person in England who did not claim to have longed for his return [33].

As soon as the summer was over, arrangements for the coronation were put in hand. A committee had been appointed to oversee the occasion, and they were joined at their meetings by the King himself, who personally decided all the most important aspects of the event. Charles made it clear from the outset that what he wanted was a full-blooded medieval coronation. The ancient precedent books were to be consulted and no

Opposite 33 Charles II, c.1661–62, by John Michael Wright. The King is depicted with the new regalia: the state crown, the orb and the Sovereign's Sceptre with Cross.

opportunity missed to express the glamour and glory of the English monarchy.

At their first meeting in September 1660, item two on the coronation committee agenda was: 'What have beene the Regalia, & in whose Custody they ought to be, & how supplyed de Novo.' The question was put before the principal herald, Sir Edward Walker, who explained that as the whole collection had been lost in 'the late unhappy times' they would need to start from scratch. Following the King's lead about continuity with the past, Walker recommended that there should once again be a coronation crown and a state crown: 'the one named St Edwards Crowne, & the other an Imperiall Crowne.' In addition to these, Walker listed six further essential elements of regalia: the orb, sceptre, swords, spurs, ring and bracelets. Other than the coronation ring (then regarded as a personal object), all these pieces made for the 1661 coronation are today in the Jewel House at the Tower of London [see pp. 2–3]. Therefore, the English Crown Jewels as a collection is essentially that made for Charles II, supplemented only as necessary in the succeeding centuries. The extent of the survival of the Restoration commission is remarkable; while the majority of the English Crown Jewels are not as old as some of their European counterparts, the collection

retains at its heart an extraordinarily complete assemblage of early-modern regalia.

The single most important item to be remade in 1660–61 and still the most significant item of the Crown Jewels, was the coronation crown itself [35], called St Edward's Crown after its medieval predecessor. For though the coronation regalia associated with Edward the Confessor had been destroyed in 1649, the memory of it caused Charles II to commission a new coronation crown bearing the saint-king's name. The identity of the goldsmith who created this seminal piece of regalia is still unknown, as the whole regalia commission was awarded to the great Restoration financier, Robert Vyner. Nominally a goldsmith, Vyner was in reality a private banker, who would lend the King many tens of thousands of pounds during the following decades. He managed the regalia commission for the

Master of the Jewel House, farming out individual pieces to various jewellers and goldsmiths and submitting one massive bill for the work. The eleven principal pieces of regalia alone would cost some £13,000, as much as three new fully equipped warships.

The new St Edward's Crown of 1661 was essentially a very a simple structure. Gold elements – the headband, the crosses and fleurs-de-lys and arches – were bolted together to form the frame of the crown. The settings for the jewels were then fixed through this frame from behind. Each gem was held in place by a gold collar, with

Below 34 DETAIL OF ST EDWARD'S CROWN, 1661.
The enamel mounts are in the shape of acanthus leaves.

Opposite 35 ST EDWARD'S CROWN, 1661. *Named after the coronation crown melted down in 1649, St Edward's Crown is still very much as it was when completed for Charles II in 1661.*

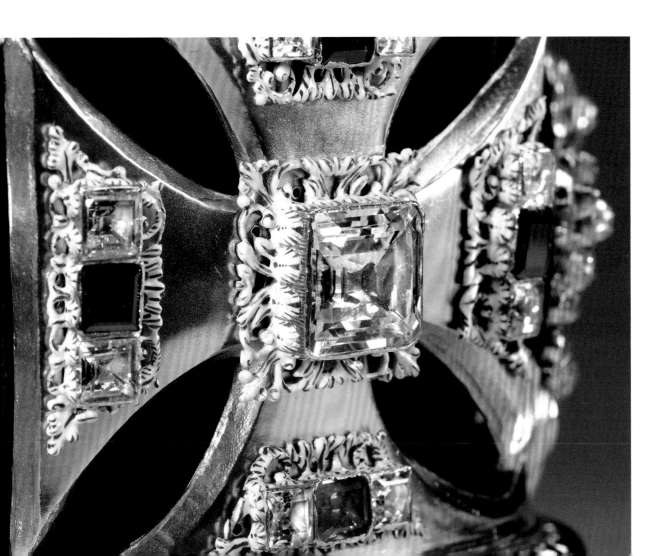

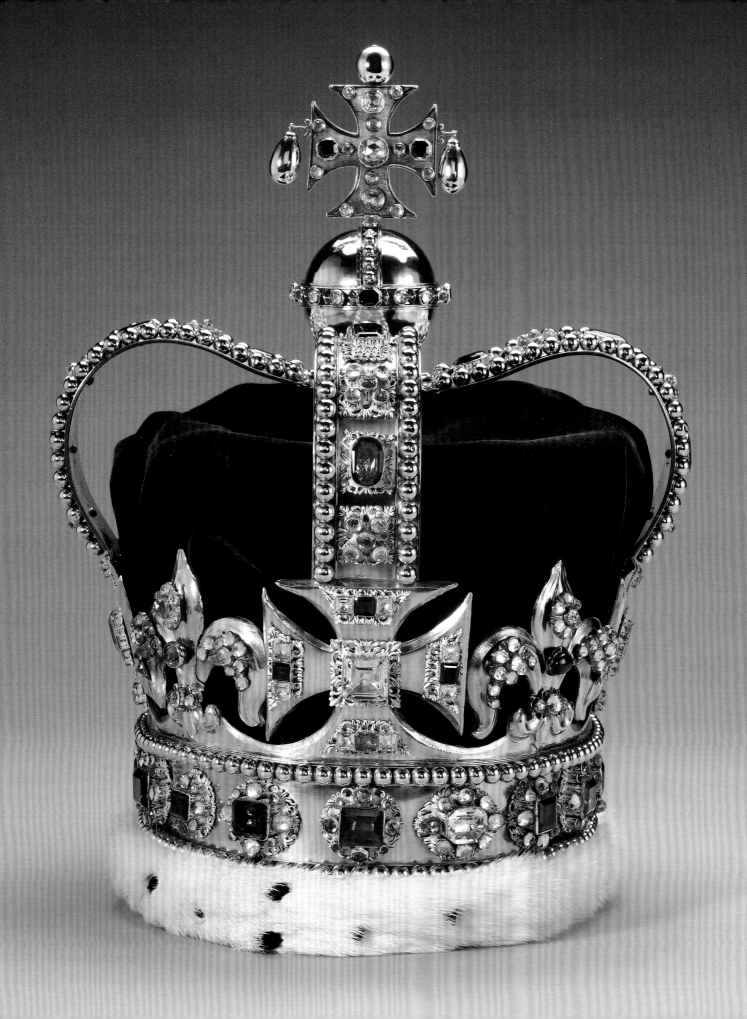

the stones set in clusters surrounded by white enamel mounts in the form of acanthus leaves [34]. Other than the jewels themselves, almost all these elements survive in the crown today. In particular the mounts, delicately picked out in dark red, are a rare and important survival of Restoration enamelling. The soft gold collars for the gems were made to open easily, which was to be all-important as six days after the coronation the crown was returned to the goldsmith and stripped of every stone.

Sir Edward Walker's original proposal had been for the new coronation crown to be of plain gold without gemstones – probably in the spirit of the medieval St Edward's Crown, which had had very few jewels. The King was not happy with such an understated approach, but the cost of buying gems was prohibitive – and so a compromise was reached. As the crown would be worn only once, for the act of coronation, it was to be set with magnificent jewels that Robert Vyner would provide solely for the occasion and then retrieve. The hire cost alone for the stones, which were a mixture of diamonds and coloured gems, was a colossal £500, giving some indication of the splendour of the piece when fully set.

Although there was no longer any need for the coronation crown to remain in Westminster Abbey after the ceremony as a sacred relic, the tradition of exchanging the coronation crown for a state crown

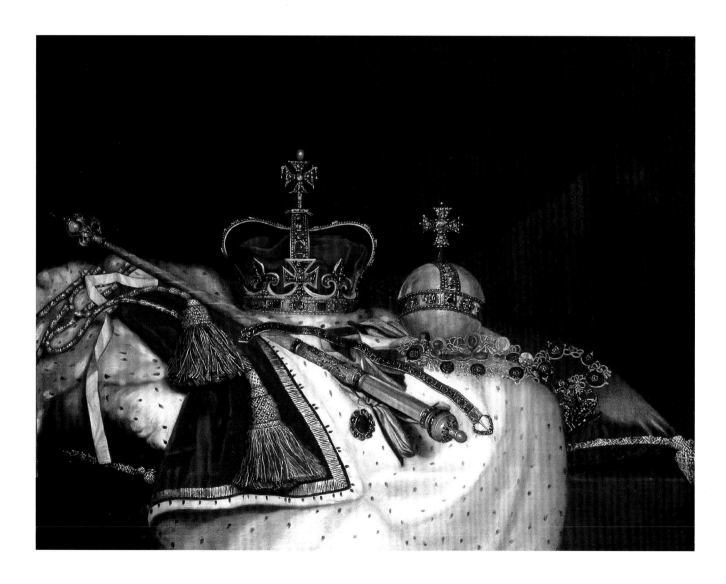

Opposite 36 *Regalia of Charles II, c.1670, by an unknown artist. The state crown made for Charles II in 1661, shown here, was in regular use for over fifty years until its frame was replaced in 1714.*

Left 37 *Copper and glass crown made in England in 1664, to be sent as a gift to the king of the West African city state of Ardra. This remarkable object, made to cement a trading deal, gives a good impression of the appearance of Charles II's state crown, on which it was almost certainly modelled.*

at the end of the service was to be continued. So Vyner supplied a second, 'state', crown, for use on all other occasions and permanently set with stones. The gems were an astonishing collection: almost 900 diamonds, 549 pearls, 20 emeralds, 18 sapphires and 10 rubies. As the state crown has always had much more regular use than the coronation crown, it has needed periodic replacement. So while Charles II's coronation crown has survived, though the stones have changed, his state crown has long since been replaced, but a number of the 17th-century stones remain. The state crown continued in use until the early 18th century, and its appearance is known from contemporary sources [36, 37].

The only items in the collection that rivalled the coronation crown for spiritual power or significance were those connected with the anointing – the most solemn part of the coronation ceremony. Initially, the coronation committee had asked for both a new ampulla – the vessel that held the holy anointing oil – and a new spoon into which to pour the oil (following the use to which the Coronation Spoon had been put in the early 17th century) [38]. During the weeks that followed, however, Clement Kynnersley, who had bought the medieval Coronation Spoon in the 1649 sale, returned it to the Jewel House. Though Kynnersley had been an

official of the royal wardrobe in the 1630s, his loyalty to Charles I had not run deep and he had become one of the commissioners for the sale of the King's goods. Given this rather chequered history, Kynnersley's desire to curry favour with the Restoration regime was understandably strong, and thanks to him the 12th-century spoon, alone of the medieval regalia, remains part of the English Crown Jewels.

The spoon, with a small amount of repair, was considered fit for use at the coronation of 1661, but a new vessel was needed to replace the ampulla, which had certainly been melted down. In the late Middle Ages English kings had been anointed with a special oil said to have been given to St Thomas Becket by the Virgin Mary – in a tale suspiciously similar to the legend of the French coronation oil being delivered by a dove to Clovis, the first Christian king of the Franks. 'Becket's oil' was kept in a phial in the form of a small eagle, which, according to a contemporary source, was rediscovered in the Tower of London by Richard II in 1399 and first used for the coronation of his cousin and deposer, Henry IV. The 'oil of St Thomas' continued in use until the Reformation, but by 1626, if not well before, it had been replaced with a rather more Protestant concoction. However, the legend was

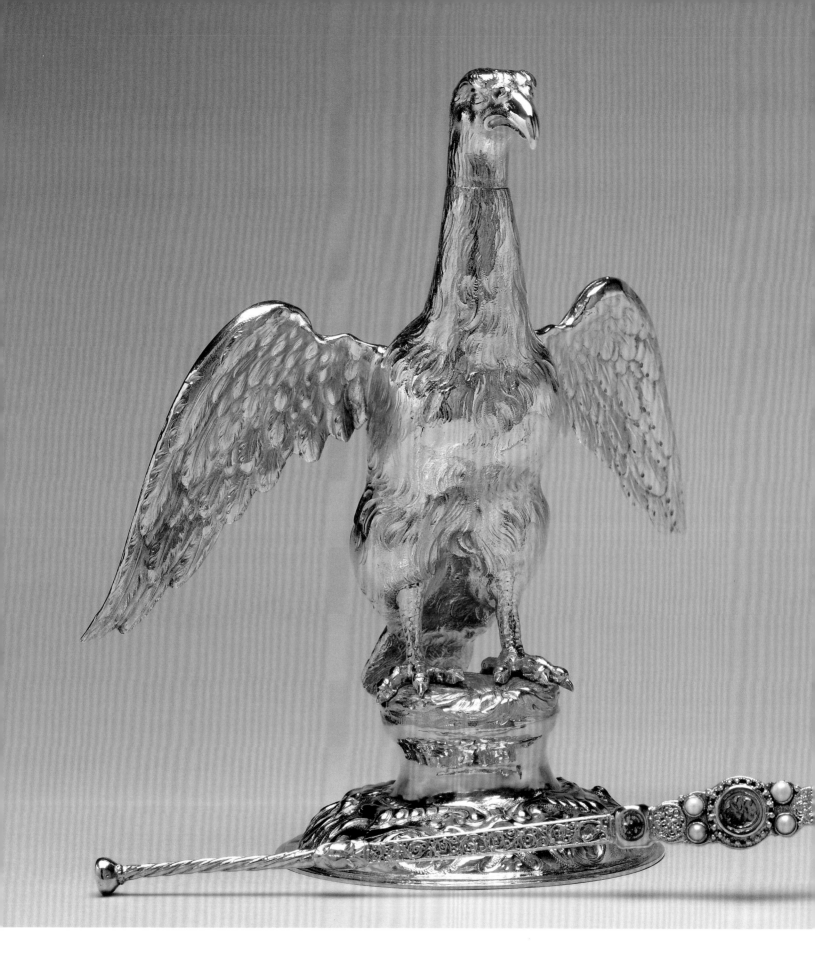

tenacious and at the Restoration it was decided the new Ampulla should again be 'in forme of an Eagle'.

Though larger than its medieval precursor, the Ampulla is nonetheless a small object, made of gold and standing just over 20 cm (8 in.) high. The head of the eagle was made so that it could be unscrewed, to allow the body to be filled with oil [39]; the liquid pours out of a small hole in the bird's beak. At Charles II's coronation, as has been the practice since, the Archbishop of Canterbury poured the oil from the Ampulla into the spoon, and then used his fingers to anoint the King.

The craftsmanship of the orb supplied by Vyner in 1661 [40] was very similar to that of St Edward's Crown. Made of two hollow gold hemispheres, the object is fixed

Left and below 38, 39 **THE AMPULLA**, *1661.* **THE CORONATION SPOON,** *12th century. While the 12th-century spoon was returned to Charles II at the Restoration, the medieval ampulla, which held the anointing oil, was lost. The new Ampulla (shown left slightly larger than life-size) takes the form of an eagle, from the beak of which the oil can be poured onto the spoon. The eagle's head is removable, allowing the vessel to be filled.*

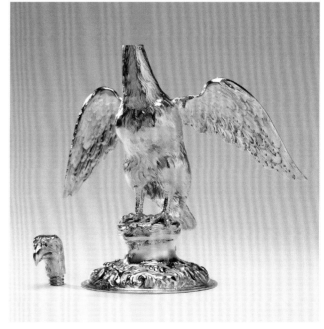

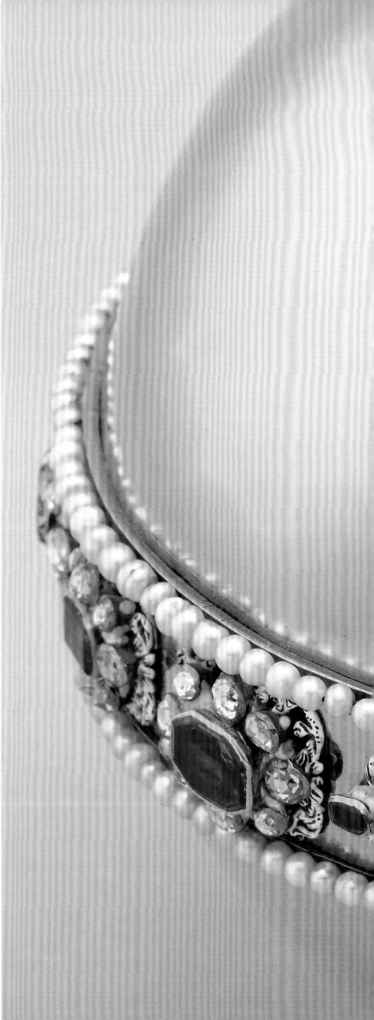

Below 40 **THE SOVEREIGN'S ORB**, *1661. Representing Christ's authority over the globe, the orb has been used for every coronation since 1661. The surmounting amethyst and cross originally faced forward over the jewelled band on which they sit [see 36].*

Right 41 **DETAIL OF THE SOVEREIGN'S ORB**, *1661. More than any other 17th-century piece in the collection, the orb retains its original gems, including most of the 365 rose-cut diamonds.*

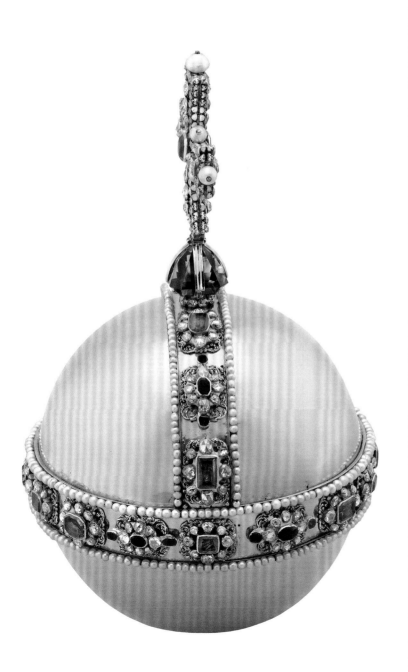

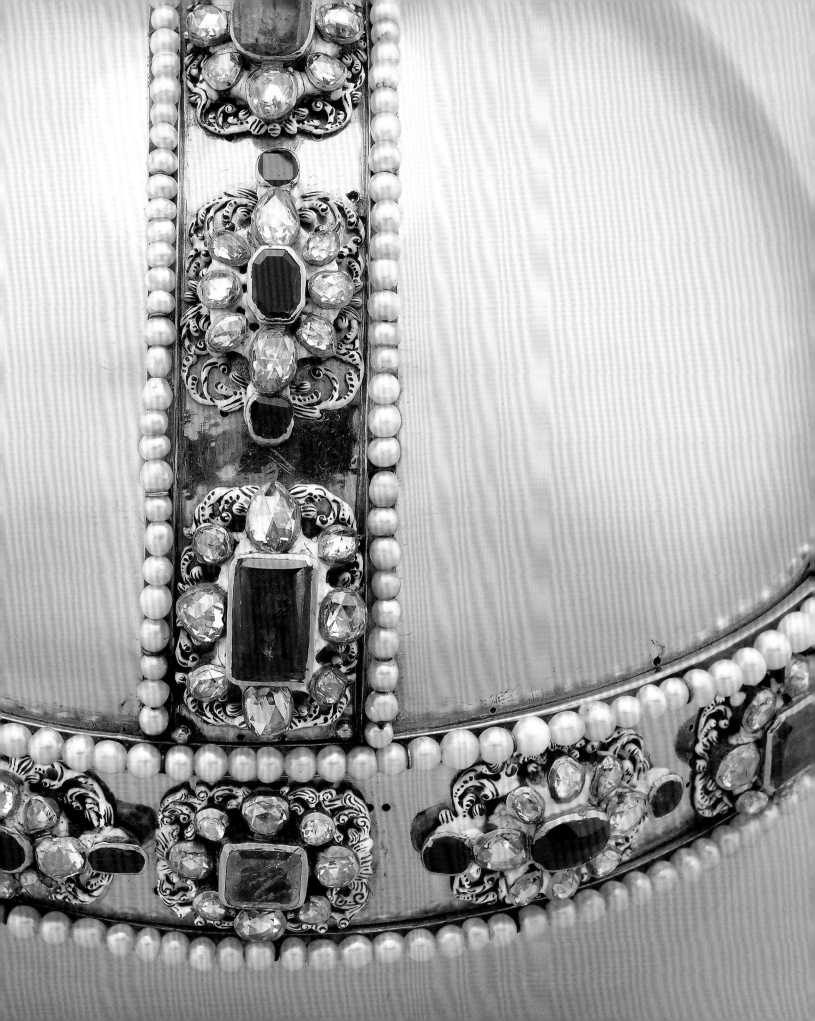

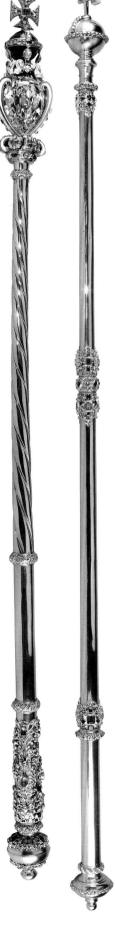

together at the equator and the join covered by a band of jewels in white enamel settings [41]. The size of the Tudor orb melted in 1649 is not known, but at over 1 kg (2½ lb) the 1661 orb is about twice the weight of its predecessor. A group of precious stones was purchased to set the orb, the most prominent and precious of which was the large amethyst that forms the 'monde', the small stone that surmounts the orb [*see* p. 1]. Cut in a pyramidal form known as an octagonal step-cut, this deep-purple stone measures just over 2.5 cm (1 in.) in each direction and can be clearly seen in 17th-century paintings. Used at every coronation since 1661, the orb has been repaired and the stones replaced from time to time, and it is now set with 365 diamonds, 18 rubies, 9 emeralds and 9 sapphires.

The orb was a straightforward enough commission in 1661, but the question of the sceptres was more tricky. There had been two sceptres in circulation before the Civil War, but Walker initially recommended that only one be made new for the king in 1661 – keen,

Right 42 THE SOVEREIGN'S SCEPTRE WITH CROSS, *1661*. THE SOVEREIGN'S SCEPTRE WITH DOVE, *1661*. *The Sceptre with Dove, the bird symbolizing the Holy Ghost, denotes the sovereign's spiritual authority, while the Sceptre with Cross represents temporal royal authority in the service of God. The Sovereign's Sceptre with Dove has remained largely unaltered since it was made, but the Sovereign's Sceptre with Cross has undergone various changes, notably the addition of the First Star of Africa (Cullinan I) diamond in 1911.*

Opposite 43, 44 DETAILS OF THE SOVEREIGN'S SCEPTRE WITH DOVE, *1661*. *The sceptre, sometimes known as 'The Rod of Equity and Mercy', is made of gold and set with 285 gems. As is characteristic of Charles II's new regalia, enamel is used skilfully to create a unifying decorative setting for the individual stones.*

perhaps, to resolve the long-standing difficulty of investing the king with three objects (two sceptres and an orb), when he had only two hands with which to hold them. In the event, however, the King's insistence on replicating the past won through and two were remade: the Sovereign's Sceptre with Dove and the Sovereign's Sceptre with Cross [42].

In its use of a dove with spread wings the new Sovereign's Sceptre with Dove [43] was firmly in the English historical tradition [*see* 7, 12 and 13]. Reaching right back to the pagan deification of strong and beautiful animals, a sceptre topped by a dove was fixed in the English regalia by Edward the Confessor's adoption of the emblem as his own. Medieval sceptres appear to have been very long – Edward I's was over 150 cm (5 ft) – whereas that made for Charles II in 1661 was 110.5 cm (3 ft 7 in.), a more manageable length even for a 1.8-metre (6-ft) king. Very little altered since 1661, the Sovereign's Sceptre with Dove is a slender gold staff, encircled in four places with jewelled collars. Many of the stones with which it is set today are part of the original collection bought for the sceptre in 1661 [44].

While the Sceptre with Dove cost £440 in 1661, its pair, the Sovereign's Sceptre with Cross, was well over twice as much at £1,025, making it the most expensive individual item other than the crowns. Since 1911 this sceptre has been dominated by the enormous diamond, the First Star of Africa (Cullinan I), set at its head (*see* 158). But as originally created, the surviving amethyst globe and gold cross nestled in a sensuous enamelled fleur-de-lys [46, 47]. The additional expense of the Sceptre with Cross in 1660–61 was probably due to the precious stones that

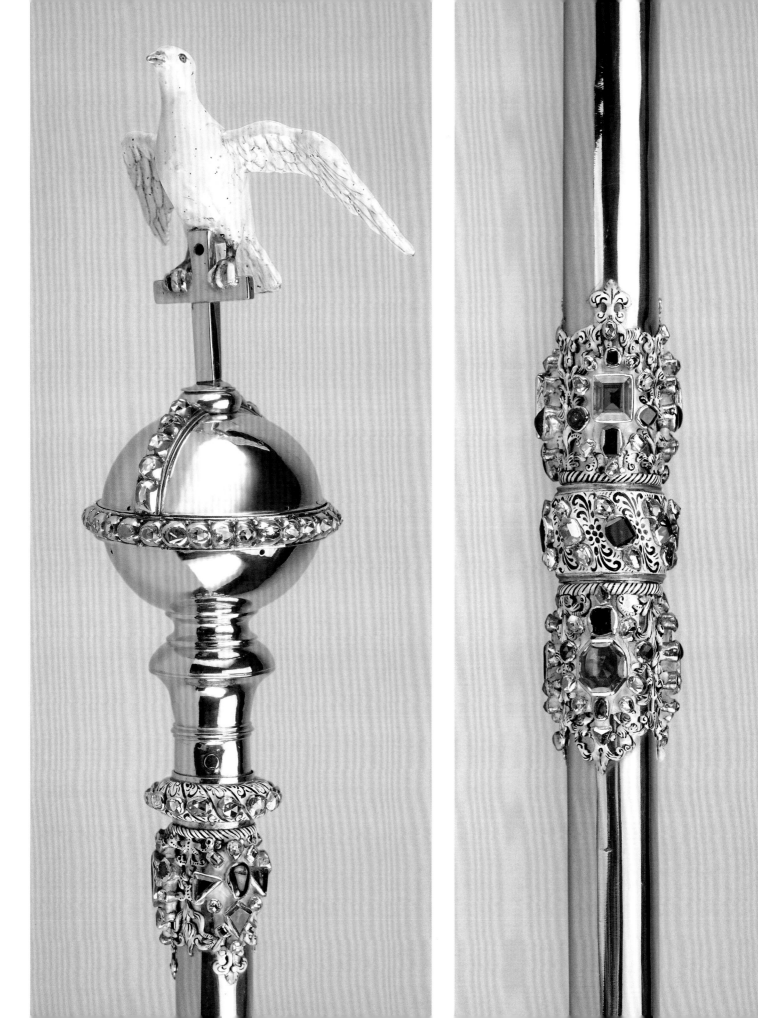

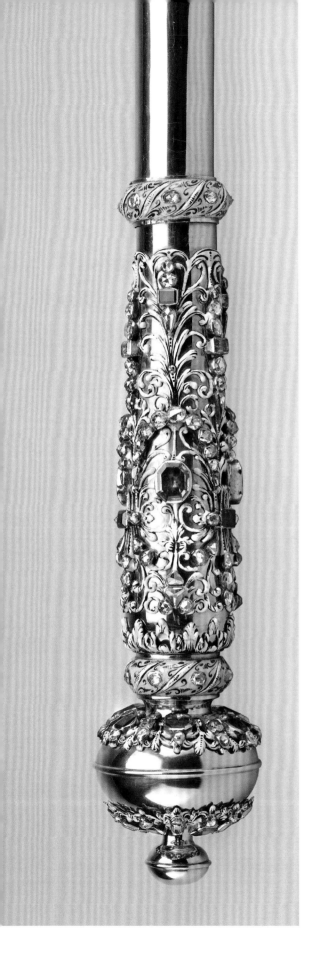

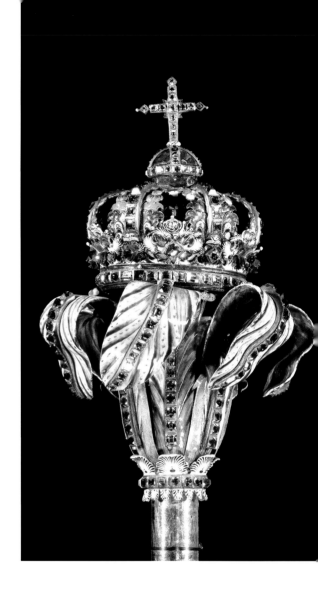

Left 45 **DETAIL OF THE SOVEREIGN'S SCEPTRE WITH CROSS**, 1661. As a comparison with a 17th-century engraving of the sceptre shows [on the right in 46 above], the jewelled enamelled band was originally set higher up, but was moved down for Queen Victoria in 1838.

Above left 46 Pieces of Charles II's regalia, from an engraving of 1687. From left to right they are: St Edward's Staff, the Sovereign's Sceptre with Dove and the Sovereign's Sceptre with Cross. The last shows the sceptre before the jewelled band was moved and the top was remodelled to receive the First Star of Africa (Cullinan I).

Above right 47 The Danish royal sceptre, made for the coronation of Charles II's cousin Frederick III in 1648. Like the Sovereign's Sceptre with Cross before it was remodelled, the Danish sceptre features an enamelled fleur-de-lys.

Opposite 48 **DETAIL OF ST EDWARD'S STAFF**, 1661. A replacement for the medieval St Edward's Staff was commissioned in 1660–61, though its precise function was unknown.

adorned it, in particular those which encrusted the broad jewelled sleeve, originally set in the middle of the shaft but moved to the bottom in 1838 to make it easier for Queen Victoria to hold. This gorgeous gem-encrusted enamel band is today set with 99 rose-cut diamonds as well as sapphires, rubies and emeralds – many of them the original stones [45].

Alongside the two sceptres, the regalia commission of 1660–61 also included a comparable third object, called St Edward's Staff [48]. This simple gold rod embodies the spirit of the 1661 coronation more than any other item, as it was commissioned just because such an object had been part of the medieval regalia, and in spite of the fact that its function had been long forgotten. Not on Walker's original list of essential items, its inclusion was decided upon by the coronation committee, quite possibly by the King himself. It was to be 'a long Sceptre or Staff of Gold with a Cross upon yᵉ topp and a Pike at yᵉ Foot of Steel, called Sᵗ Edwards Staff'. The purpose of the staff, which was not one of the objects with which the sovereign was invested during the coronation itself, had long baffled royal officials. James I was said to have been mystified. The likelihood is that the original staff had been revered as a relic of Edward the Confessor, rather than as a piece of coronation regalia per se, and was carried simply as a sacred object rather than being bestowed on a new king. Such was the determination of the coronation committee to re-create the past that the staff was commissioned, though it remained on the altar throughout the service.

Two further pieces of antiquated personal regalia commissioned for the 1661 coronation survive today: the Spurs and the bracelets [49, 51]. English kings had been invested with spurs at their coronations since at least the inauguration of Richard I (the Lionheart) in 1189. The essence of the ceremony of creating a knight, in which the subject 'earned his spurs', was easily absorbed into the coronation – especially in the 12th century when English dominion on the Continent was at its peak and crusading the favoured sport of kings. During the part of the coronation service when the sovereign was 'invested' with the robes and regalia, the spurs were fixed to the royal feet, immediately after which a sword was fastened to the royal waist. These knightly accoutrements were presented regardless of the sex of the monarch – a contemporary description of Mary Tudor's coronation in 1554 described how the 'spurs were put upon her feet'. By the early 15th century a specific set, known as 'saint Edwardes spores' were used for coronations, and continued to perform this function until they were dropped into the parliamentary melting pots in 1649. In making new Spurs in 1660–61, the coronation committee might have specified a more modern design featuring a wheel rather than a spike for the spur [50]. But again history won through; it was remembered that the old spurs had been of the prick form so the new pair was made to follow this pattern, though they had been out of common use since the 14th century.

The bracelets or 'armills' are another archaic ornament remade in 1660–61 [51]. The 1649 inventory described those that had been lost as '2 coronation bracelets weighing 7 oz' adorned with pearls and rubies. The new bracelets weigh almost the same as their predecessors but instead of being jewelled are

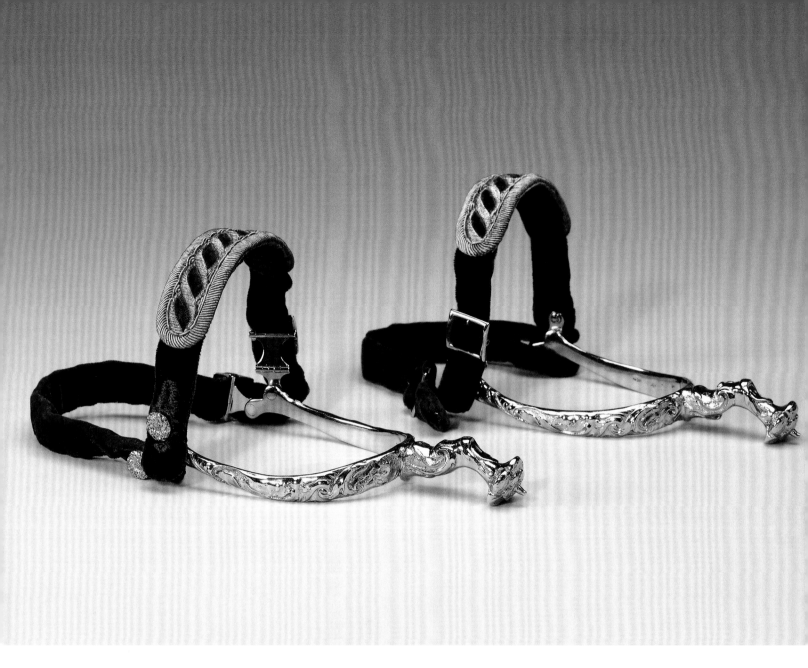

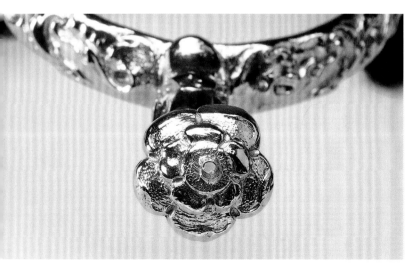

Above and left 49, 50 **THE SPURS**, 1660–61. The new Spurs, with which the sovereign was invested at the coronation, were made in a deliberately antiquated fashion in imitation of the lost medieval spurs. The tiny heel spikes project from the centre of a Tudor rose.

Opposite 51, 52 **THE SOVEREIGN'S ARMILLS**, 1661. These enamelled bracelets are adorned with the emblems of England, Scotland, France and Ireland.

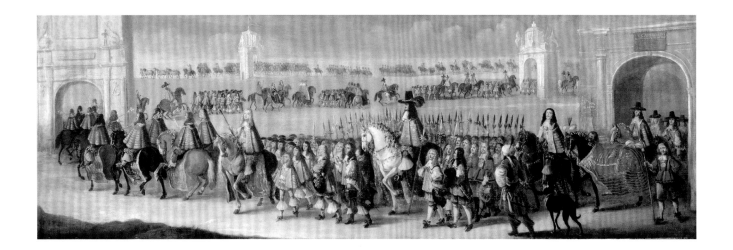

enamelled with the emblems of the kingdoms over which kings of England claimed sovereignty [52]. Despite the trouble and expense taken to remake the bracelets, they seem never to have featured prominently – if at all – in the coronation. In following the coronation rubric, officials carefully ensured the King received the long fabric stole called the 'armilla', but in a confusion over terminology omitted to present the bracelets (properly the 'armillae') that had once been attached to it.

So these then were the Crown Jewels that the coronation committee charged the Jewel House to supply, and that the Master of the Jewel House commissioned Robert Vyner to have made. When coronation day, 23 April 1661, came, the King must have presented a remarkable figure – a dazzling blend of old and new [*see* 33, 53 and 54]. The coronation ornaments were at a glance ancient objects, many of them archaic in form, made of gold with simple, striking silhouettes; and yet in detail featured gorgeous, continentally influenced workmanship. Edward I's ancient Coronation Chair was set out for the occasion, encasing the huge mute mass of the Stone of Scone, but comfortably spruced up with a gold cushion and gilt footstool. The King's own clothes were of the first fashion, allowing for three costume changes; they were of glittering gold and silver silk, made for almost £500 each by the most sought-after tailors in Paris. Yet on his feet Charles II would wear the prick spurs of a crusader. Altogether it was a supremely theatrical affair, and any inconsistencies in the coronation committee's thinking were drowned out by the glorious roar of crowds, the costume and colour.

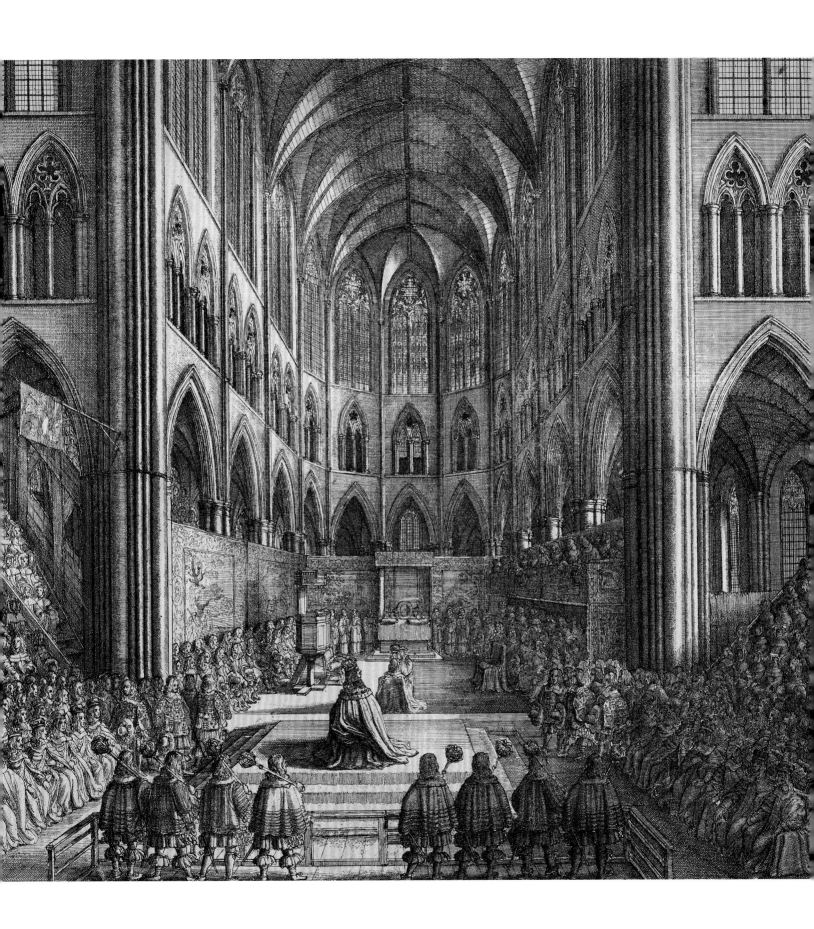

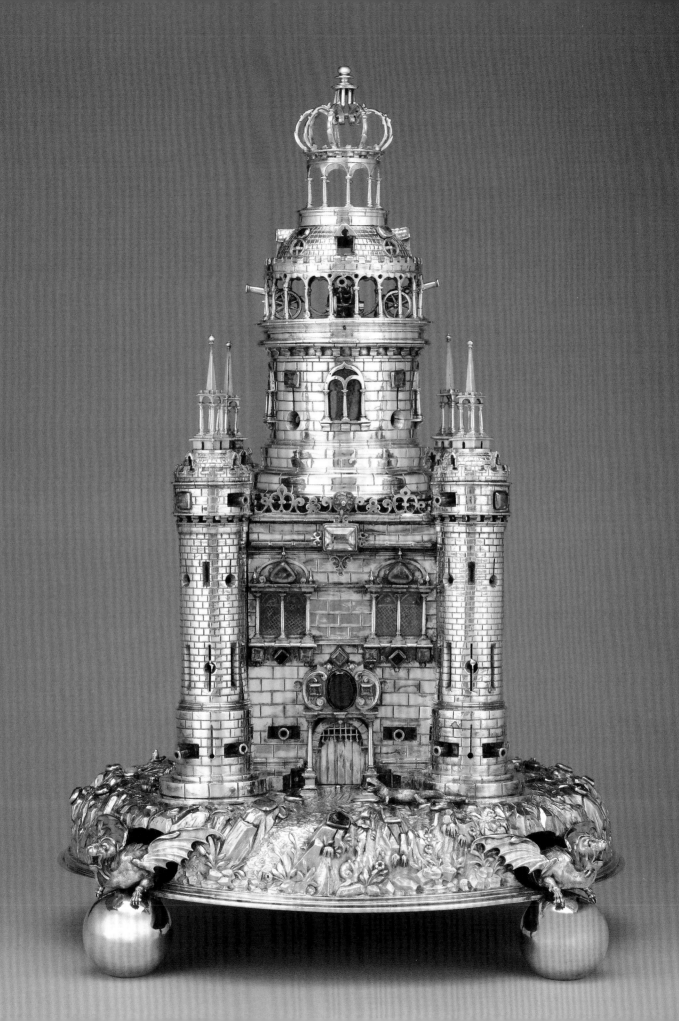

5

SPLENDOURS OF THE TABLE

The coronation was the ceremonial high point of Charles II's reign, but it was only the first and most prominent of an endless round of regal ceremonies. The royal calendar featured numerous ritual occasions on which the sovereign appeared. Among them were the daily routines of rising and retiring, regular diplomatic meetings and receptions, civic processions and the celebration of church feast days. For their enthusiastic revival by Charles II, new equipment was needed and the Jewel House was also responsible for supplying vessels for the altar and the dining table. These objects are not regalia, which is strictly speaking just the precious insignia carried or worn by the king. However, they were commissioned and managed by the Jewel House, used at coronations and other formal occasions, and housed together with the regalia at the Tower of London. As a consequence, they have come to be considered part of the Crown Jewels.

Opposite 55 THE SALT OF STATE, c.1630. *Also known as the Exeter Salt because it was a gift of allegiance to Charles II from the city of Exeter in 1660. It was made by the German goldsmith Johann Hass and was used on important occasions, including the coronation banquet.*

From the Middle Ages and well into more modern times lavish feasts were one of the most conspicuous ways a king could reward his entourage and demonstrate his own wealth and status. For this reason coronations had always been followed by a great banquet. The decision to continue this medieval tradition in 1661, like that to stage the procession from the Tower of London the day before, was probably taken by Charles II himself – a decade and a half of exile had taught him to exploit every opportunity to court the crowds. So, after the service in the Abbey, the King walked the short distance from the church to Westminster Hall, with the items of the regalia borne for him by the greatest men in the land. Inside the building, the King's own table stood alone on the raised dais at the south end while various grandees sat at the four long tables below. A number of remarkable pieces of 17th-century banqueting plate, now among the Crown Jewels, were used on this occasion, of which the most striking and important, the Salt of State, stood on the King's own table [55].

High-quality salt was a sought-after commodity in the Middle Ages, and was the most important substance on any dining table. When the salt was set on the royal table, all those present rose to their feet in respect. This special status had stimulated English craftsmen to create

ever more elaborate and ingenious salt vessels, often making them to resemble fantastic or even comical things. Henry VIII had owned at least one salt in the form of a castle, as well as others depicting writhing snakes, morris dancers and even a pair of shoes.

Charles II's Salt of State was made by the German goldsmith Jonann Hass; standing an imposing 46 cm (18 in.) high, it takes the form of a turreted castle standing on a rocky outcrop. With its gunports bristling with cannon, and lizards and frogs crawling over the base, it was designed both to impress and to delight [57]. The object was given to Charles II in 1660 by the prosperous city of Exeter, which was keen to make

amends for having conspicuously deserted Charles I at the beginning of the Civil War. Made in about 1630, it was bought at the cost of some £500 and the Exeter worthies almost certainly arranged for the precious stones to be added. As well as being a dazzling

Below 56 **THE SALT OF STATE**, *c.1630. Shallow wells under the turrets, and a large drawer in the body of the Salt, held seasoning and spices.*

Opposite 57 **DETAIL OF THE SALT OF STATE**, *c.1630. Emeralds make up the majority of the impressive collection of gems added to the Salt of State, probably in 1660. Here they flank the great amethyst over the door and the deep-red almandine garnets under the windows.*

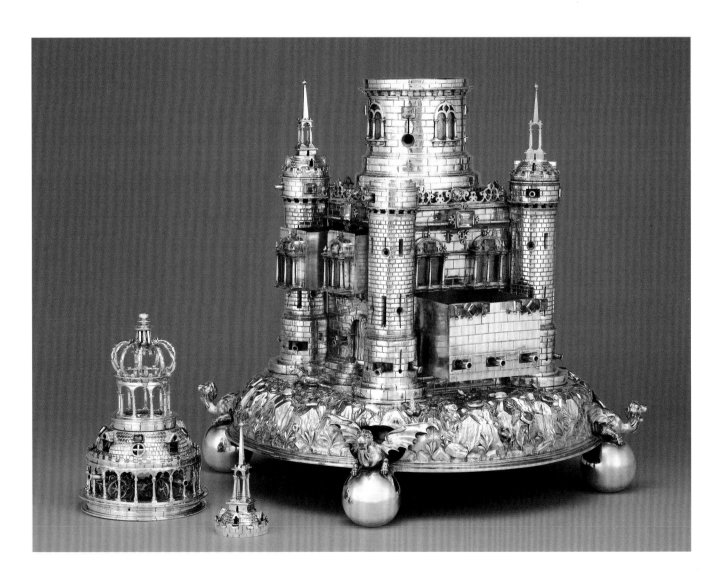

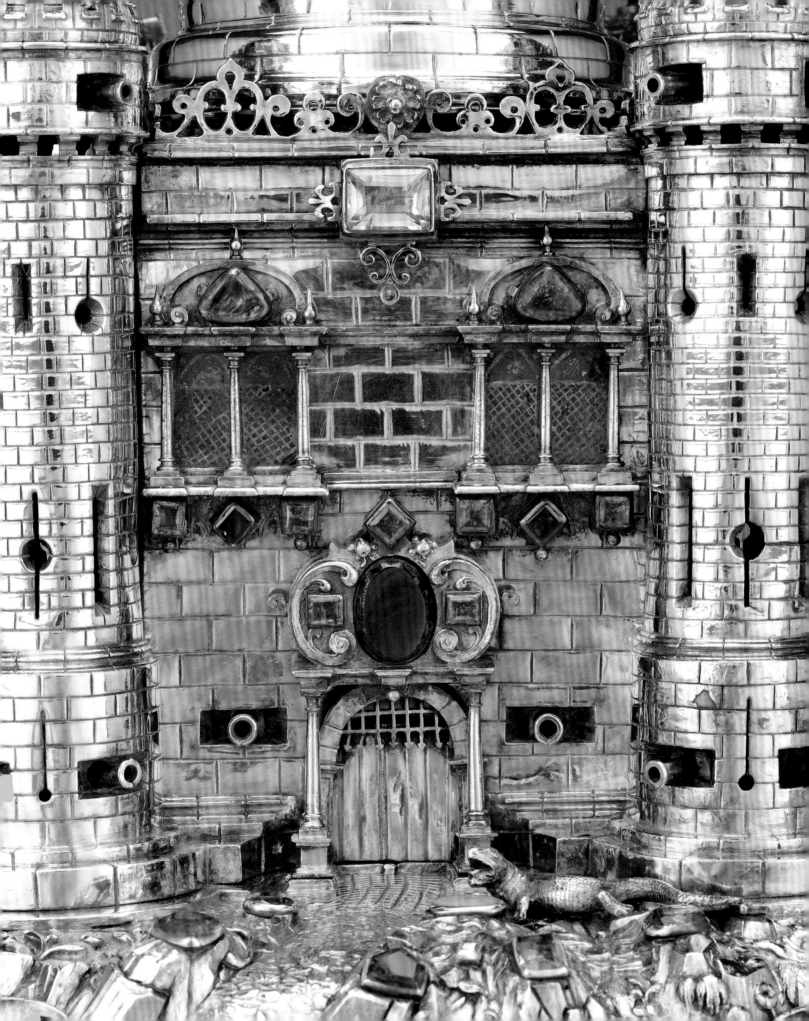

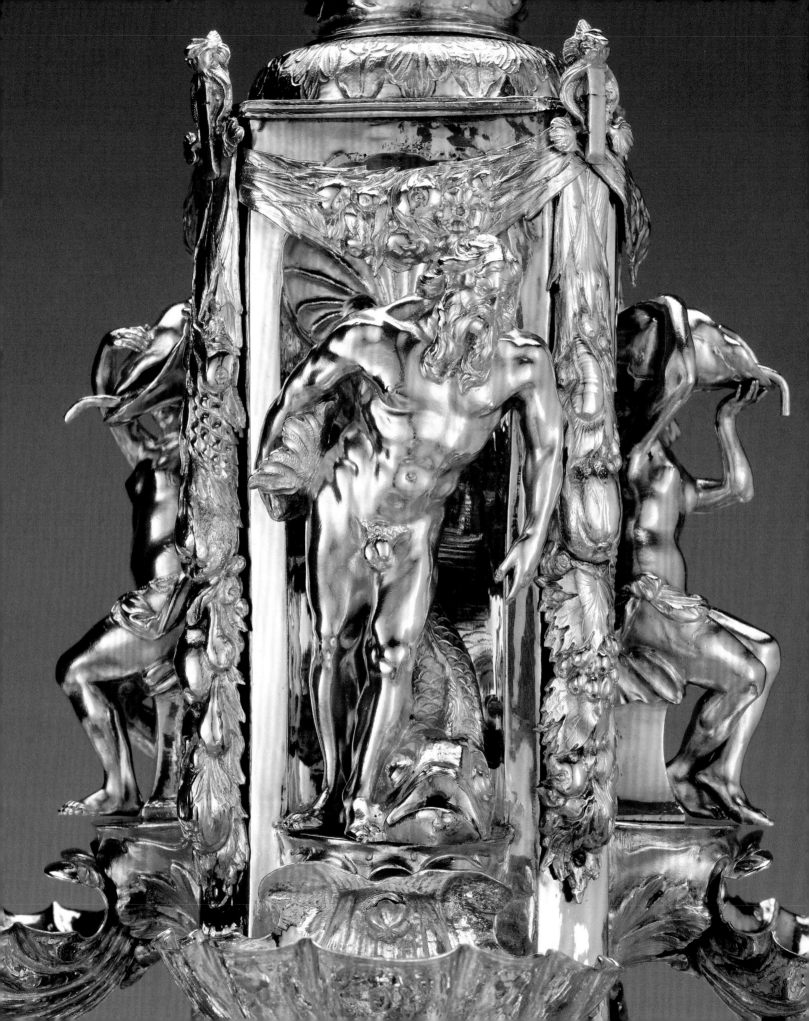

centrepiece, the State Salt was a functioning salt and spice container. The top of the central tower lifts off to reveal the main salt cellar, while smaller wells lie at the top of the corner towers and a large drawer opens out from the body of the vessel, presumably for reserve salt or additional spices [56]. Only the principal pieces of regalia in the Jewel House are gold; most other pieces, including the Salt of State, are silver gilt, which gave solid silver objects the appearance of gold and protected them from tarnishing.

While the city of Exeter was acquiring the Salt of State, just thirty miles along the coast the civic officers of Plymouth, which had a similarly shaky record of loyalty to the Stuart dynasty, were

Opposite and right 58, 59 **THE PLYMOUTH FOUNTAIN**, *mid-17th century. This silver-gilt table fountain was given to Charles II in 1661. On the column the figure of Poseidon, the Greek god of the sea, is flanked by nymphs, from whose shells liquid flowed into the basins below.*

commissioning another fabulous piece of plate to be given to the King. Known as the Plymouth Fountain, it was acquired through the royal goldsmith Robert Vyner and was probably made on the Continent, perhaps in Hamburg [58, 59]. The fountain has been altered in two important respects since 1660. In its original form it was surmounted by the heroic figure of Hercules – a more fitting subject for the virile Charles II than the statue of one of the vengeful female Furies with which it was replaced in the late 18th century. And as first made, the fountain actually played: the pipes held by the figures on the square column originally poured forth 'sweet waters' that fell into the shells below, and then down into the four broad basins. Such rose-water fountains were often used as centrepieces on the grandest dining tables, but this was more than a fountain as the original figure on the finial held an incense burner and 'out of the tope prefumed [*sic*] fier did apeare'. Altogether it was a spectacular piece, and Charles II was understandably impressed.

Left 60 The Reception of Charles II and his Brothers in the Guild of Saint Barbara in Bruges, *17th century, by Jean-Baptist van Meunincxhove. In this scene from the 1650s, a salt of similar form to those now in the Jewel House can be seen on the table.*

Below 61 The Feast of the Order of the Garter at Windsor Castle, *1672, by Wenceslaus Hollar. The King dines alone at the high end of the hall while the Knights of the Garter sit two to a table down the side.*

There were only a small number of formal occasions on which Charles II dined in the company of even his most distinguished subjects [60]. The coronation feast was one, others included the feasts of the Order of the Garter [61] and civic and diplomatic banquets. Every aspect of such events, from the dress of the participants to the manner of the service, was painstakingly regulated, and plate played its own part. A set of eleven silver-gilt salt cellars still in the Jewel House, each containing a shallow salt well at the top, was made in 1660 or soon after for use at one of these large-scale banquets; by the end of the 17th century their regular appearance at the Garter feasts earned them the name 'St George's Salts' [63]. These salts have long been shown with a twelfth vessel, which looks similar at a glance. Known as 'Queen Elizabeth's Salt' [62], it is in fact a much older and more sophisticated vessel made by the royal goldsmith Affabel Partridge in 1572. It may be that the loss of one of the St George's Salts towards the end of the 17th century caused Queen Elizabeth's Salt to be joined to that collection.

Formal banquets happened only once or twice a year, whereas Charles II dined in front of spectators at Whitehall several times a week. On these occasions handsome vessels on a smaller scale to those used at banquets were needed. Among the grandest of these was the 'caddinet', a rectangular gold or silver tray designed to hold bread and to function as a sort of side plate. These specialized objects seem to have been used only

Right 62 QUEEN ELIZABETH'S SALT, 1572. *This exquisite salt cellar may have been made for Elizabeth I: the vessel and its cover are decorated with images of female virtues, gods and rulers, and it is surmounted by an armoured classical warrior.*

Overleaf 63 ST GEORGE'S SALTS, 1660–61. *These ornate salt cellars were made for use at formal banquets. Eleven in number, they are made to three different designs, probably reflecting the rank of the diners: those where the shallow salt dish has no cover (middle), those on which the cover has a knight with a lowered sword (left) and those on which the cover has a knight with a raised sword on a rearing horse (right).*

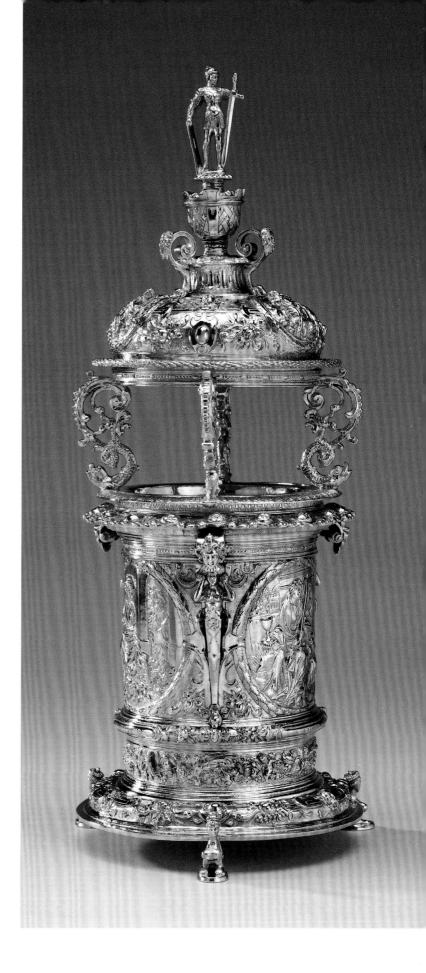

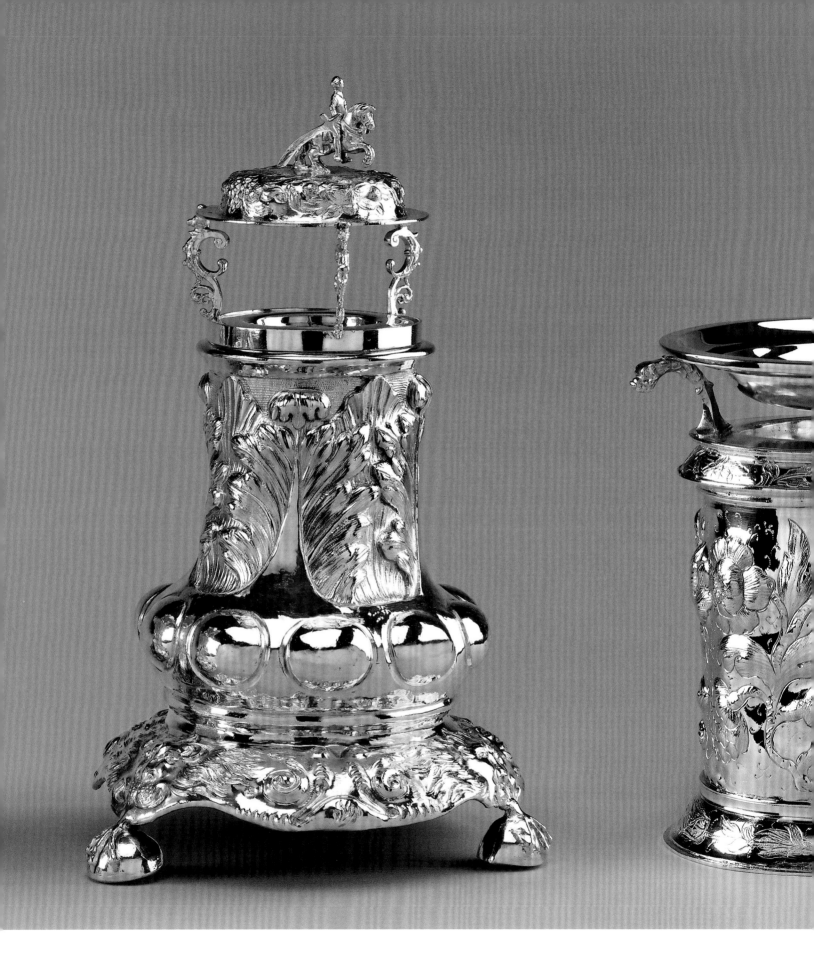

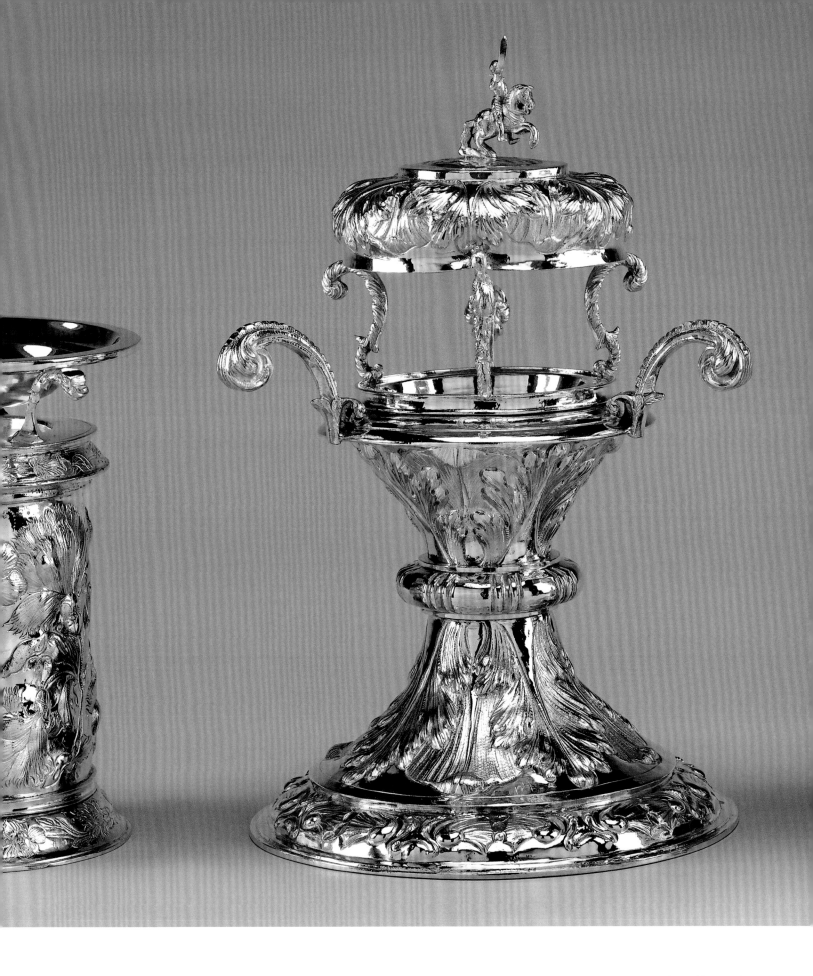

by people of the very highest rank. They were a passing fashion in England and very few English examples now survive. Two are among the collection in the Jewel House: one made for Charles II in 1683 (with his cypher later replaced) and the other made for his nephew and niece, William III and Mary II, in 1688 [64].

The other place where new gold plate was urgently needed at the Restoration was in the Chapel Royal. Though Charles II was not famous for his piety, he attended services every Sunday throughout his reign, and on various days during the year gave alms to the poor and took communion at the altar. For all these activities gold and silver-gilt plate was required, including vessels to hold the wine at communion and the gold, frankincense and myrrh offered by the King at Epiphany.

The Jewel House retains to this day a truly remarkable collection of 17th-century church plate, representing much of that made for Charles II in 1660–61 and in regular use at the Whitehall chapel in the decades that followed. First among these is unquestionably the Chalice and Paten created for Charles II's coronation and bearing the maker's mark TV, for Thomas Vyner, uncle of Robert [65]. While almost all the church and dining plate in the collection is silver gilt, this Chalice and Paten are made of gold and are in a deliberately archaic form. The arms on the Chalice and Paten today are those of William III and Mary II, for whom they were re-engraved soon after 1688.

In 17th-century churches communion was normally taken on just three or four feast days during the year and on these occasions many pints of wine were needed to offer the sacrament to the whole congregation. To prevent the use of unsightly jars and barrels, churches were required to provide handsome pewter, silver or gold flagons to hold the wine. At the Restoration, three pairs of flagons were commissioned to stand on the altar in the Chapel Royal. Two pairs were 'feathered' – covered with a vivid design of overlapping bird feathers – and the smaller third pair featured the royal device of the crowned rose as a naturalistic plant growing vigorously in rich foliage [66, 67 and 68].

As well as this forest of flagons, the altar was to be decked with three large shallow dishes or 'chargers'

Opposite 64 **Two Caddinets**, *1683 (below) and 1688 (above). These unusual objects functioned as side plates. They held the diner's cutlery and seasoning, and were found only on the grandest dining tables. The cypher on the one made for Charles II in 1683 was later replaced.*

Right 65 **Chalice and Paten**, *c.1661. Charles II took communion from these at his coronation on 23 April 1661. They are made of gold.*

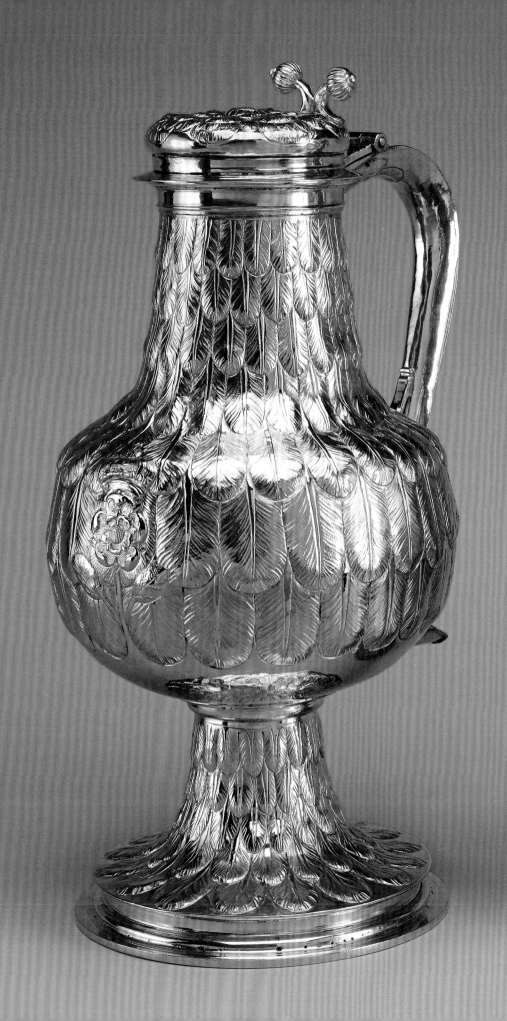

Opposite 66 **FEATHERED FLAGON**, *1660. A pear-shaped feathered flagon. Three pairs of silver-gilt flagons were made for Charles II in 1660–61, two of which were chased and engraved with feathers. The flagons stood on the altar and held enough wine for the whole congregation to receive communion.*

Below 67 **DETAIL OF FEATHERED FLAGON**, *1660. The crowned rose from one of the feathered flagons. Pieces made for use by the King were given this distinctive royal mark.*

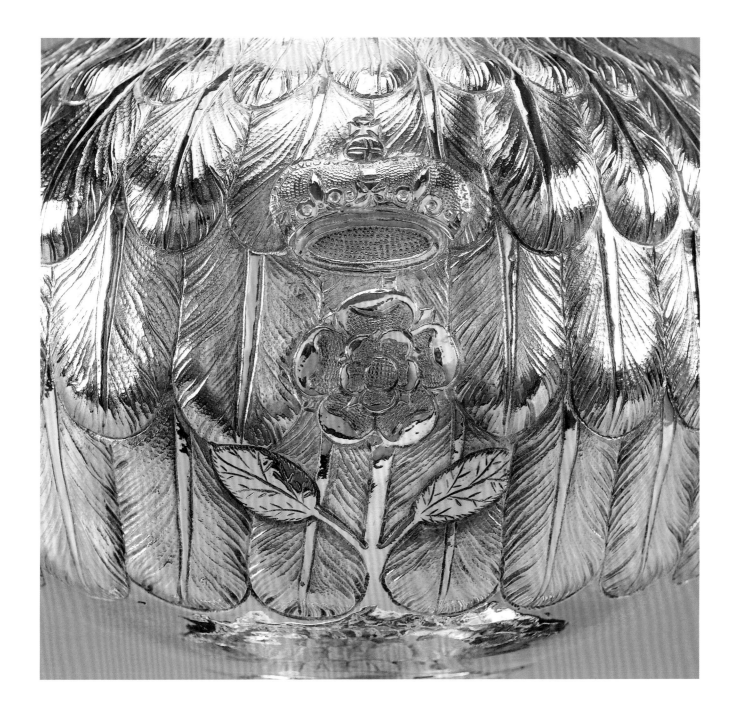

and a pair of candlesticks. A great pair of altar candlesticks, made by the goldsmith John Neave in about 1661, remains in the collection, and may well be those that stood on the Whitehall chapel altar [69]. It is harder to identify the chapel chargers from the current collection in the Tower, though it includes several remarkable royal plates from the early 1660s [70, 71].

One very plain altar plate made in 1660 has since the 1690s been known as the 'Maundy Dish', because

Below 68 **FLAGONS**, 1660–61. *As well as the large pear-shaped feathered flagons, two further pairs were supplied to Charles II for the altar in the Chapel Royal. One pair consisted of straight-edged feathered flagons (left) and the other of flagons 'chac'd' with flowers and foliage (right).*

Opposite 69 **ALTAR CANDLESTICKS**, c.1661. *These enormous candlesticks were probably made for the altar in the Chapel Royal at Whitehall.*

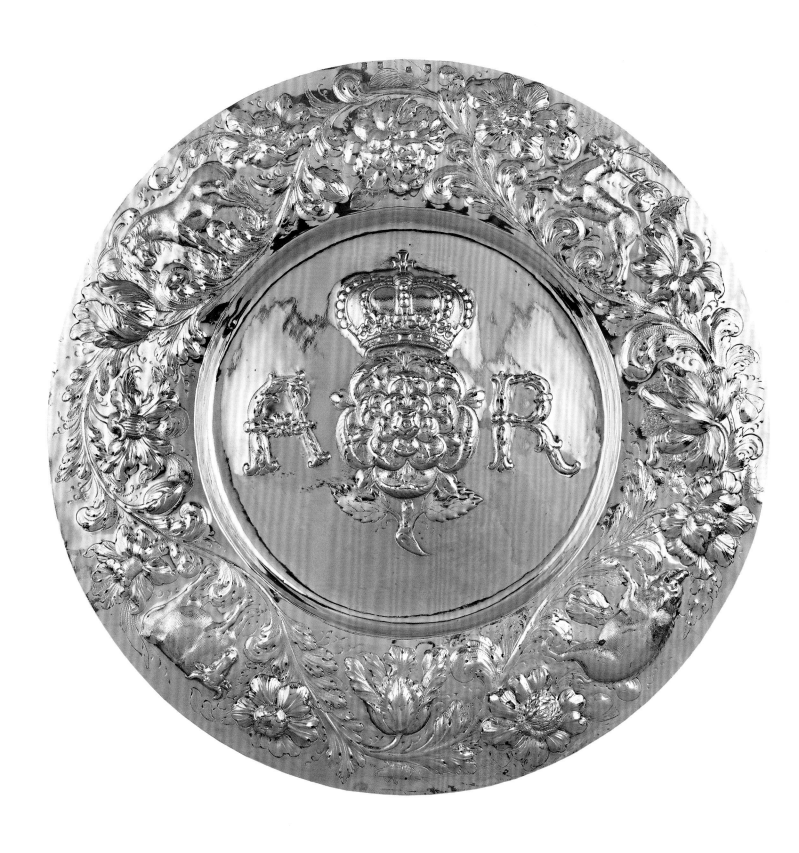

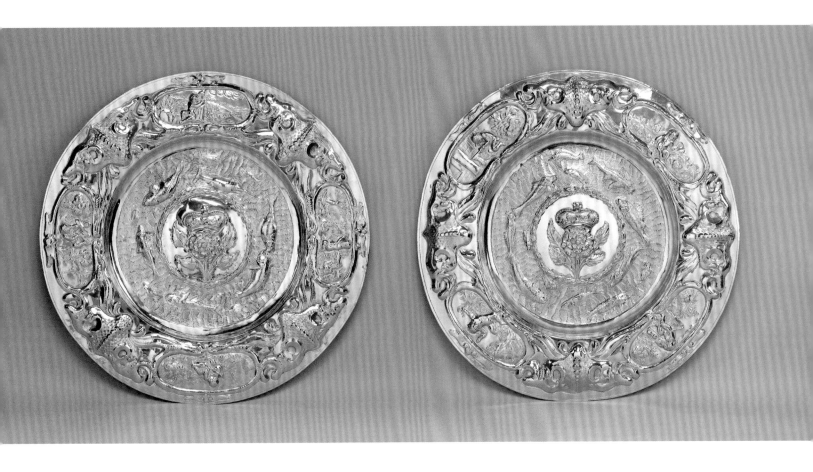

of its use in one of the royal ceremonies of Holy Week [central dish, 72]. From the Middle Ages to the late 17th century English monarchs washed the feet of paupers on Maundy Thursday in imitation of Christ's gesture of humility and love for his disciples. Though the ceremony of foot-washing ceased in 1685, the

Opposite 70 **ALTAR DISH**, *1660. This dish was made by the English goldsmith Henry Greenway. A boar, a cow, a horse and stag nestle among the foliage on the broad border. Charles II's cypher 'CR' was later remodelled as 'AR' for his niece Queen Anne.*

Above 71 **PAIR OF ALTAR DISHES**, *c.1661. These dishes made for Charles II may have been intended for banqueting, but were later used as altar plates. Fish swim around the King's crowned rose in the basin and images of the virtues and human experience decorate the border. These dishes are now used to supplement the Maundy Dish at the annual Maundy service.*

distribution of alms on Maundy Thursday continues, with the purses carried still on the Maundy Dish.

So it was that within a year or so of his return from exile Charles II was provided with a collection of magnificent plate for the Chapel Royal at Whitehall [72]. Interestingly, an almost equally ornate collection of church plate was also commissioned for his brother, James, Duke of York [74], in the 1660s [73]. This was probably provided for use in the Chapel Royal at St James's Palace, where the Duke lived for much of the year and where he attended services before he converted to Catholicism in the late 1660s. The plate made for James, Duke of York, in the mid-1660s is essentially a matching set to the King's own and is easily identified by his insignia: the princely crown without arches and his 'DJ' cypher [75]. The most striking piece in this part of the collection is the superb 'Last Supper' altar dish [77].

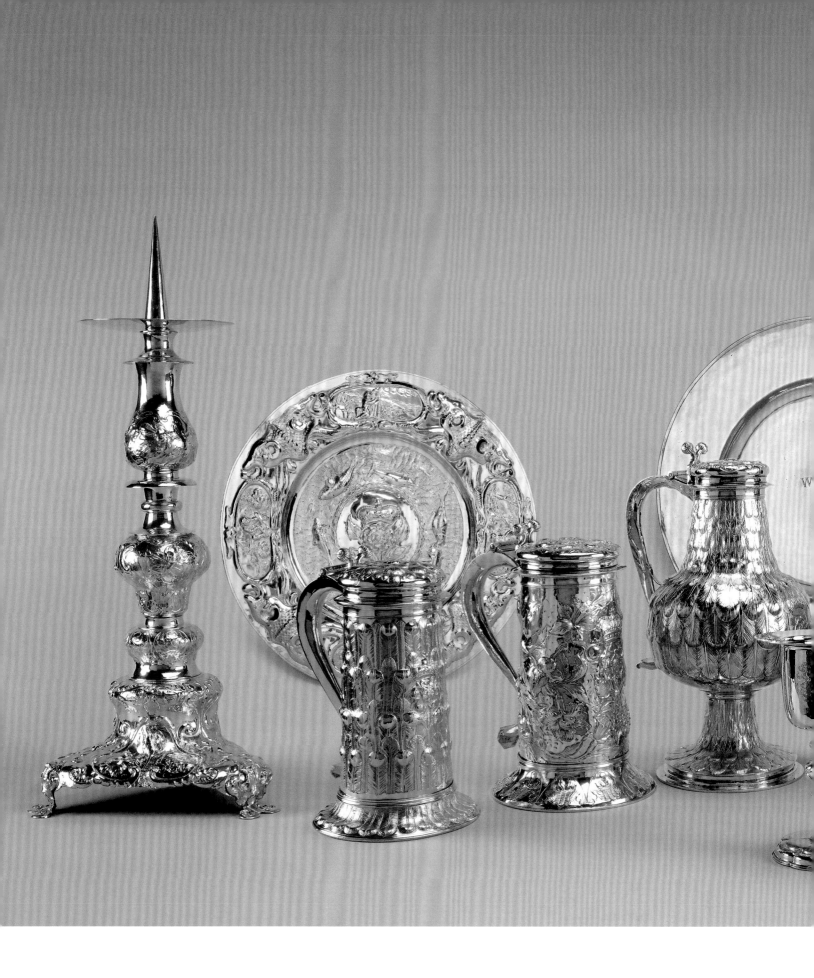

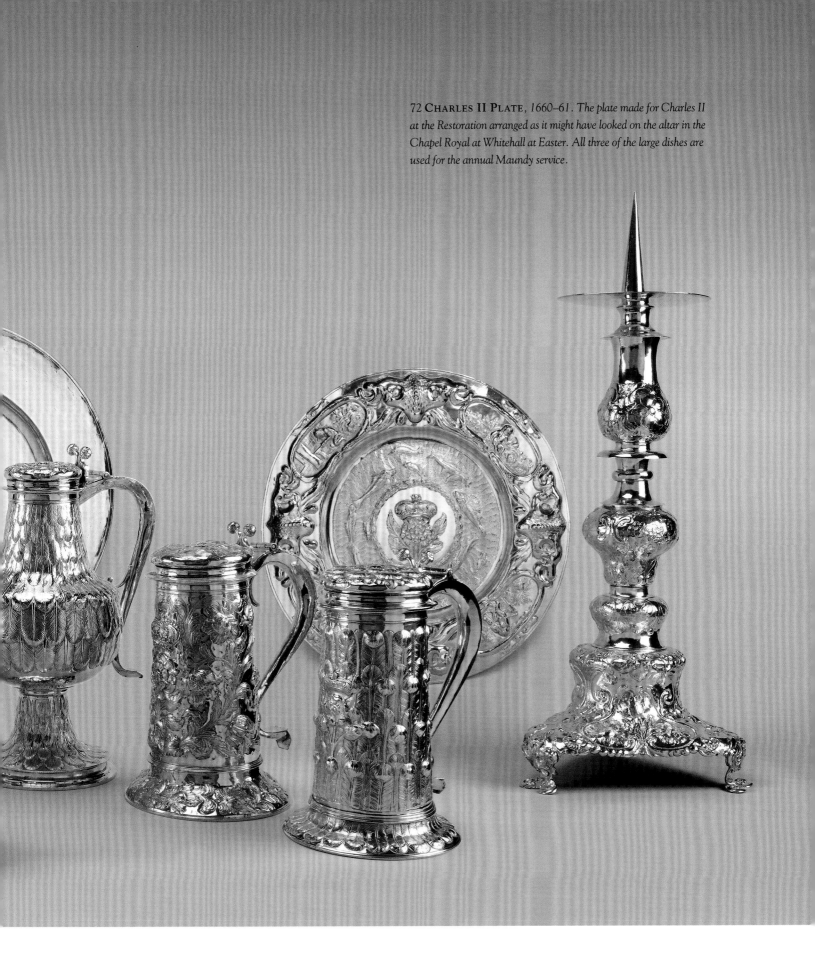

72 **Charles II Plate**, 1660–61. *The plate made for Charles II at the Restoration arranged as it might have looked on the altar in the Chapel Royal at Whitehall at Easter. All three of the large dishes are used for the annual Maundy service.*

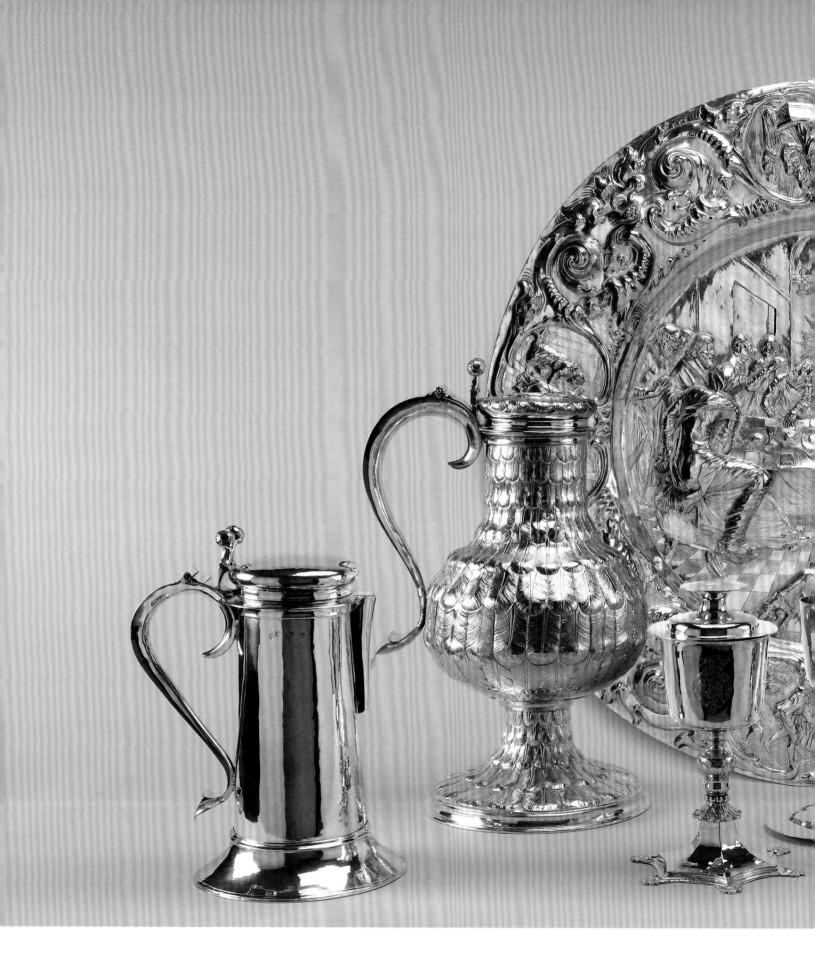

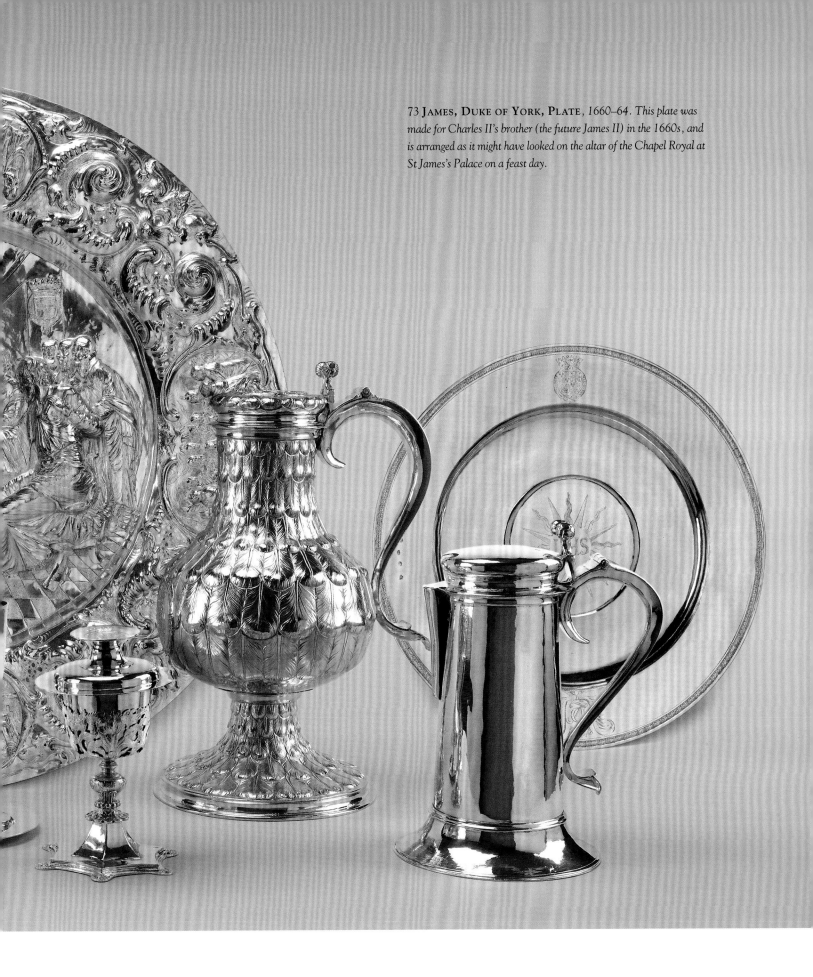

73 **JAMES, DUKE OF YORK, PLATE**, *1660–64. This plate was made for Charles II's brother (the future James II) in the 1660s, and is arranged as it might have looked on the altar of the Chapel Royal at St James's Palace on a feast day.*

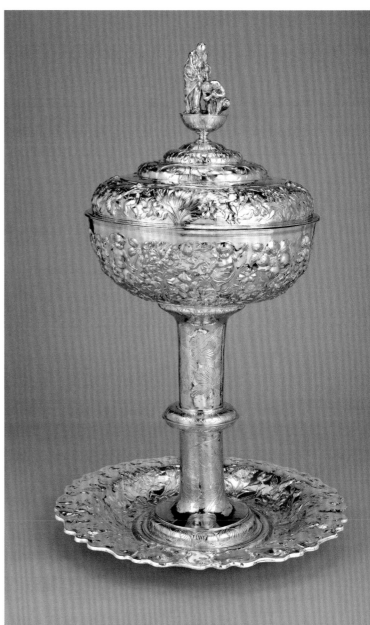

Above left 74 James II when Duke of York, *17th century, Studio of Sir Peter Lely.*

Above right 75 **DETAIL OF FEATHERED FLAGON**, 1664. *The cypher on the lid of one of the feathered flagons made for James, Duke of York. The Duke's pieces are clearly marked with his insignia: a royal ducal crown and a device apparently composed of the letters 'DJ'.*

Right 76 **BAPTISMAL FONT AND BASIN**, 1660. *As Charles II was unmarried when these pieces were made, they were almost certainly intended for the baptism of his brother's first child, Charles, Duke of Cambridge, born on 22 October 1660.*

Opposite 77 **THE 'LAST SUPPER' ALTAR DISH**, 1664. *Made for James, Duke of York, by Henry Greenway, this extraordinary dish depicts Christ dining with the twelve Disciples. Ornate plate with figurative imagery came to have a special importance in English churches after the Reformation.*

Measuring over 94 cm (37 in.) in diameter, it would have formed a dazzling focus to the altar on holy days. The central scene shows Christ presiding over the Last Supper, while four smaller images on the border depict events before and after. The dish bears marks indicating it was made by the royal goldsmith Henry Greenway in 1664. An almost identical dish made for Charles II in 1660 remains in use in the Chapel Royal at St James's today.

Also associated with James, Duke of York, is the silver-gilt Font and Basin of 1660 [76], which may have been created for the baptism of his short-lived first child, Charles, Duke of Cambridge, on 1 January 1661. The Font was probably used for all of his children's baptisms, and was certainly used in 1688 for that of his last son, James, later known as the 'Old Pretender'.

When the royal family attended services in the Chapel Royal they were conveyed there from their apartments in a colourful procession made up of the ceremonial guards of the state apartments. Prominent among them were the Sergeants at Arms, the medieval royal bodyguard, each of

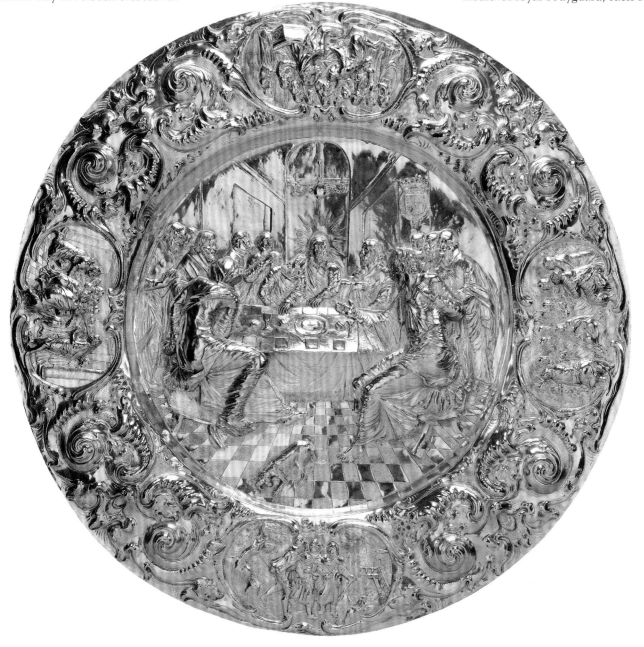

whom carried a mace, a great silver-gilt baton that had evolved from a medieval battle-axe [78]. Sixteen new maces were provided for Charles II's coronation; and though repaired, ten late 17th-century maces survive in the Jewel House [79]. Three further maces, which are properly part of the collection, are not shown at the Tower of London as they are used to represent royal authority in the Houses of Parliament [80].

Another ceremonial weapon was carried in the weekly chapel processions and on almost all formal occasions: the Sword of State [81]. Usually borne point up, a sword had been carried before English kings since at least the 9th century and Charles II wasted no time commissioning a new sword in 1660. The frequency with which the Sword of State was used prompted the Lord Chamberlain to order an almost identical second sword in 1678. This way, the new sword could be used exclusively within the royal apartments and the other, existing, sword could serve on occasions when the king left the palace, in particular when he attended Parliament. The new sword of 1678 has been in regular use ever since (the 1660 sword disappeared in the 18th century). Measuring over 120 cm (47 in.) in length, it has a steel blade etched with intricate foliage, and a wooden scabbard covered in velvet and wrapped round with silver-gilt mounts representing the countries over which Charles II claimed dominion. The hilt of the sword is particularly elaborate, with the handles – known as 'quillons' – in the form of the Stuart heraldic animals: the lion and unicorn.

Royal authority in Ireland was exercised on the king's behalf by a Viceroy or Lord Lieutenant. To signify the sovereign authority he exercised, the holder of this position was issued with a special set of royal insignia. Among these were the Irish Sword of State that was made for Charles II's loyal friend the Duke of Ormond in 1660–61. It remained in use until King George V's state visit to Ireland in 1911 – the last before the creation of the Irish Free State, later the Republic of Ireland, in 1922.

Opposite top 78 *A Sergeant at Arms carrying a mace. An engraving from Francis Sandford's* History of the Coronation of James II and his Consort Queen Mary, *1687.*

Opposite below 79 MACE, *1660. One of the silver-gilt maces made for Charles II at the Restoration.*

Above 80 *Prime Minister Margaret Thatcher with her front-bench team in the House of Commons awaiting the summons to the House of Lords for the State Opening of Parliament, 15 May 1979. The 'House of Commons Mace' is always on the table during a parliamentary debate.*

Below 81 THE SWORD OF STATE, *1678. This sword is still carried before the monarch on state occasions, including the annual procession to the State Opening of Parliament.*

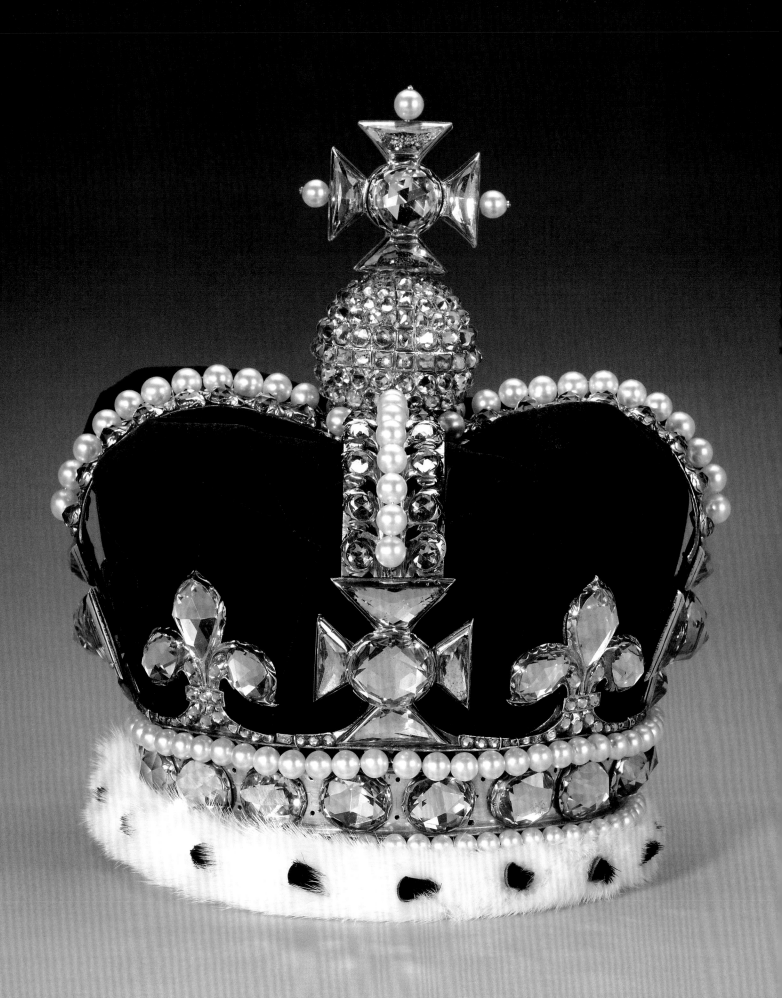

6

CROWNS FOR QUEENS

Charles II died at Whitehall Palace soon after the sun had risen on 6 February 1685. The following day twenty-six officials crowded round to watch his body be cut open and his internal organs removed. A week later the embalmed corpse, enclosed in a lead coffin within a wooden coffin, was interred at Westminster Abbey just metres from the high altar where he had been crowned twenty-five years earlier. On the purple velvet coffin-cover lay a perfect replica of the Imperial State Crown, its gilt tin glinting in the light of the flaming torches as the coffin was lowered into the vault.

Opposite 82 **THE STATE CROWN OF MARY OF MODENA**, 1685. *Made by Richard de Beauvoir. This was the first queen's crown to be made after the destruction of the medieval crown jewels in 1649. It served as the consort's crown for a century.*

Right 83 *Mary of Modena's coronation crown. Two crowns were made for Mary of Modena, the first just for the act of coronation and the second for all other occasions. This, her coronation crown, has been extensively altered since 1685 and is set with imitation stones.*

Despite his widespread unpopularity, the Catholic James, Duke of York, succeeded his brother without a murmur of opposition [84]. Knowing this good fortune might not last, James II was anxious to shore up his position with the powerful legitimization of a coronation. The day after Charles II was buried, a coronation committee assembled and the earliest possible date, only two months away, was agreed on for the ceremony.

The main issue faced by the officials organizing the 1685 coronation was providing for the Queen Consort. Charles II had been unmarried in 1661 and so Queen Catherine had never been crowned and had had few, if any, items of regalia. In contrast, the new 27-year-old Queen Consort, Mary of Modena [85], was to be crowned alongside her husband, and less than three weeks into the new reign detailed proposals for her regalia were submitted for approval.

The medieval coronation orders had long allowed for the coronation of a queen consort with the sovereign. After the king's anointing and investiture, the queen would also be anointed and

then various items of regalia were bestowed on her, including a ring, a crown, a gold sceptre and an 'ivory rod'. This list, as well as a consideration of what had been lost in 1649, informed the plans for the new consort's regalia. It was agreed that Sir Robert Vyner, now well into his sixties but still nominally the royal goldsmith, would provide a diadem for the Queen to wear in the procession, a coronation crown and a state crown for the ceremony itself, a gold sceptre topped by a cross, an ivory rod topped by a dove and a coronation ring. Of these, the Diadem, State Crown and two sceptres survive at the Tower of London [87], while the coronation crown – now much altered – is in the Museum of London [83].

 Mary of Modena's State Crown [82] was made by the jeweller Richard de Beauvoir, and his original design

Above left 84 King James II, *1684, by Sir Godfrey Kneller. James II was able to use his brother's regalia, with only minor alterations, at his coronation.*

Above right 85 Mary of Modena, c.1685, by William Wissing. *As Charles II had been unmarried at the time of his coronation, no consort's regalia had been made in 1660–61.*

Opposite 86 Richard de Beauvoir's 'Origenall Draf' of Mary of Modena's state crown. *This is the oldest craftsman's drawing for an English crown.*

for it – the earliest design drawing for any English crown – survives [86]. Like her two other crowns, Mary's State Crown was entirely set with hired stones. It must have been a dazzling sight, as other than the 129 pearls, all the gems mounted in the gold frame were diamonds: 38 on the body of the crown and several hundred on the

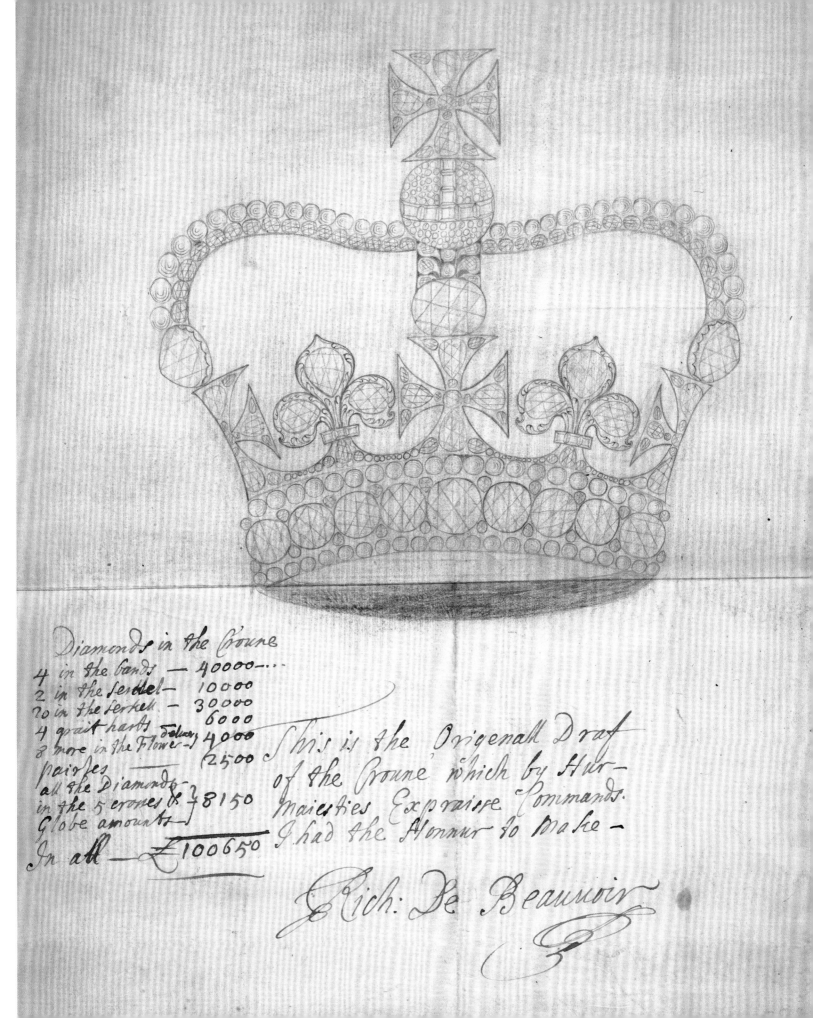

Diamonds in the Croune
4 in the bands ——— 40000
2 in the serttel — 10000
70 in the sertell — 30000
4 grait harts ——— 6000
8 more in the Flowers delivr 4000
pairses ——— 2500
all the Diamonds ———
in the 5 crones & }8150
Globe amounts ——
In all ——— £100650

This is the Origenall Draf
of the Croune which by Hir—
maiesties Expraiss Commands.
I had the Honnur to Make —

Rich: De Beauvoir

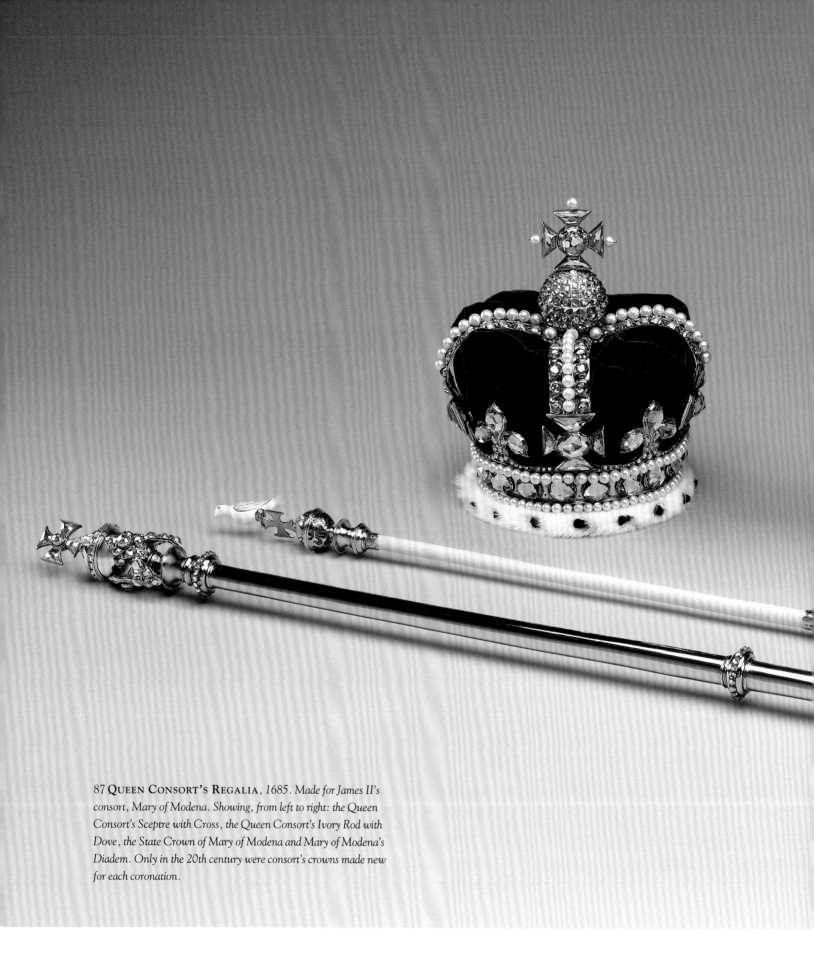

87 QUEEN CONSORT'S REGALIA, *1685. Made for James II's consort, Mary of Modena. Showing, from left to right: the Queen Consort's Sceptre with Cross, the Queen Consort's Ivory Rod with Dove, the State Crown of Mary of Modena and Mary of Modena's Diadem. Only in the 20th century were consort's crowns made new for each coronation.*

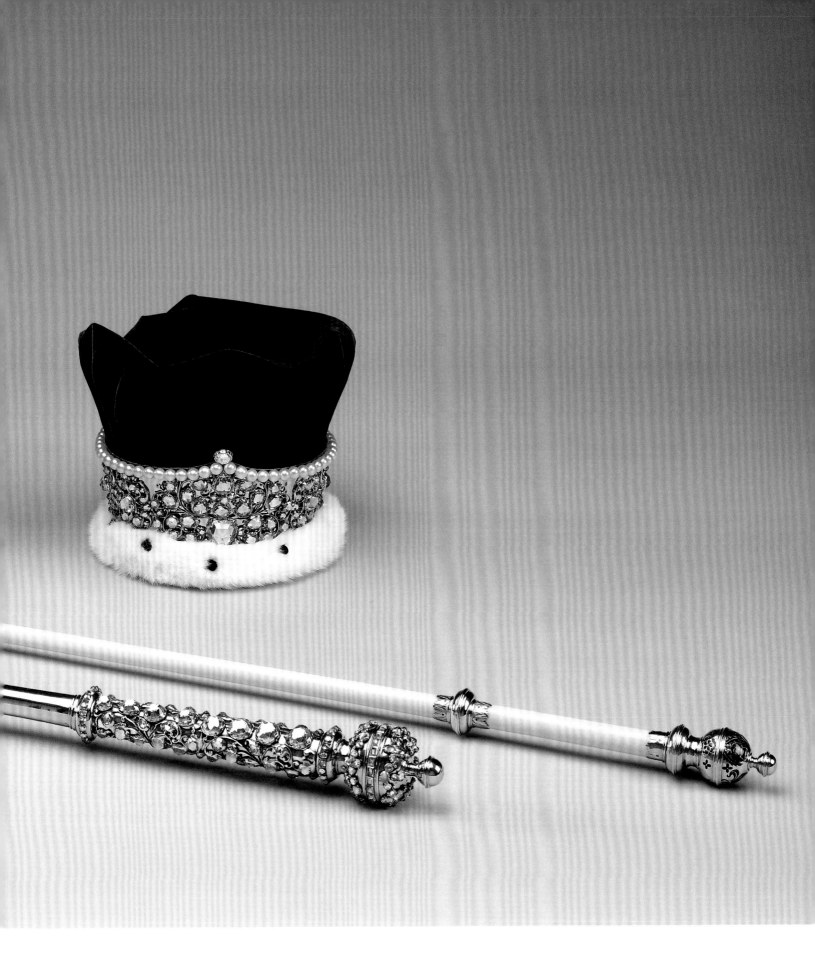

monde. The value of this glittering collection was the subject of feverish speculation – one admiring courtier commenting that 'never any queen was so richly decked' [88].

For the procession from the Palace of Westminster to the Abbey kings and queens normally wore a simple velvet cap or circlet, which they would then remove for the coronation proper. Few of these comparatively ephemeral pieces of headgear survive, but one exception is Mary of Modena's Diadem [89]. Formed of a wide gold band designed to encircle a velvet and ermine cap, the Diadem is adorned with intricate silver settings in the form of rosettes. For Mary of Modena's coronation these held 177 diamonds, a ruby, emerald and sapphire and 78 pearls. The Diadem was probably worn by

Queen Caroline at the coronation of George II in 1727, but has been little used since.

The Queen Consort's Sceptre with Cross created for Mary of Modena in 1685 was a simplified version of the Sovereign's Sceptre, and was described as 'very like the Kings in all the Imbellishments thereof only smaller and more wreathed, nor altogether so thick'.

Below 88 *A detail from an engraving depicting the coronation of James II and Mary of Modena in Westminster Abbey in 1685. The monarchs are shown enthroned and wearing their regalia.*

Opposite 89 **MARY OF MODENA'S DIADEM**, *1685. Mary of Modena's Diadem was made for the Queen to wear in the procession to the coronation. It was set with 177 diamonds for the occasion but these have since been replaced with rock crystals.*

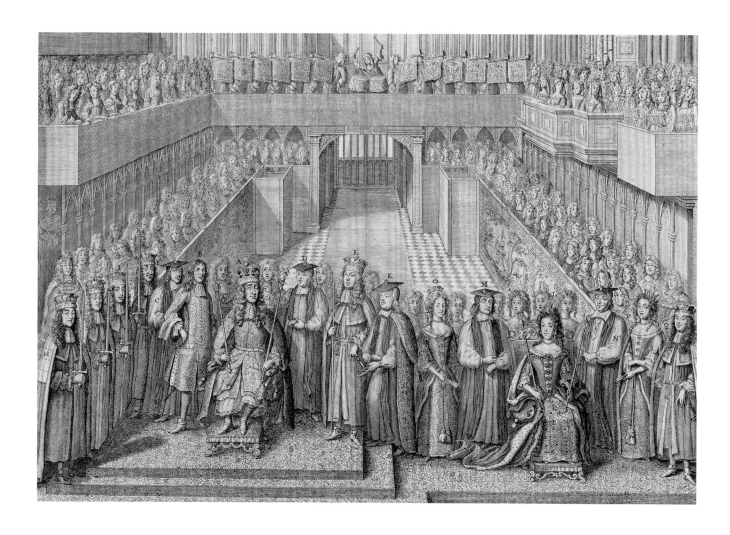

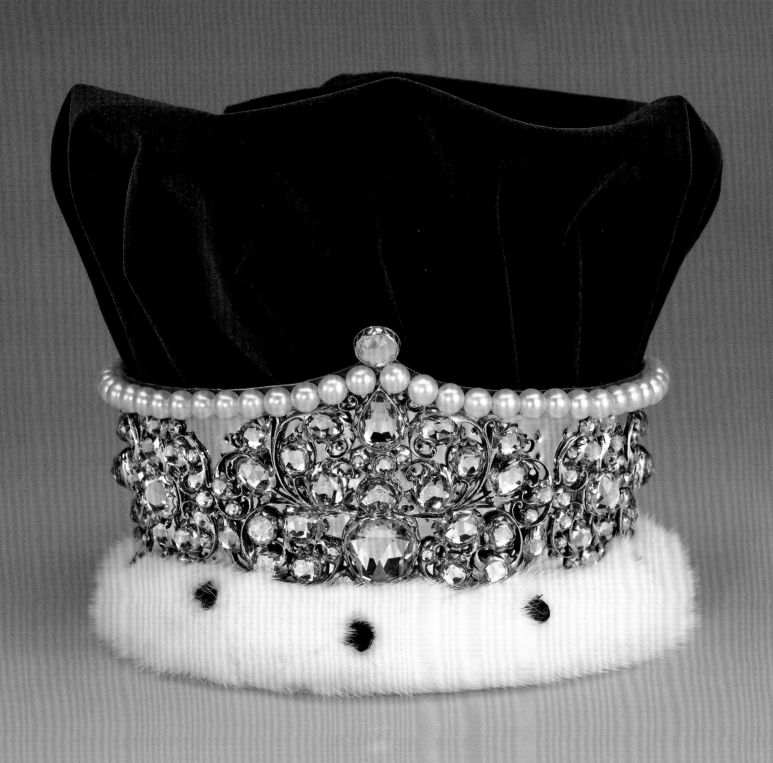

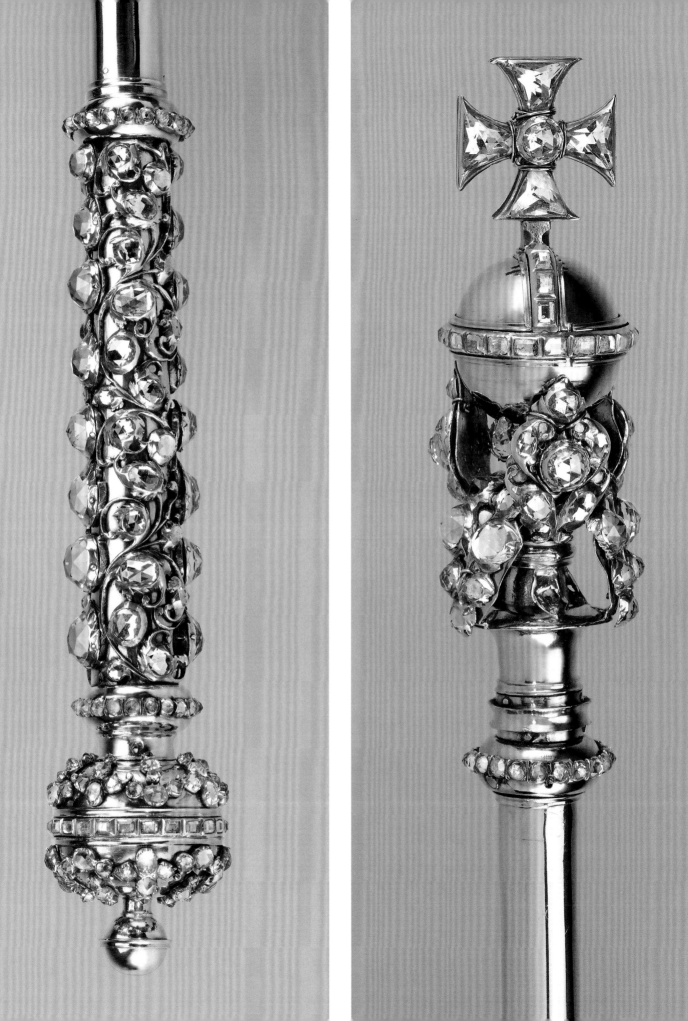

The jewelled iris leaves that hold the monde at the top give an excellent idea of the shape of the top of the Sovereign's Sceptre before it was remodelled to take the First Star of Africa in 1911 [91 and *see* 158]. The intricate jewelled sleeve that now covers the bottom section of the sceptre was moved down from the section above and remodelled, probably for Mary II in 1689 [90].

The medieval coronation orders specified that a queen consort should have both a sceptre and an 'ivory rod with golden dove'. An ivory staff topped by a dove was among the items sold in 1649, and the officials working on the 1685 coronation had no hesitation in listing an 'Ivory rod with dove' among the essentials for the new queen. The Queen Consort's Ivory Rod with Dove is made of three lengths of elephant ivory joined together by two gold collars. While the enamelled dove on the Sovereign's Sceptre with Dove has spread wings [*see* 43], those on the consort's are folded and picked out in blue and red on the bird's back [92].

The consort's regalia was made completely new in 1685, whereas the sovereign's regalia of 1661 needed only minor modification for James II. Both St Edward's Crown and the state crown were given new mondes. The former retains its 1685 monde today, and while the latter crown is now gone the monde survives [93]. As in

Opposite left 90 **Detail of the Queen Consort's Sceptre with Cross**, *1685. Mary of Modena's sceptre was closely modelled on the Sovereign's Sceptre with Cross made for Charles II in 1661. It was last used by Queen Elizabeth at the coronation of King George VI in 1937. This detail shows the handle, now set with rock crystals.*

Opposite right 91 **Detail of the Queen Consort's Sceptre with Cross**, *1685. This detail shows the top of the sceptre, now set with rock crystals.*

Right 92 **Detail of the Queen Consort's Ivory Rod with Dove**, *1685. The enamelled dove has folded wings, signifying the consort, while that on the Sovereign's Sceptre has outstretched wings.*

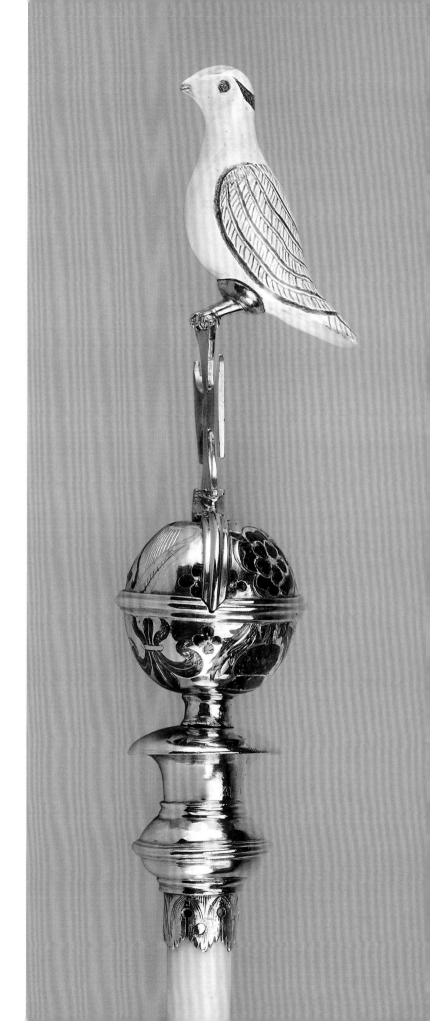

1661, a set of precious stones was hired for St Edward's Crown, and the state crown received a new addition to its permanent collection of gems. This was the first of the famous stones to adorn the English state crown: a magnificent red spinel known since the early 19th century as 'the Black Prince's Ruby' [94, 95]. This large semi-precious stone, weighing 170 carats, was fixed to the front of the band; probably originally mined in Badakhshan in Afghanistan, it is unfaceted and has a small ruby set into its surface. Its history before 1685 is uncertain, but by the end of the 18th century several romantic stories had grown up around this

exotic-looking gem. It was claimed to have been given to Edward III's son, the Black Prince, by Pedro I, King of Castile, and that it had subsequently been worn by Henry V on his helmet at the Battle of Agincourt. Sadly the stories cannot be substantiated. That said, the stone probably was in circulation long before 1685, and it is possible it was sold from the Jewel House in 1649 – one of the stones in the sale is described as a 'Ruby Ballass, peirced, and wrapt in a paper by it[selfe]' – and reacquired after the Restoration.

All the glory of the coronation of 1685 could not solve the intractable problem of a Catholic king at the helm of a Protestant country. The liturgy of the occasion threw the issue into stark relief: a Catholic king was being anointed by a Protestant archbishop. The mass itself was quietly dropped from the proceedings on the pretext that it made the service too long. Just three and a half years later, on the auspicious date of 5 November, James's Protestant son-in-law William of Orange landed a fleet of 15,000 professional soldiers on the south coast of England between Exeter and Plymouth. On 18 December William rode into London to a rapturous

Below left 93 **JAMES II'S MONDE**. *The 'aquamarine' monde, added to the state crown in 1685, was later discovered to be glass and was removed from the crown at the time of George IV's coronation.*

Below right 94 *The Crown of State set with the Black Prince's Ruby, from Francis Sandford's* History of the Coronation of James II and his Consort Queen Mary, *1687.*

Opposite 95 **THE BLACK PRINCE'S RUBY**. *Detail of the cross at the front of the Imperial State Crown, showing the large red spinel known as 'the Black Prince's Ruby'.*

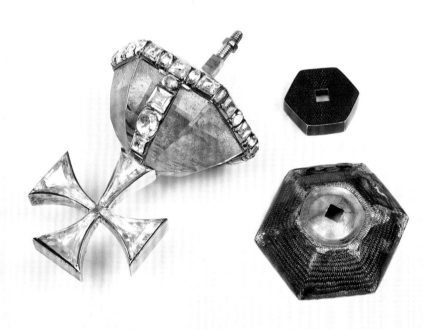

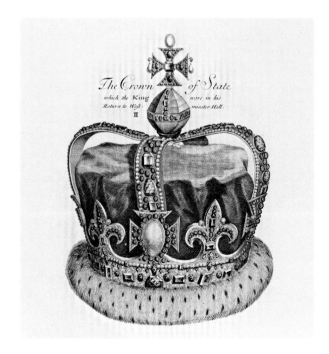

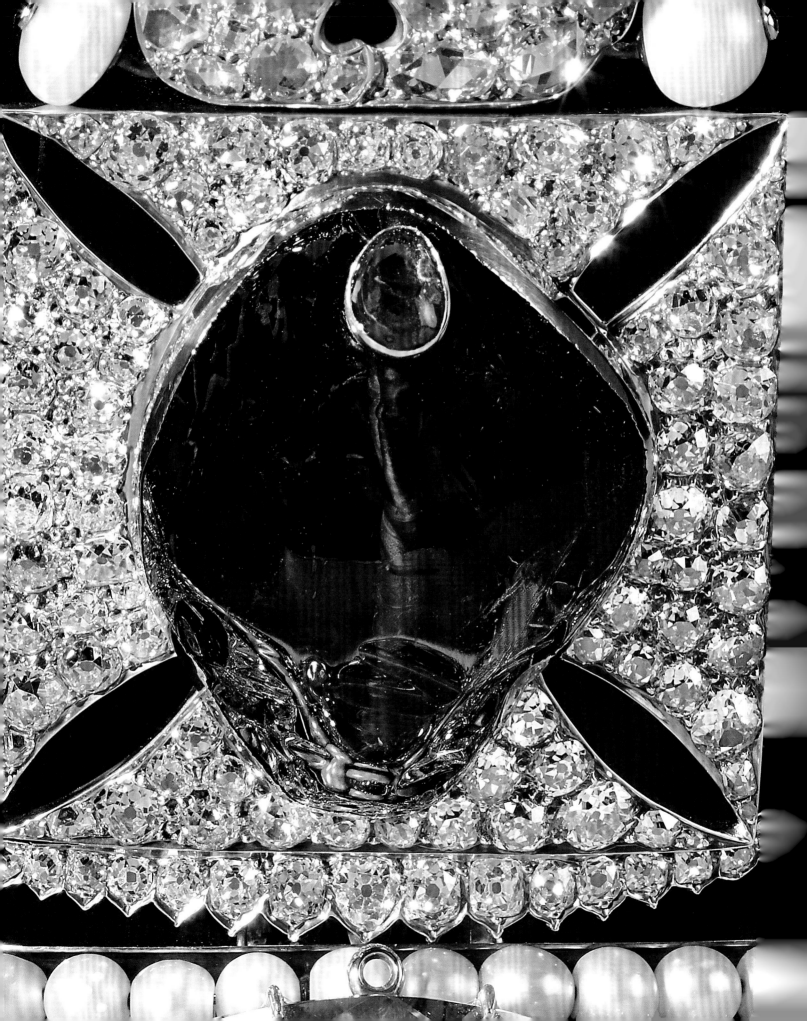

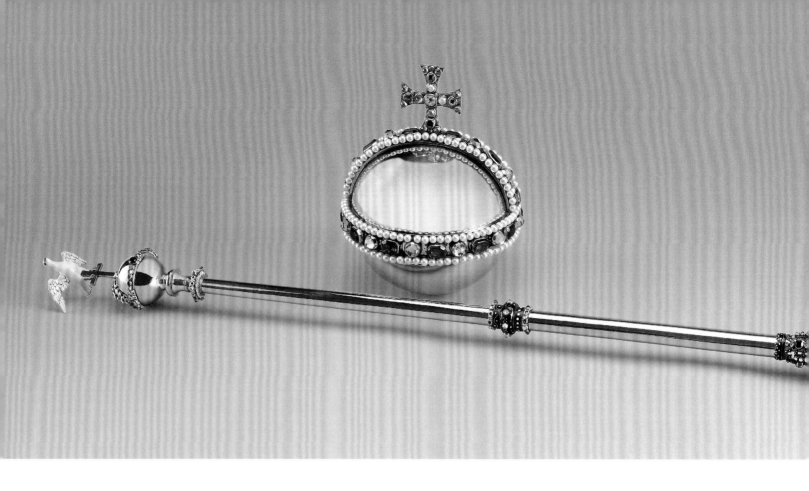

welcome, while James slipped quietly away, taking ship to France, where he disembarked on Christmas Day, never to return. On 13 February 1689 William and his wife, Mary, were jointly offered the English crown and duly accepted [97].

Though achieved without a single shot this was unquestionably an invasion, and to secure the position of the new sovereigns a swift coronation was thought essential. So again the royal officials found themselves with only two months to plan a large and complicated event. The 1689 coronation was a unique occasion in English history as two sovereigns, rather than a sovereign and consort, were to be crowned. This meant that Mary II needed to have exactly equivalent equipment to her husband, not the lesser, consort's regalia. This even included a matching coronation chair – a 'Chaire like unto St Edwards chaire' – made by the royal furniture maker Thomas Roberts. While the crowns made for her stepmother, Mary of Modena, were felt to be usable, Mary II needed the additional

pieces of monarch's regalia: an orb and a Sceptre with Dove with outstretched wings [96].

The gold orb and Sceptre with Dove made for Mary II are simplified versions of the Sovereign's Sceptre and orb made for Charles II in 1661. Sir Robert Vyner had died in 1688 but his business passed into the hands of a kinsman, also Robert, who received the commission for the new regalia. Mary II's Sceptre with Dove is made up of three sections of gold rod joined together with enamelled collars to form a piece 110 cm (43 in.) in length. Gems worth £13,000 were hired to adorn it, set into the collars and around and over the small gold sphere at the top of the sceptre. The enamel dove perching on the cross has the spread wings that define its sovereign status [98]. The sceptre is now set with 274 stones, most of which are rose-cut quartz [99]. Mary II was considerably taller than William III, and her sceptre was at least as long as his. The orb of 1689, though, is smaller and simpler than the Sovereign's Orb, standing at just over 20 cm (8 in.) to the King's 27 cm (10 in.).

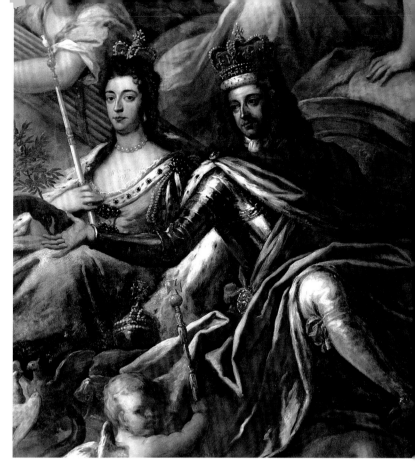

It is made of two hemispheres of gold joined together around the waist. It was set with 301 large and 60 small diamonds for the coronation, along with a handful of coloured stones and 259 pearls.

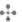

At the Restoration the royal office of the Jewel House had been reconstituted on a reduced basis; its remit was now confined to the regalia and the royal dining and chapel plate, and no longer included the sovereign's personal jewels. Despite this reduction in scale, the Jewel House staff soon resumed their old practice of showing the collection to curious visitors for a fee, and by the early 18th century a printed guidebook was even being sold. It was almost certainly to support this enterprise that the Keeper of the Jewel House arranged for objects that had been set with hired stones to be re-set with imitation gems. Empty frames had limited appeal to visitors, and so glass, paste and quartz 'jewels'

Above left 96 **QUEEN MARY II'S SCEPTRE WITH DOVE**, *1689.* **QUEEN MARY II'S ORB**, *1689. This sceptre and Queen Mary II's Orb were made for a unique occasion: the coronation of two sovereigns.*

Above right 97 King William III and Queen Mary II Enthroned, *1707–14, by Sir James Thornhill. This detail from the ceiling of the Painted Hall at the Old Royal Naval College, Greenwich, shows Queen Mary II's Sceptre with Dove and her orb.*

were substituted after the event and happily passed off as the real thing. As late as the 1930s several little-used pieces were still set with 17th-century sham stones. These included the pieces made for Mary II – never used again after 1689; on her orb, for instance, the Crown Jewellers replaced 'rows of broken and discoloured imitation pearls' in 1939.

It was in 1671, during the early years of the Restoration visiting arrangements, that an audacious attempt was made to steal the prize pieces of the new regalia. It was a scheme that came extraordinarily close

to success, and had it succeeded several of the most important objects in the collection would be known to us only through one-line entries in the Jewel House account books. The perpetrator of the crime was the disaffected adventurer 'Colonel' Thomas Blood. A tall, pock-marked Irishman, Blood was a smooth-talking scoundrel mixed up in any number of schemes to unseat the government in England and Ireland during the 1660s. So slippery was he, that he was soon both conspiring with and informing against his collaborators to Charles II's officials.

Blood's plan was simple but effective [100]. Disguised as a clergyman he came to the Tower with his 'wife' and paid to see the collection. During their visit Blood's wife feigned illness and was ministered to by the elderly Keeper of the Crown Jewels, Talbot Edwards, and his wife. Blood then relentlessly pursued the acquaintance, making further visits and giving gifts in thanks. In the course of these he purchased Edwards's pistol collection, so disarming him. Finally, Blood suggested he bring his wealthy nephew to meet the Edwards's unmarried daughter. This provided him with the opportunity to bring in accomplices. As Miss Edwards was preparing to meet her suitor, Blood suggested Edwards show his nephew the crowns. On entering the vault they pounced, throwing a cloak over Edwards's head and, when he would not be silent, viciously stabbing him in the stomach. Blood then hid the Imperial State Crown under his cloak, his accomplice, one Parret, stuffed the orb into his breeches and a third companion started to file the Sovereign's Sceptre in two to enable him to do likewise. At this

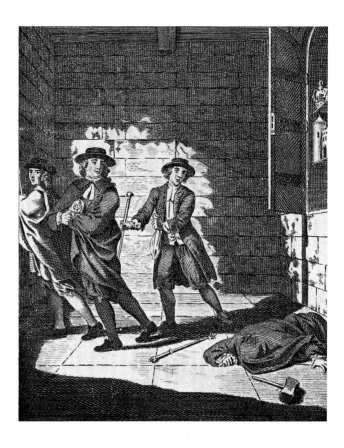

crucial moment Edwards's son returned unexpectedly from Flanders and interrupted the theft. Blood and Parret abandoned the sceptre and fled with the crown and orb. With Blood still dressed in his clerical robes, and firing shots over this shoulder as he ran, the pair made it to the riverfront before being overtaken and seized. Blood's status as an existing government informer, and his promises of further intelligence on enemies of the state, saved him from prosecution, and three months later he was pardoned. The regalia itself was 'bruised': a large stone was found shoved into Parret's pocket while a huge pearl and a diamond fell off the state crown during the 'robustious struggle'. Over the following nine months repair work would be undertaken at a cost of £145. Though the practice of showing the regalia to visitors would soon recommence, the collection would never again be on open display.

Opposite 98, 99 **Details of Queen Mary II's Sceptre with Dove**, 1689. *This gold sceptre is set with 274 gemstones including a number of deep red almandine garnets.*

Above 100 *Thomas Blood's attempted theft of the Crown Jewels in 1671, shown in a later engraving. Here Blood, disguised as a clergyman, leaves the stabbed Talbot Edwards for dead.*

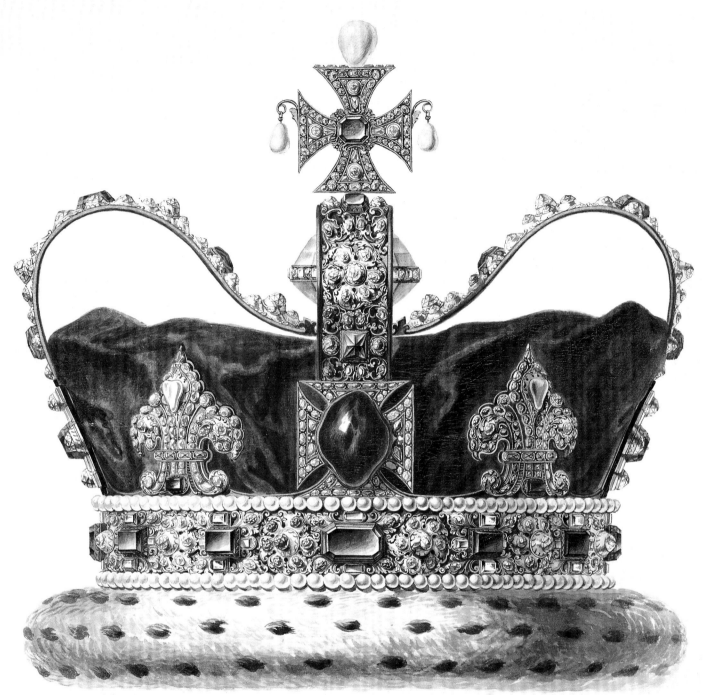

The Crown wherwith George King of Great-Brittain was crowned; y.ᵉ Cap is of crimson Velvet; y Welt on w.ᶜʰ y crown is fixed
is of Ermin; y Circle & Barrs are beaten gold; y ornaments are only Silver & set w. small diamonds; y Larger Stones
are Saphirs & Emerauds; & a few rubys very small; y Balass in y Cross in front was given to y Crown by King
James II; y Ball, on w.ᶜʰ y Upper Cross is fixed, is an Aque-marine but y Lower part is gold enamelled green. y.ᵉ Crown
is wore at y Coronation, & whenever y King goes to y.ᵉ Parliament; & is made new for evvry Coronation. it is
kept in y.ᵉ Tower of London.

Iasephᵉ Grisoni delin

7

FATHERS AND SONS

The second half of the 17th century had seen new regalia made in a series of waves – first for a new monarchy, then for two new queens – whereas the 18th century was a period of relative quiet. Most of the pieces that might be required for the most formal royal events were already to be found in the Jewel House, while the arrival of the Hanoverian dynasty and the changing times saw a reduction in the number and lavishness of state occasions. The State Opening of Parliament would continue, but the king no longer regularly dined in public or participated in the Royal Maundy services. As a result, new objects were made only as an exception. The Hanoverian queens Caroline of Ansbach and Charlotte of Mecklenburg-Strelitz were happy to use Mary of Modena's regalia for their coronations, while the Restoration plate continued to be used in the Chapel Royal and at state banquets.

The state crown was much the most intensively used item of the sovereign's regalia and after fifty years of regular wearing, periodic adaptation to various

monarchs' heads, and a rough ride from Colonel Blood, it was in a fragile condition. So in 1714 the royal goldsmith Samuel Smithin made a very similar new frame into which its distinguished collection of stones was re-set [101, 102 and 104]. Like its precursor, it was a gold structure surmounted by the 'aquamarine' monde made in 1685 (see 93), and adorned with silver settings. Though the crown had a permanent set of coloured stones, changes in the use of the regalia meant these would need to be readily removable.

The most significant change of this period was the quiet setting aside of St Edward's Crown. From the early 18th century the crown was carried in the coronation processions but no longer actually worn. Instead, the sovereign was crowned with the Imperial State Crown adorned temporarily with hired diamonds. So for the coronation of George II in 1727, the coloured stones were removed from the new state crown and it was set instead with several hundred hired diamonds. By the middle of the 18th century the solid mass and sparse settings of St Edward's Crown were considered old-fashioned. A rampant vogue for diamonds had gripped the country and London was now the centre of the international diamond trade. The purity and clear colour of these hardest of gems saw them eclipse all

Opposite 101 George I's state crown in a watercolour by Giuseppe Grisoni, 1718. The Black Prince's Ruby dominates the front of the crown.

others, accelerated by their discovery in Brazil in 1725. Advances in cutting techniques further increased the lustre of diamonds to the *beau monde*, in particular the invention of the brilliant cut, which reflects light within the stone to mesmerizing effect. St Edward's Crown was no match for the sparkling spectacles beloved of the Hanoverians and would be consigned to the shadows, unworn for almost two hundred years, until its revival in the early 20th century.

The story of the royal family in the 18th century is a tale of fathers and sons. With chilling consistency, each generation loathed the next: George I was on lamentable terms with his son George II; George II detested his son, Frederick, Prince of Wales, while Frederick's son George III considered his own heir, George IV, to be an imbecile. For periods there was complete estrangement between the generations. The seeds of alienation between George II and Frederick, Prince of Wales, were sown as the 7-year-old prince was left behind when his grandfather, George I, succeeded to

the British throne. Frederick remained in Germany for twenty-one years, separated from his family, while his parents lavished all their affection on their second son, William. When Frederick was eventually brought to London in 1728, the year after his father became King George II, it was more to stop him meddling in international relations than from any desire for his presence. That year, presumably in anticipation of his arrival, a gold crown [103] was commissioned for him at the cost of £140. 5s. It was made with one arch running from front to back, rather than the two crossing arches of a royal crown. George II's coronation – for which

Above 102 George I, c.1715, *Studio of Sir Godfrey Kneller. The state crown made for the King in 1714 can be seen on the left, set with the Black Prince's Ruby.*

Left 103 **THE CROWN OF FREDERICK, PRINCE OF WALES,** *1728. The single arch was used to distinguish the crown of the heir to the throne from that of the sovereign.*

Opposite 104 **GEORGE I'S STATE CROWN, FRAME,** *1714. The 'monde' on the top was that added to Charles II's state crown by James II and later removed when it was discovered to be paste.*

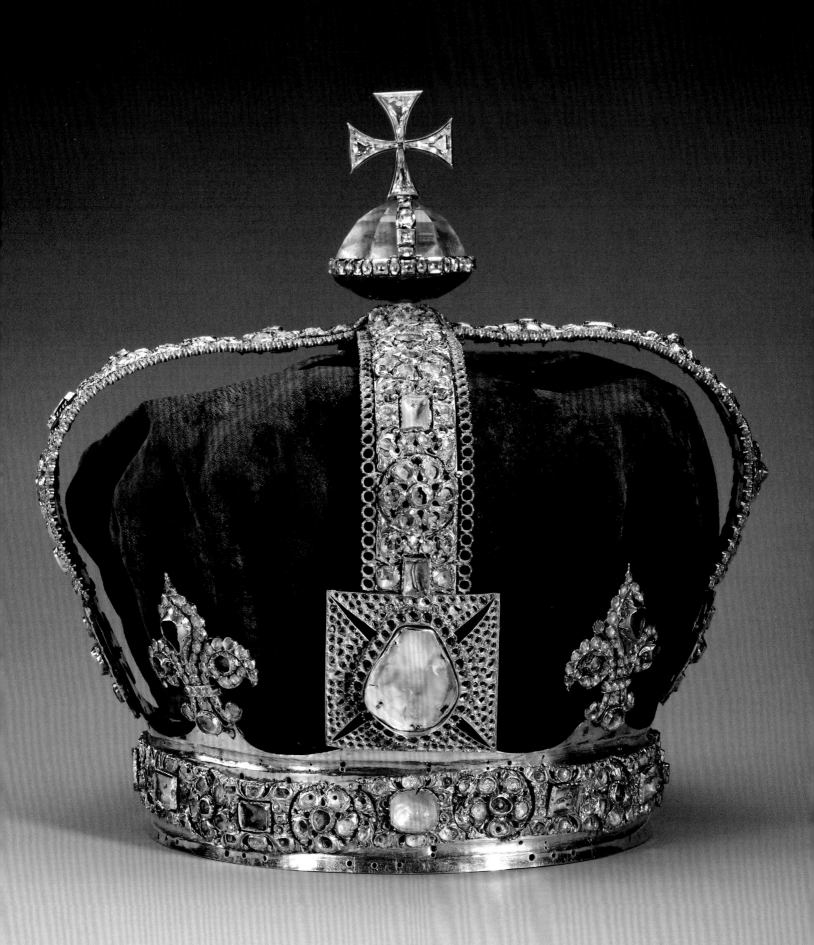

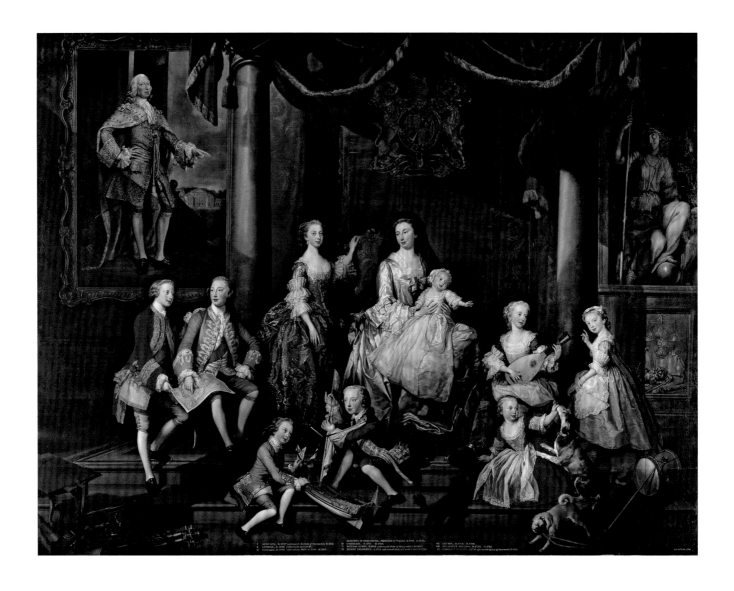

Handel had devised his famous musical settings – had already passed and it is unclear if Frederick ever wore the crown. It has, however, been used frequently since then, including by Frederick's son, the future George III [105], and his grandson, George IV.

Frederick's arrival at the English court did not improve family relations, and arguments over the Prince's allowance soon soured them further. The breaking point came when Augusta, the Princess of Wales, went into labour with the couple's first child. So determined was Frederick to escape his parents at Hampton Court that he risked the life of his pregnant wife and unborn daughter by making Augusta travel fourteen miles to St James's Palace while she was in labour. The rift that resulted was complete and saw Frederick and Augusta ejected from the royal palaces. They moved, instead, into the town house of the Dukes of Norfolk in St James's Square, where they would live for four years. The Princess was due to deliver her second child the following July; several weeks early, she went into premature labour and on 4 June 1738 gave birth to a tiny son, the future George III. The fragile baby was thought almost certain to die and at eleven o'clock that evening he was baptized by the rector of the parish, the

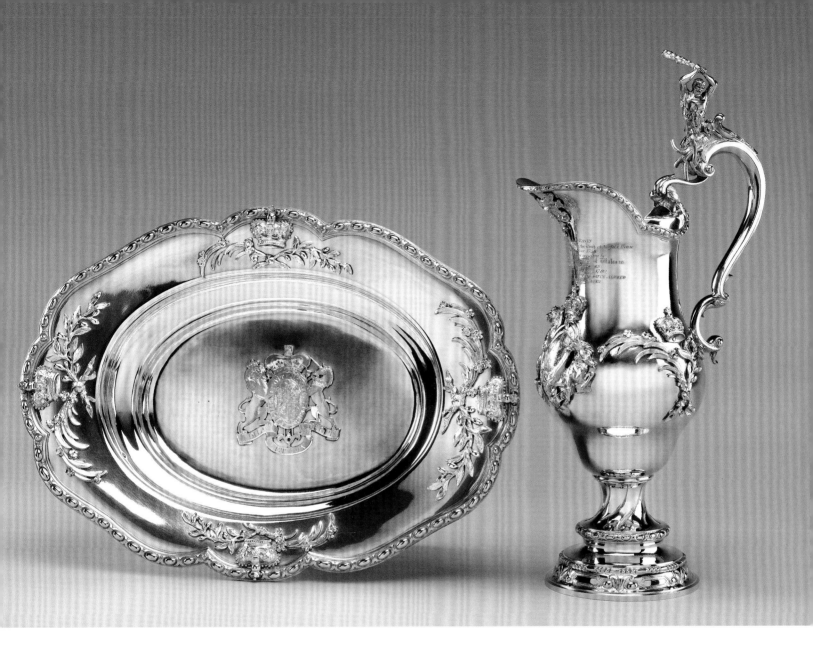

Opposite 105 The Family of Frederick, Prince of Wales, *1751*, *by George Knapton. The future George III (shown here second from the left) was the first son of the Prince and Princess of Wales. Frederick, Prince of Wales, who had died the year this painting was made, appears in a portrait at the top left.*

Above 106 CHRISTENING BASIN AND EWER, *c.1735. These were used for the baptism of the future George III in 1738. The figure of Hercules slaying the Hydra is represented on the handle of the Ewer.*

Bishop of Oxford. Thanks to the constant attentions of a devoted nurse, however, the baby rallied, and on 21 June a second, official, christening was held.

As royal outcasts with no access to the Jewel House, Frederick and Augusta had to baptize their son with the plate available to them. So instead of the royal font, a ewer and basin – vessels normally used for handwashing – were pressed into service for the ceremony [106]. The pieces may already have been Frederick's, or may have been acquired for the event at short notice. Both the Ewer and Basin are silver gilt and their original decoration is now obscured by the arms of George III,

added over forty years later. In 1780 the vessels were used once again for a royal christening, this time for George III's own son, Prince Alfred. While George had himself survived a shaky infancy, his fourteenth child, 'dear little Alfred', was not so fortunate, and to his parents' profound grief he died shortly before his second birthday. It may well have been his death that prompted the addition of engraved legends to the Ewer and Basin describing their use for the christening of father and son, so commemorating one of the few significant events in Prince Alfred's brief life.

When George III died on 29 January 1820 he had reigned longer than any monarch in English history, and his son and heir was already 57. The Prince of Wales, now George IV, had passed his adult life shopping, gambling, conducting love affairs and indulging his sophisticated and avant-garde artistic tastes. His flamboyance, extravagance and feeling for the romance of the past – as well as his delight at finally being king – meant George IV's coronation was bound to be a lavish affair. Planning was immediately begun and a date set for the summer of 1820. It soon became clear, though, that there was a considerable obstacle. When Prince of Wales, George had been persuaded to marry his German cousin Caroline of Brunswick, and though the couple had had a daughter within a year, the marriage was not a success. Within months George returned to his mistresses while Caroline embarked on a string of unsuitable affairs, eventually moving to the Continent. On the news of George IV's accession, Queen Caroline announced her intention to return to England to be crowned. The King was horrified and determined it should not be allowed to happen; as the wrangling went on, the coronation was postponed.

The delay allowed plenty of time for discussion and planning, in which the King himself was unquestionably the major force. He spent happy hours deciding on the seating arrangements, the form of the costumes to be worn by the various participants and the alterations to be made to the regalia. Since the last coronation in 1761, the separate kingdoms of Great Britain and Ireland had ceased to exist, and the Act of Union with Ireland in 1800 had created the United Kingdom of Great Britain and Ireland. This, together with the consequences of the fall of the French monarchy, had prompted George III to drop the ancient English claim to France and as a result the fleurs-de-lys were removed from the English royal arms. Keen to do more in this vein, George IV wanted to remove the fleurs-de-lys from the English regalia and replace them with a new 'patriotic device' made up of the rose, thistle and shamrock. Despite the King's entreaties, the proposal was blocked by the College of Arms, who argued forcefully, and correctly, that the symbol long predated English claims to rule France. The King had to make do, instead, with using the device on the diamond circlet he commissioned to wear over his velvet cap on his way to the coronation [107].

While George III used the state crown set with diamonds for the act of coronation, his son was prepared to make no such economies. The chief diamond setter of the London jewellers Rundell, Bridge and Rundell, Philip Liebart, was commissioned to design a new coronation crown. The result was genuinely innovative: until this date English crowns had been solid frames on to which the various stones were attached in settings with closed backs. The frame of the coronation crown made in 1820 was, instead, an open latticework of gold and silver on to which were fixed over 12,000

Opposite 107 George IV's Diadem, 1820. Designed by Philip Liebart. George IV wore this diamond circlet, featuring his beloved patriotic device combining rose, thistle and shamrock, to his coronation. Queen Elizabeth II is shown wearing the Diadem on postage stamps, coinage and bank notes.

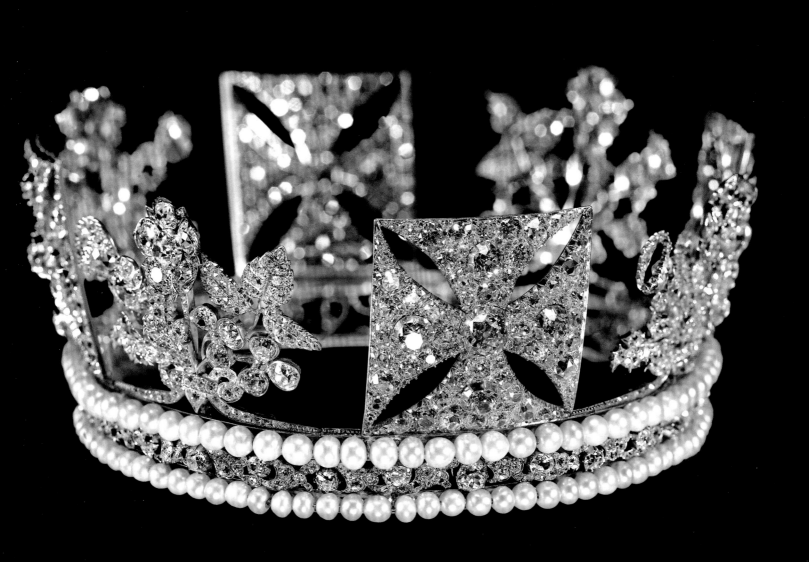

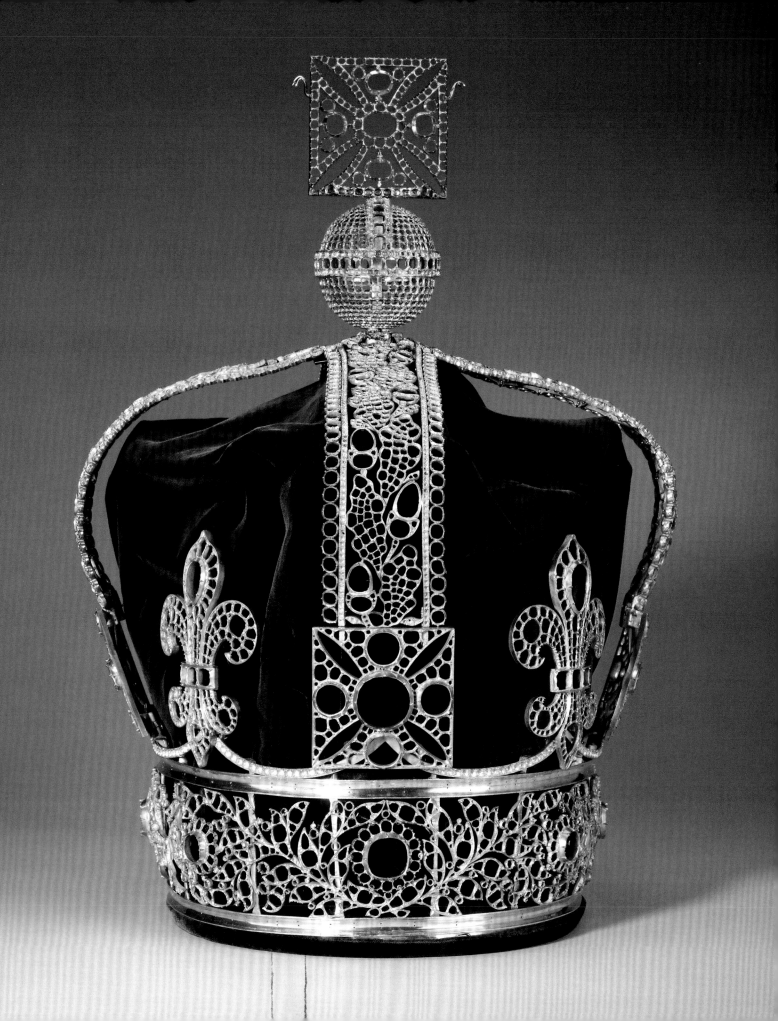

The Original Drawing
of The Imperial Crown of Great Britain
with which His Majesty King George the fourth was Crowned 19 July 1821
Designed & Executed by
Philip Liebart
The Diamonds & Pearls furnished by Mess.rs Rundell Bridge & Rundell
Jewellers to the King

brilliant-cut and one large rose-cut diamond [108]. As a result, the frame itself was invisible and the whole crown appeared to be formed of a blinding mass of diamonds [109, 111].

Although George IV did not use George I's state crown for the coronation, it was nonetheless carried in the procession and refurbished for the occasion. The 'aquamarine' monde surmounting the crown was now known to be fake and was replaced with a new diamond monde, and a handsome sapphire was bought for the back of the band. At this time the octagonal rose-cut gem known as 'St Edward's Sapphire', which still surmounts the Imperial State Crown today, can first be identified in the collection [110]. Measuring over 1.2 cm (½ in.) across, this deep velvety blue gem has definitely been on every version of the state crown since George IV's coronation, but – like the Black Prince's Ruby – may very well have been part of the collection for far longer. Its name derives from its identification with the sapphire that Edward the Confessor wore in his ring and which he gave to a beggar, who later revealed himself to be St John the Evangelist. The ring was returned to the Confessor, who was buried with it; according to the legend the stone was removed from the tomb and added to the regalia some years later.

George IV may have failed to have his 'patriotic device' added to his coronation crown, but he succeeded in including the flowers of the respective nations on his magnificent new Sword of Offering [112]. The Sword of State, the two swords of Justice and Curtana were established elements of the regalia, whereas the sword that the sovereign offered on the altar during the service in an act of alms-giving was normally his own weapon. This presented George IV with an opportunity to create an entirely new piece of regalia – one he exploited to the full.

The jewelled Sword of Offering is a genuinely breathtaking object – encrusted with thousands of jewels cut with the new techniques. The scabbard is set with large emeralds, rubies and sapphires and a massive 2,000 diamonds, arranged to form repeating devices of roses, thistles and shamrocks [113], and terminating in a

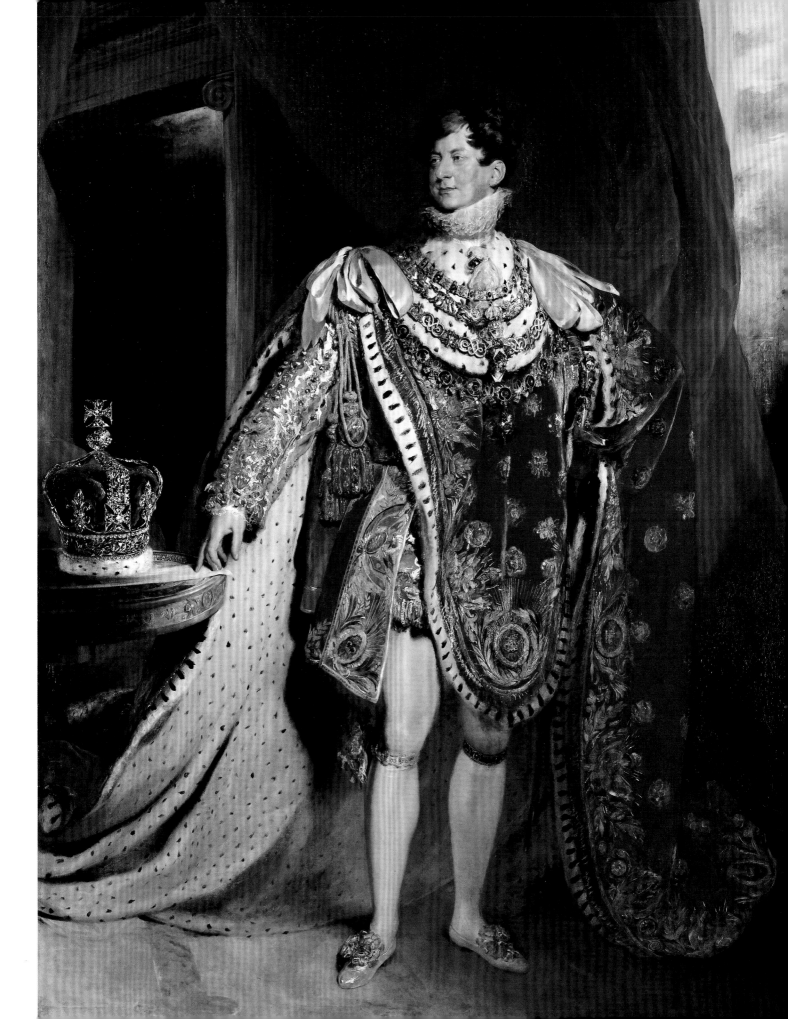

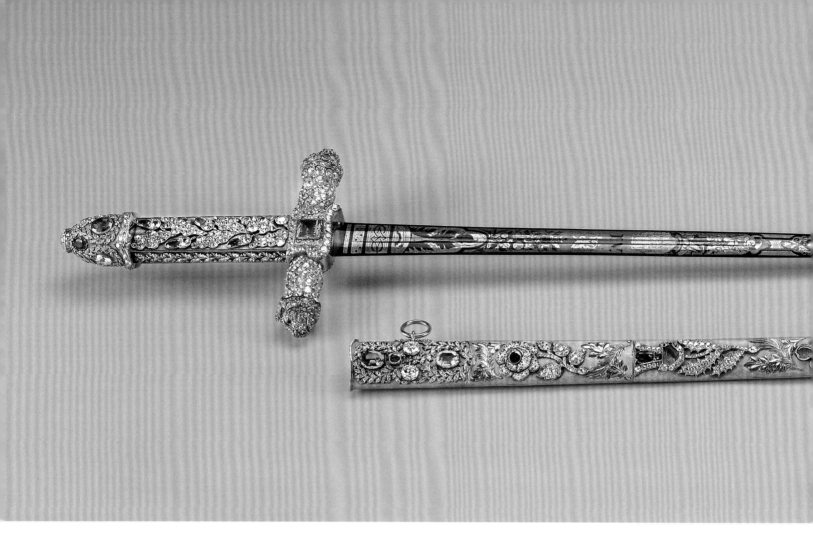

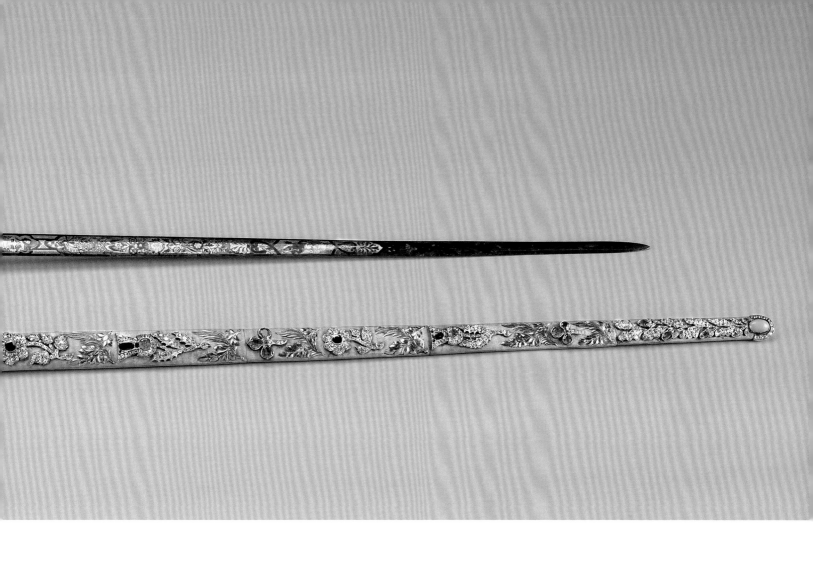

Top 112 **THE SWORD OF OFFERING**, *1820. George IV's jewelled Sword of Offering set with emeralds, rubies, sapphires and diamonds in the form of roses, thistles and shamrocks.*

Above 113 **DETAIL OF THE SCABBARD OF THE SWORD OF OFFERING**, *1820. While other monarchs had been content to use an existing sword in the Offering, George IV commissioned this magnificent jewelled object specially for the purpose.*

stunning unfaceted turquoise. On the jewelled hilt diamond oak leaves bud with large emerald acorns, while two lions' heads form the handles, their eyes flashing with tiny rubies. The blade itself is a masterpiece, covered all over with blued and gilt-edged decoration of heraldic devices, flowers of the nations and royal crowns.

Below 114 George IV's extravagant coronation was mercilessly lampooned by contemporary satirists. In this anonymous cartoon, the future Prime Minister, George Canning, bends to kiss the King's foot while giving a sycophantic address.

Opposite 115 Queen Victoria and Prince Albert at the Bal Costumé of 12 May 1842, 1842–46, by Sir Edwin Landseer. Remarkably, Prince Albert is shown wearing the Sword of Offering as part of his costume as Edward III.

As it was a personal piece, George IV paid for the sword from his own purse, at a cost of almost £6,000. It remained part of the sovereign's private collection throughout the 19th century, and was worn as part of a fancy-dress costume by Prince Albert in 1842 [115], before it joined the items in the Jewel House in 1903.

Despite all the care and consideration he lavished on it, the coronation was not a happy occasion for George IV [114]. It took place at the height of a July heatwave and the King – overweight and swathed in cloth of gold, chains of office and metres of fur – suffered visibly. As well as the physical discomfort, the King was wracked with anxiety at the possibility of his estranged wife ambushing the event. His fear was well founded and, to the enthusiastic cheers of the crowds, the Queen

ADULATION, or a CORONATION ORATION, by the ~~George~~ Jack Pudding of the NATION

actually presented herself at the Abbey and was prevented from entering only by the steeliness of the royal officials manning the doors.

It was just marginally cooler inside the church, where the raked seating that filled the nave and transepts was crammed with thousands of spectators. At the moment of anointing, the King removed his fur-lined robes and was invested with the golden coronation vestments. Most splendid of these was the Mantle, a great cloak-like garment also known as a 'dalmatic', at this time made new for each coronation [118]. The use of the dalmatic – an item of clerical dress – gave expression to the notion of the sovereign as a quasi-divine figure, appointed directly by God [116]. Like most coronation robes, the Mantle was made of cloth of gold – fabric woven from silk thread around which very fine gold wire had been wound. After the

coronation the Mantle passed into private hands, and only came back into the royal collection as a gift in the early 20th century. It has been worn by all monarchs since King George V.

At the ceremonial highpoints of the anointing and investiture, George IV was ghostly pale and sweating profusely. The one sight that rallied him was the portly figure of his mistress, Lady Conyngham, seated hard on the proceedings and dripping with magnificent jewels. On her ample arm, in a diamond and pearl setting, she wore the sensational stone known as the Stuart Sapphire [117]. Measuring almost 5 cm (2 in.) in length, this ravishing azure-blue gem had been acquired by George IV seven years earlier from the collection of Henry, Cardinal York, the last surviving heir of James II, and was reputed to have come from the 17th-century state crown. The King first gave the sapphire to his

Left 116 Queen Elizabeth I, c.1559, by an unknown artist. This coronation portrait of Elizabeth I shows her wearing a gold mantle or dalmatic similar to that made for George IV in 1821.

Above 117 THE STUART SAPPHIRE. After the death of George IV, the sapphire was placed on the front of the state crown. It was moved to the back when the Second Star of Africa (Cullinan II) was added.

Opposite 118 THE MANTLE, 1821. This magnificent cloak, made for George IV's coronation, was used again at the coronations of George V, George VI and Queen Elizabeth II.

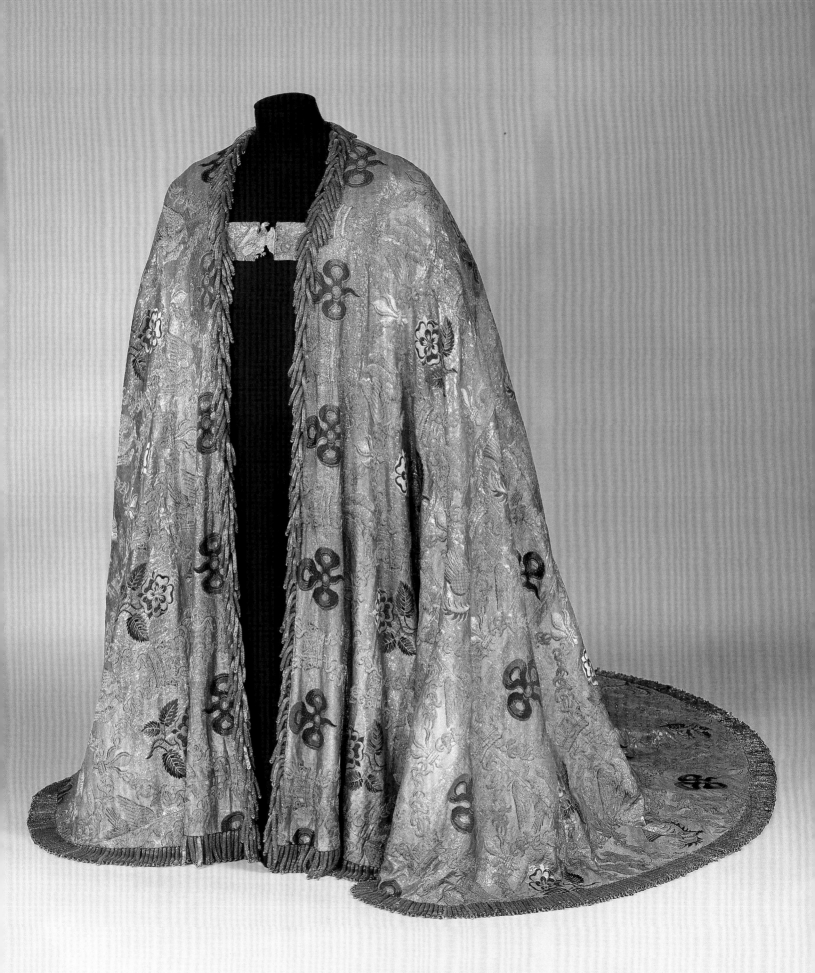

daughter, Princess Charlotte, but retrieved it on her death, with the argument that he needed it 'for his coronation as it was to go on the crown'. In the end it adorned Lady Conyngham rather than the crown, but it would eventually find its place in the Crown Jewels after George IV's death.

On leaving the Abbey the King processed to Westminster Hall for what was to be the last English coronation banquet [119]. The King and the royal dukes dined on a 1.8-metre (6-ft) high dais while some three hundred dignitaries sat at six 15-metre (60-ft) tables in the hall below. The royal banqueting plate (largely the 17th-century collection described in chapter 5) dazzled on two sideboards flanking the King's table. The collection had been cleaned and some pieces revamped for the event – in the course of which a set of twelve silver-gilt spoons was created to accompany the St George's Salts [120]. When the first course was taken to the King's table it was accompanied by the Duke of Wellington on horseback, who afterwards rode backwards down the length of the room. The heat in Westminster Hall was immense, intensified by the thousands of candles that blazed unnecessarily in the bright summer sunlight. The thick, hot air reduced the ladies' elegantly curled hair to lank strands, and the vast chandeliers rained down showers of scorching wax on the diners below. The feast lasted six hours, at the end of which the King was collapsing, having – like everyone else – risen at 2 a.m. to prepare for the great day. As the air began to cool, the other diners and crowds lingered on, with the last revellers stumbling home only shortly before dawn.

The cumulative expense of the various elements of George IV's coronation was astronomical. When

Right 119 The Third and Last Challenge by the Champion during George IV's Coronation Banquet in Westminster Hall, 1821, by Denis Dighton.

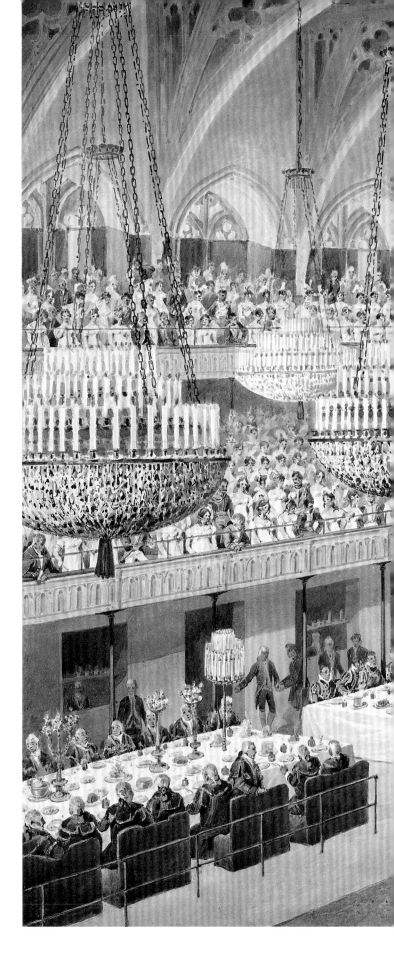

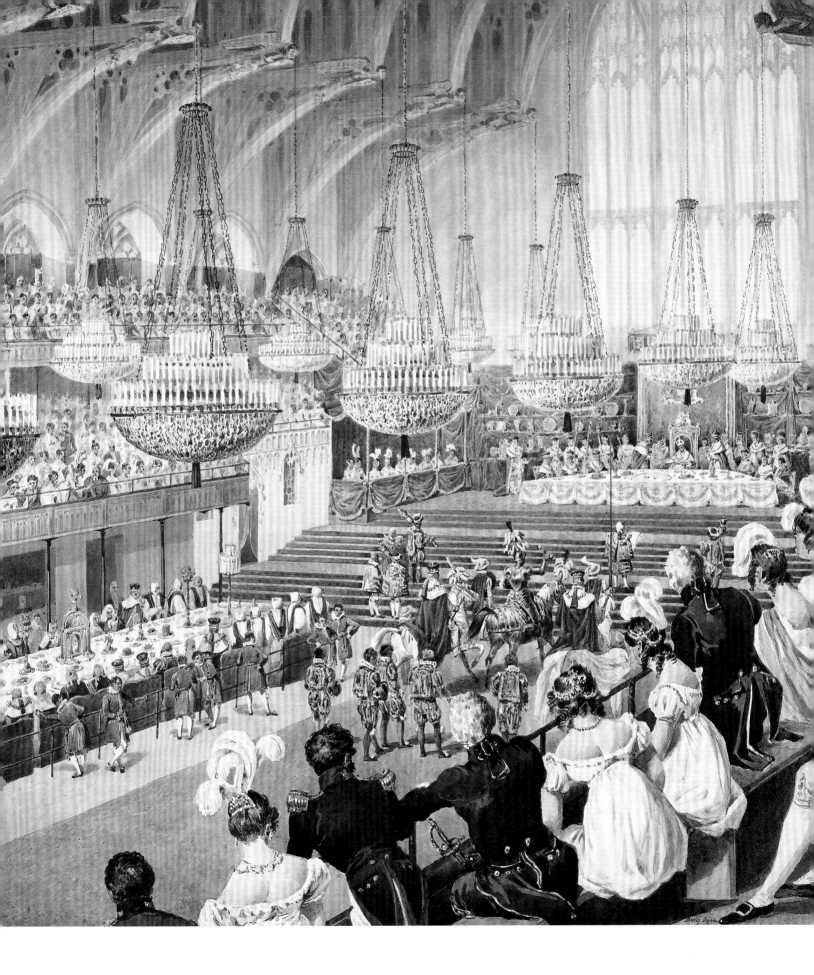

the American politician Richard Rush saw the King's diamond circlet in the jewellers' workshop, he remarked in disbelief that it cost more than three times the President's annual salary. The King had secured the government's consent to his new coronation crown by accepting that the diamonds for it would be hired, but he hoped to persuade the Prime Minister, Lord Liverpool, to buy the stones after the event. He hoped in vain, and after the loan was extended three times, the King commissioned a gilt cast of the crown as a memento and returned the diamonds with sadness [121].

The coronation marked the beginning rather than the end of the pageantry of George IV's accession, and after the elaborate London ceremony he embarked on a

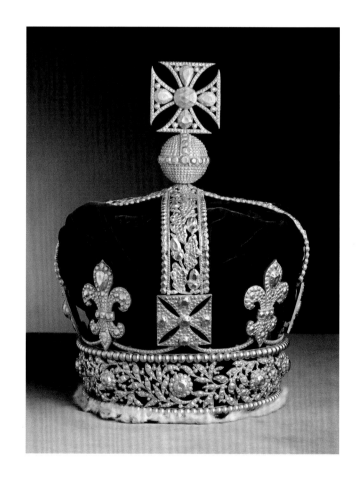

Above 120 **THE SALT SPOONS**, *1820. For George IV's coronation Philip Rundell made these twelve spoons to accompany the St George's Salts.*

Right 121 *Gilt-metal cast of George IV's crown, 1821.*

Opposite 122 *The Honours of Scotland, early 16th century. The Scottish Crown Jewels were discovered in a chest at Edinburgh Castle by Walter Scott in 1818, and were presented to George IV during his visit of 1822.*

series of visits to his various dominions. After going to Ireland and Hanover, the King set off for Scotland, the first English sovereign to do so for almost two centuries. Organized with characteristic panache by Sir Walter Scott, the visit was a wild success, with 300,000 people – a seventh of the entire population of Scotland – flocking to see their king. The visit presented the occasion for the Scottish regalia to play a role in the life of the nation once again. The most important elements of the 'Honours of Scotland', as the Scottish Crown Jewels were known, were the crown, sceptre and sword, which dated to the early decades of the 16th century [122]. They had been locked up in a chest at the time of the union of the English and Scottish parliaments in 1707 and then left undisturbed at Edinburgh Castle. In 1818, following persistent rumours that the objects had been taken to England, a group of eminent Scotsmen, including Walter Scott, broke open the chest. They found the Honours intact and three months later they were on public display. On 15 August 1822 their rehabilitation was completed as they were presented to George IV at Holyroodhouse. The Honours of Scotland have continued to play a part in Scottish ceremonial since then; when Queen Elizabeth II inaugurated the new Scottish Parliament on 1 July 1999, she did so with the crown of Scotland before her.

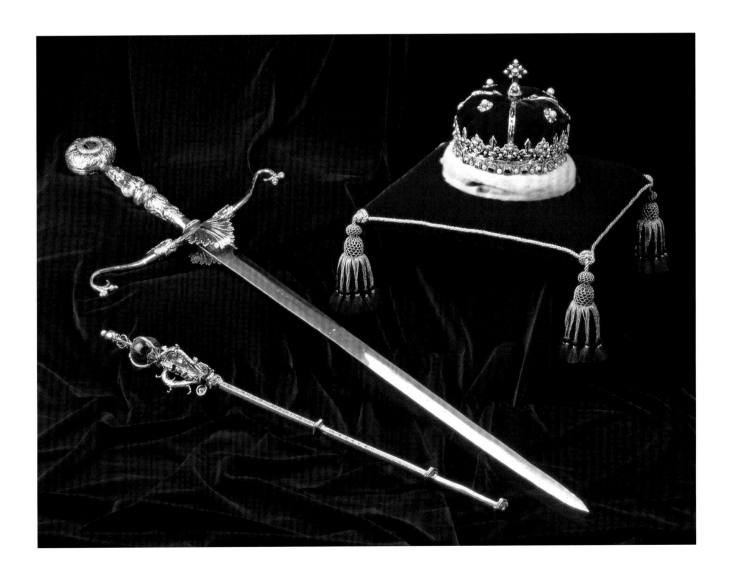

ECONOMY AND EMPIRE

Less than a decade after the extravaganza of his coronation, George IV died, obese and unloved, at Windsor Castle. His passing ended an epoch and brought about a permanent change in tempo for the British monarchy. His successor was his brother William, Duke of Clarence [123]. A ruddy-faced sailor who had never expected the throne, William IV had no taste for pomp and ceremony. His first instinct had been to dispense with a coronation altogether, but he was eventually persuaded to retain it on a smaller scale, and to

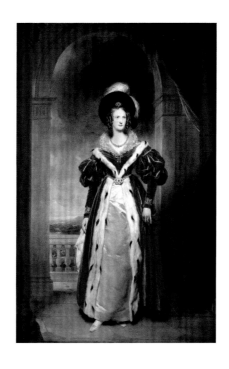

Opposite 123 William IV (detail), 1832, by Sir David Wilkie. William IV had no taste for the pageantry so beloved by his brother George IV. George I's state crown, set with its permanent collection of gems, stands on the table to his right; the King declined to hire diamonds to set in the crown for his coronation.

Right 124 Queen Adelaide, 1836, by Sir Martin Archer Shee. William IV's consort refused to use the 150-year-old crowns made for Mary of Modena for her coronation.

omit the banquet in Westminster Hall. The wags called the pared-down event the 'half-crownation', though it still cost the state almost £50,000.

Keen to avoid all unnecessary expense, the King refused suggestions that diamonds be hired for his crown, and the existing state crown with its usual collection of mostly coloured stones was used for the act of coronation [*see* 101]. Only one alteration was agreed: the addition of a thick velvet and silk lining to enable it to fit on the King's peculiarly pointed head – a feature that had earned him the nickname 'coconut'. While the state crown had benefited from repair and refurbishment ten years earlier, the consort's crowns had not been used for some seventy years and presented greater difficulties. Beneath her mousy exterior, the diminutive Queen Adelaide [124] had a steely resolve and when she was presented with Mary of Modena's crowns, she stated firmly that they were unfit for use. It was agreed, therefore, that she should

have a new crown, to cost the state no more than £300, which would be set with stones broken out of other royal pieces for the occasion. The frame, empty of stones since the 1831 coronation, is now at the Tower of London [128].

One or two other expenses were unavoidable in 1831, notably the coronation rings. Rings had featured in coronation ceremonies from the time of the earliest medieval rubrics, placed by the Archbishop of Canterbury on the fourth finger of the monarch's right hand. When asked about her failure to take a husband, Elizabeth I pointed to her coronation ring and said she was married to her country. Until the 20th century the

Top right 125 *Ruby and diamond coronation ring probably worn by Charles II at his coronation in 1661.*

Right 126 *The ruby and diamond ring given to Queen Mary II at her coronation in 1689. Until the 19th century the coronation ring was regarded as the personal possession of the wearer and not part of the Crown Jewels.*

Below 127 **THE SOVEREIGN'S RING**, *1831.* **THE QUEEN CONSORT'S CORONATION RING**, *1831. These two rings became part of the Crown Jewels on Queen Victoria's death in 1901.*

Opposite 128 **QUEEN ADELAIDE'S CROWN, FRAME**, *1831. The diamonds used to set the crown for the coronation were temporarily broken out of existing pieces of royal jewellery.*

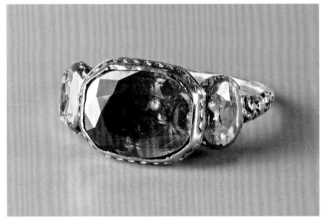

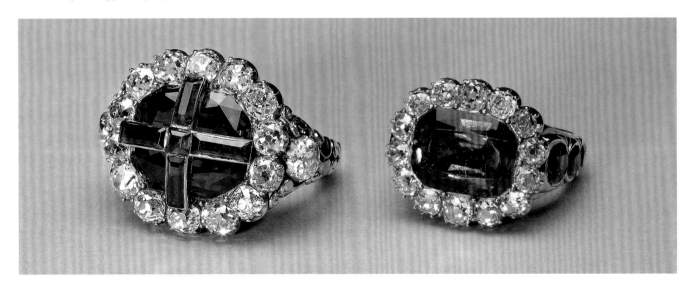

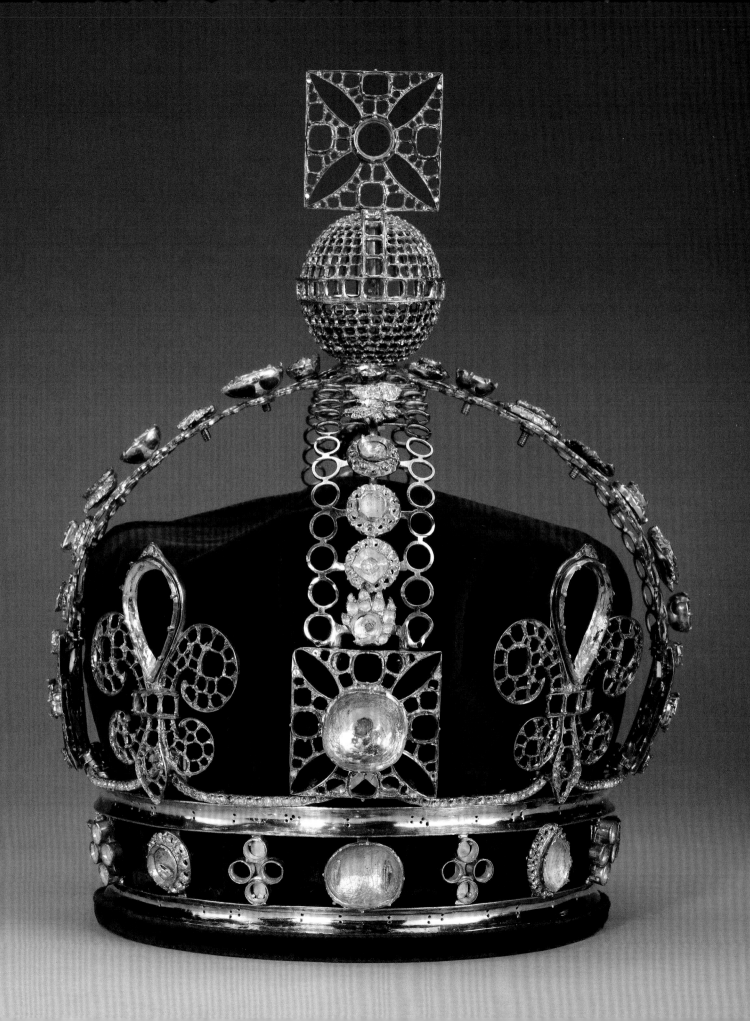

rings were made new for each coronation and treated as the personal possessions of the sovereign. As a consequence, two 17th-century coronation rings survive outside the collection in the Tower of London: that probably used by Charles II in 1661 and that belonging to Queen Mary II [125, 126].

The ring made for William IV in 1831, like those of his predecessors, had rubies as the dominant gems and was adorned with a cross. While the cross was often engraved on the stone, the 1831 Sovereign's Ring is formed of a large sapphire, surrounded by fourteen diamonds, on to which long step-cut rubies were mounted. The Consort's Ring, which was also made by Rundell, Bridge and Company, features a large ruby surrounded by fourteen brilliants, with a further fourteen rubies around the band, closely following the design of previous consorts' rings [127]. When Adelaide died in 1849 she bequeathed the 1831 coronation rings to her niece Queen Victoria. This established a tradition which Queen Victoria followed, so that she left those rings and her own to King Edward VII in 1901. As a result, a hereditary collection was created, and the practice of new rings being made for each coronation came to an end.

Inevitably, given that he had inherited the throne at 65, William IV's reign was short. Failing health prevented him from attending the eighteenth birthday party of his niece and heir, Princess Victoria, in May 1837, though he still delighted in the occasion, as it meant her mother, the Duchess of Kent, whom he detested, would never be Regent. Safe in this knowledge, William IV died 'like an old lion' just a matter of weeks later. The young Victoria was told of her accession at Kensington Palace; she was woken by her mother in the bedroom they shared and was still wearing her nightdress as the Archbishop of Canterbury delivered the news.

When Victoria became queen the change in atmosphere of the English monarchy from the heady days of the

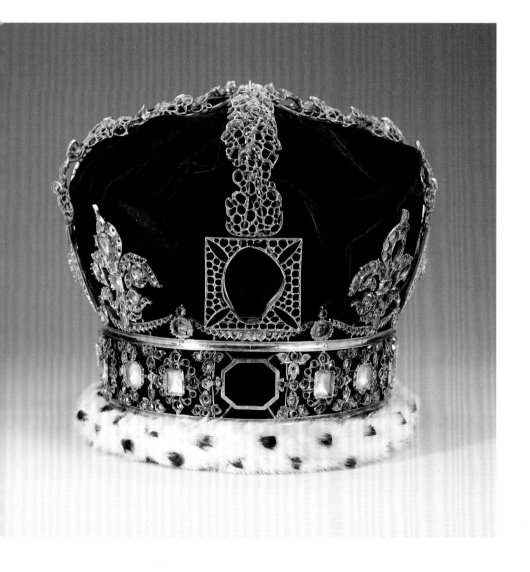

Left 129 QUEEN VICTORIA'S CROWN, FRAME, *1838. The two large apertures at the front held the Black Prince's Ruby and the Stuart Sapphire.*

Opposite 130 Queen Victoria, *1838, by Sir George Hayter. The Queen is dressed in her coronation robes and is wearing the new Imperial State Crown made for her coronation in 1838.*

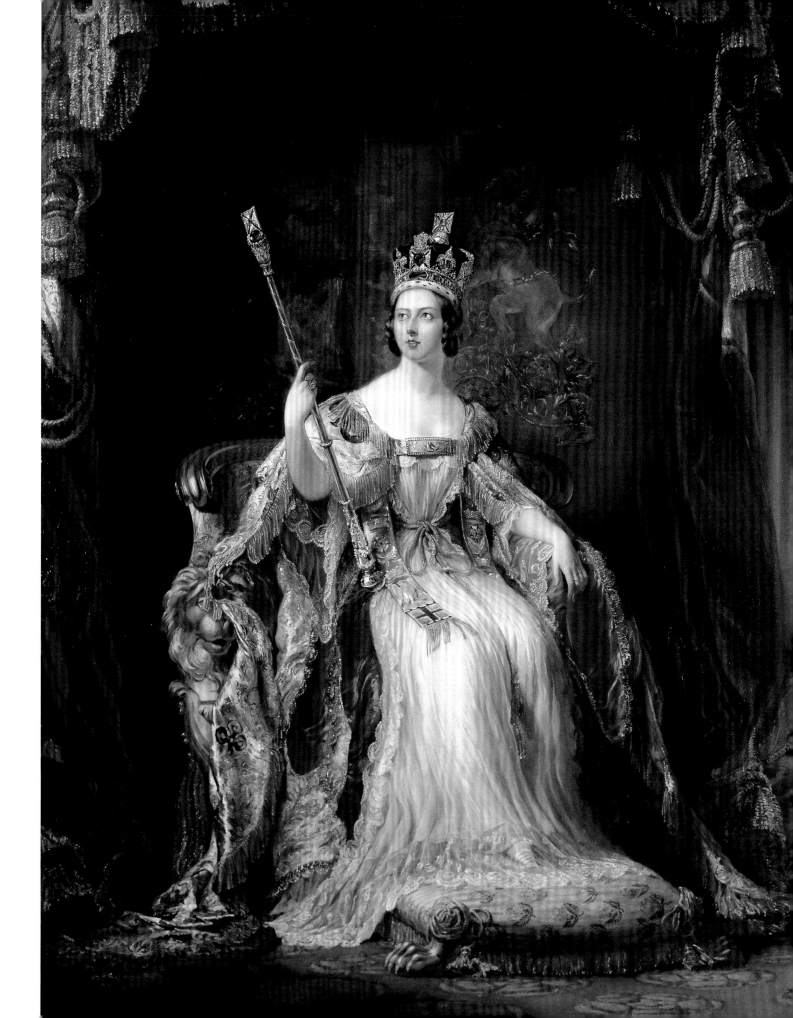

1820s was complete. On the evening of her accession she wrote in her diary that though she knew she was young and inexperienced she felt sure that 'very few have more real good will and more real desire to do what is fit and right than I have'. This girlish earnestness struck quite a different note from the monarchy of old men that had held sway for half a century. Despite the impression given by her age and tiny stature, the new queen had had a broad education and possessed clear ideas on many issues. She disliked ostentatious ceremonial and she had been thoroughly drilled in financial economy, and so she had no hesitation in refusing to reinstate the coronation banquet, though the generous budget that Parliament had voted for the coronation would have made it possible.

It was unthinkable that a teenage queen who stood well under 1.5 metres (5 ft) tall should use the large sovereign's crowns as they were. So it was decided that a new state crown should be made [129, 130], with which she could also be crowned [131], into which all the coloured gems from the state crown made for George I could be re-set. Among the handful of new stones that were added at this time was the Stuart Sapphire (*see* 117), which had been quietly extracted from Lady Conyngham. Although George IV's coronation crown was never to be used again, it lived on in the influence it exerted on the design and craftsmanship of Queen Victoria's crown. The stones were now suspended in open settings rather than being bolted to a solid frame. As with George IV's crown, the arches were in the form of curling oak leaves, symbolizing Englishness and following the contemporary fashion for naturalistic jewellery. With the creation of Queen Victoria's crown the design of the Imperial State Crown was fixed: the

Right 131 The Coronation of Queen Victoria, 28 June 1838, 1839, by Sir George Hayter. Queen Victoria is enthroned on the Coronation Chair. The altar, on the far left, is piled high with many of the pieces of plate made for Charles II in 1660–61.

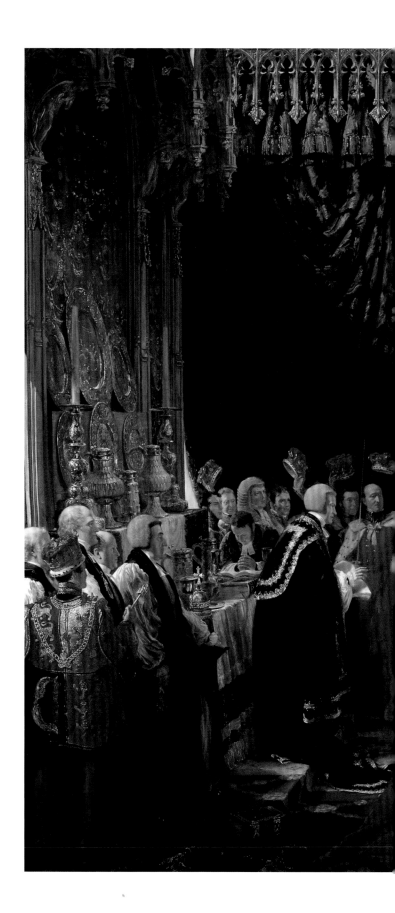

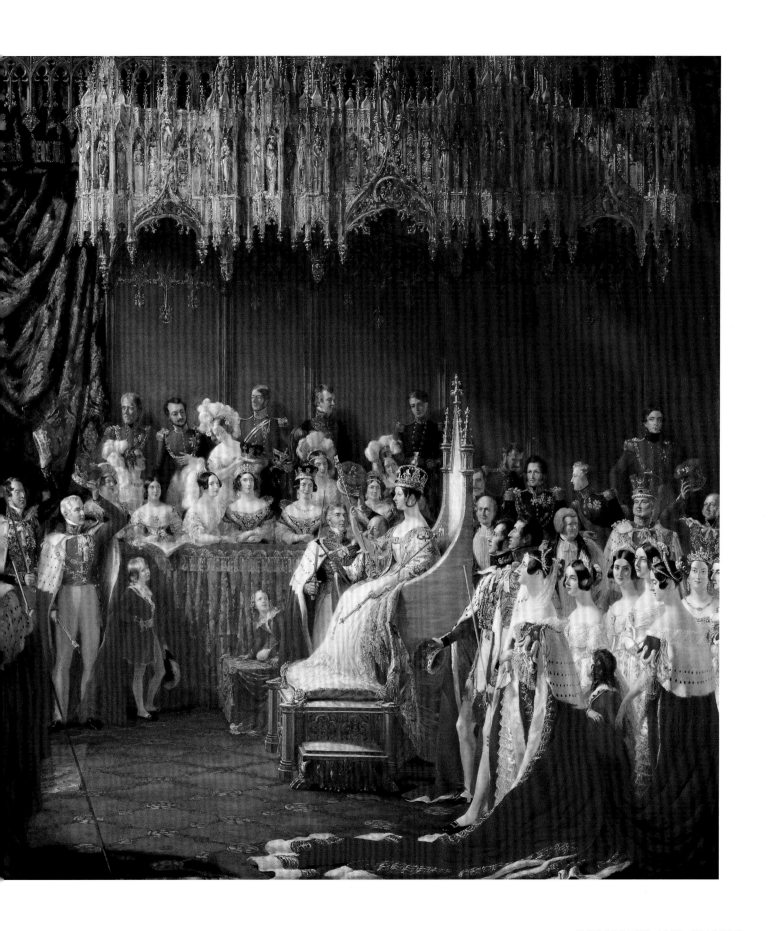

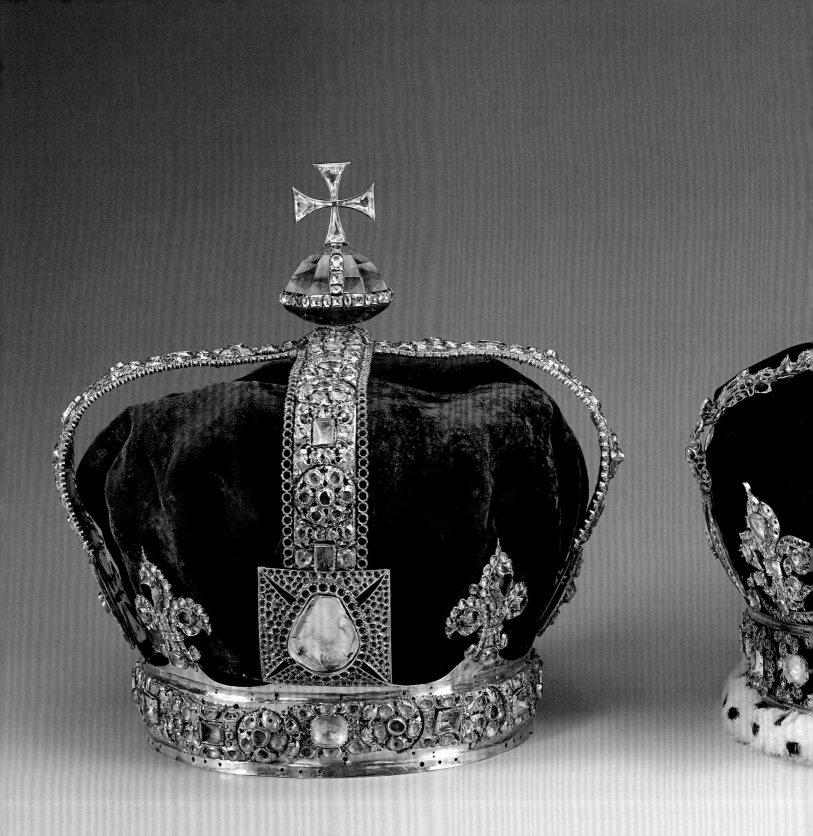

132 THREE GENERATIONS OF THE IMPERIAL STATE CROWN. *From left to right: George I's state crown (1714), Queen Victoria's crown (1838) and the Imperial State Crown (1937).*

The collection of stones acquired for Charles II's state crown in 1661 has been re-set in a new frame each subsequent century, with additions and substitutions made on every occasion.

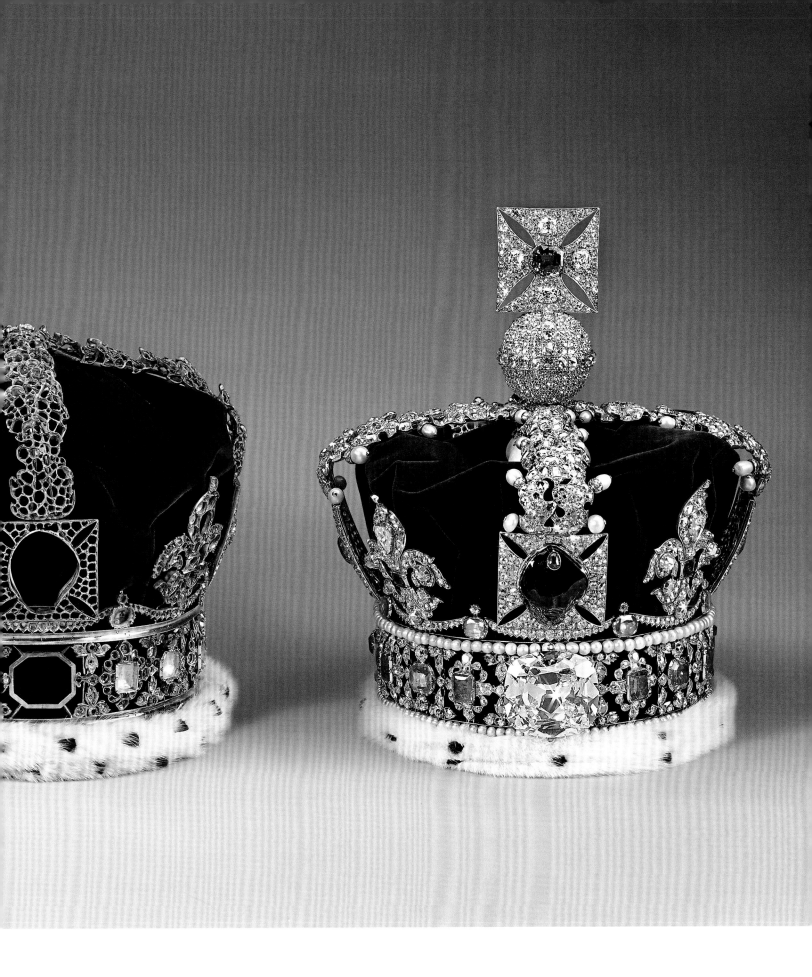

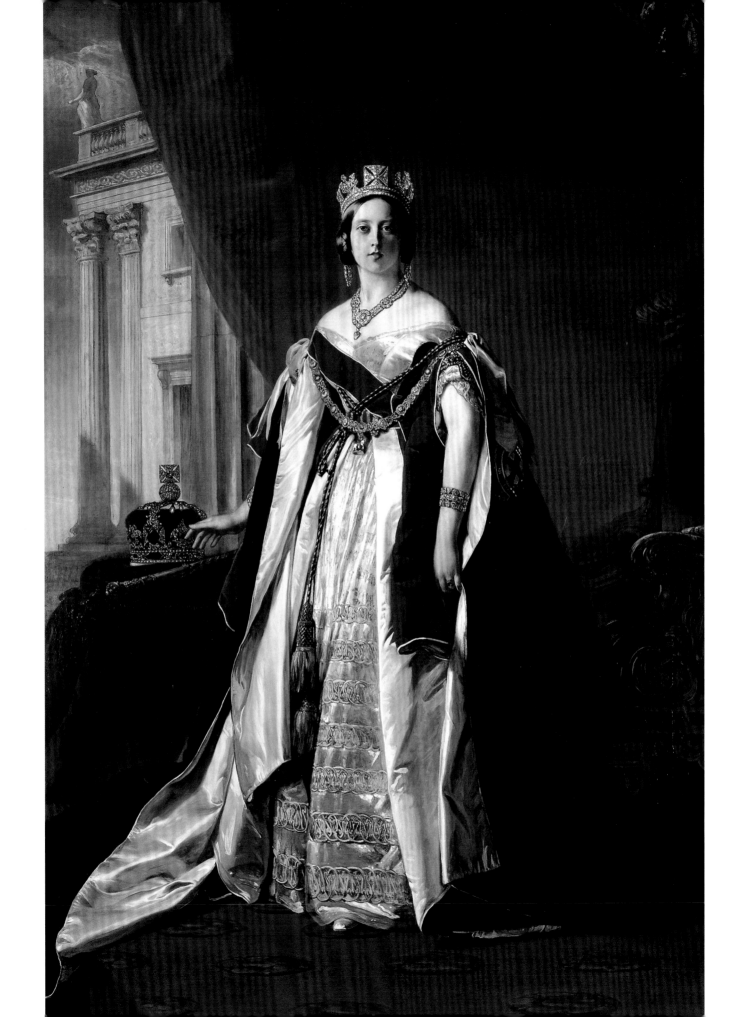

frame would serve until 1937, when it was replaced by the almost identical frame still in use today [132].

Various other changes were made to the permanent collection of regalia to make it possible for the small Queen to handle them, including altering the shafts of the sceptres to enable her to hold them comfortably [133]. A new coronation ring was ordered, as William IV's had not yet been bequeathed to the Crown. Queen Victoria's ring was an almost exact copy of her uncle's, simply scaled down in size [134]. The coronation rubric required that the ring be placed on the fourth finger of the right hand, which, counting the thumb, meant the third, 'ring', finger. However, the royal jewellers misunderstood this and made the ring to fit the Queen's fourth, little, finger. As a result the Archbishop had to

force it on the Queen's hand in the ceremony, and afterwards she struggled to take it off, managing to do so only, she said, 'with great pain'.

Victoria was, like her predecessor Queen Elizabeth I, reluctant to jeopardize her independence by marrying. But on being reintroduced to her cousin Prince Albert of Saxe-Coburg, she relented and their wedding took place at St James's Palace in February 1840. The Queen fell genuinely and passionately in love with her husband, and for the rest of her life would be completely in his thrall. Their first child, Victoria, was born exactly nine months later. For her christening the following February, the goldsmiths Edward Barnard and Sons supplied a font which in its design and decoration embodied the sincerity and sentimentality of the new court [135, 136]. On the base three winged cherubs, seated above the arms of Victoria, Albert and the Princess Royal, pluck lyres, while elongated leaves reach up to support a floral bowl edged by eight tumbling waterlilies. The Lily Font has been used for the christening of royal children and grandchildren, in combination with either the 1660 Font and Basin or the 18th-century Christening Ewer and Basin, ever since [137].

Opposite 133 Queen Victoria, 1843, by Franz Xaver Winterhalter. At the Queen's right hand lie the new state crown and the Sovereign's Sceptre with Cross, which was altered to make it easier for Victoria to hold. The Queen is wearing George IV's Diadem.

Below 134 QUEEN VICTORIA'S CORONATION RING, 1838. THE SOVEREIGN'S RING, 1831. Queen Victoria's tiny ring (left) is a scaled-down copy of William IV's ring of 1831 (right).

135, 136 **THE LILY FONT**, *1840. Made by Edward Barnard and Sons for the christening of Queen Victoria's eldest child, Princess Victoria, the future Empress of Germany. The bowl of the Lily Font has a lush, naturalistic border.*

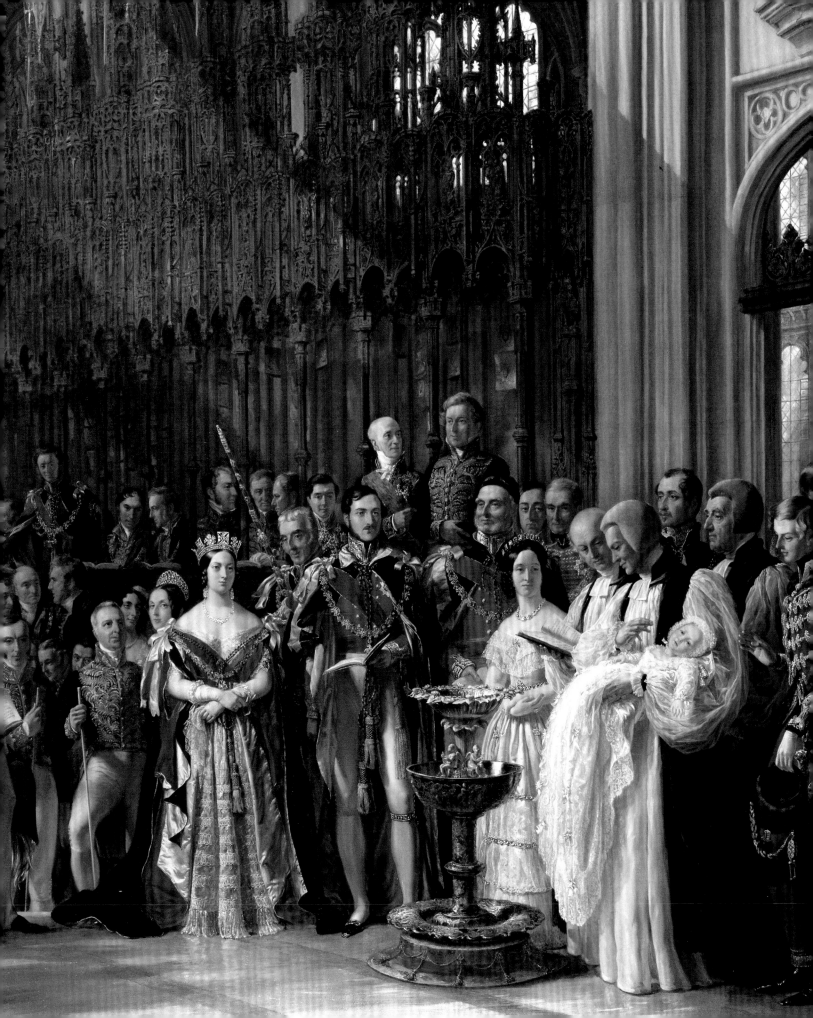

The arrival of a male heir the following year was cause for celebration, and the christening of the future King Edward VII was followed by a reception in the Waterloo Chamber at Windsor. To take away the chill of the January evening mulled wine was served, dispensed from what one spectator described as 'an immense gold vessel, more like a bath than anything else'. The vessel in question was the Grand Punch Bowl which, weighing 248 kg (almost 40 stone), is still the heaviest piece of English plate in existence [138]. Measuring 76.2 cm (30 in.) tall and over a metre (40 in.) across, it is an object on a scale that only George IV would have attempted, though it was almost certainly incomplete at his death. The Punch Bowl's original function was as a giant ice bucket, or cistern, for cooling bottles of wine, and this was the inspiration for the orgy of ornament

that adorns it [139]. The Punch Bowl was supplied by the London goldsmiths Rundell, Bridge and Rundell, who enjoyed what amounted to a monopoly over royal commissions, but it was probably designed by the celebrated painter and illustrator Thomas Stothard.

Opposite 137 The Christening of the Prince of Wales, 25 January 1842 (detail), 1842–45, by Sir George Hayter. The new Lily Font is shown with the Font and Basin of 1660 acting as a stand. The christening took place in St George's Chapel, Windsor Castle.

Below 138 THE WINE CISTERN or GRAND PUNCH BOWL, 1829. This enormous vessel, probably designed by Thomas Stothard, is the heaviest piece of English plate in existence.

Overleaf 139 DETAIL OF THE WINE CISTERN or GRAND PUNCH BOWL. The upper part of the vessel depicts the land, complete with insects and this roaring lion, while the underside represents the sea, encrusted with shells.

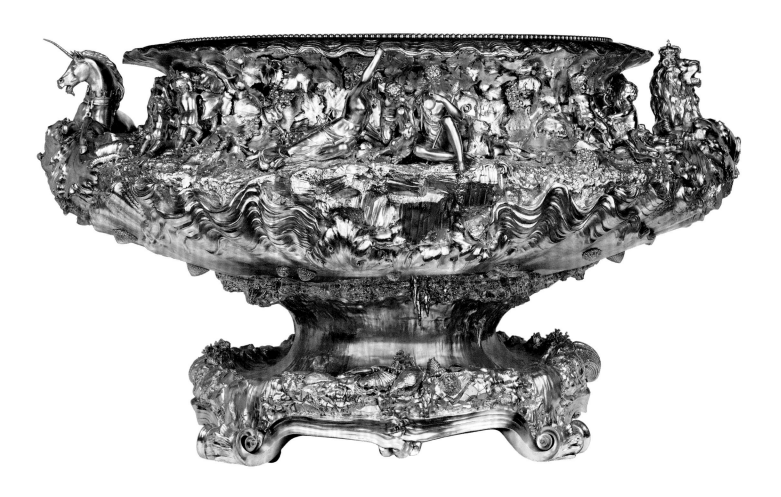

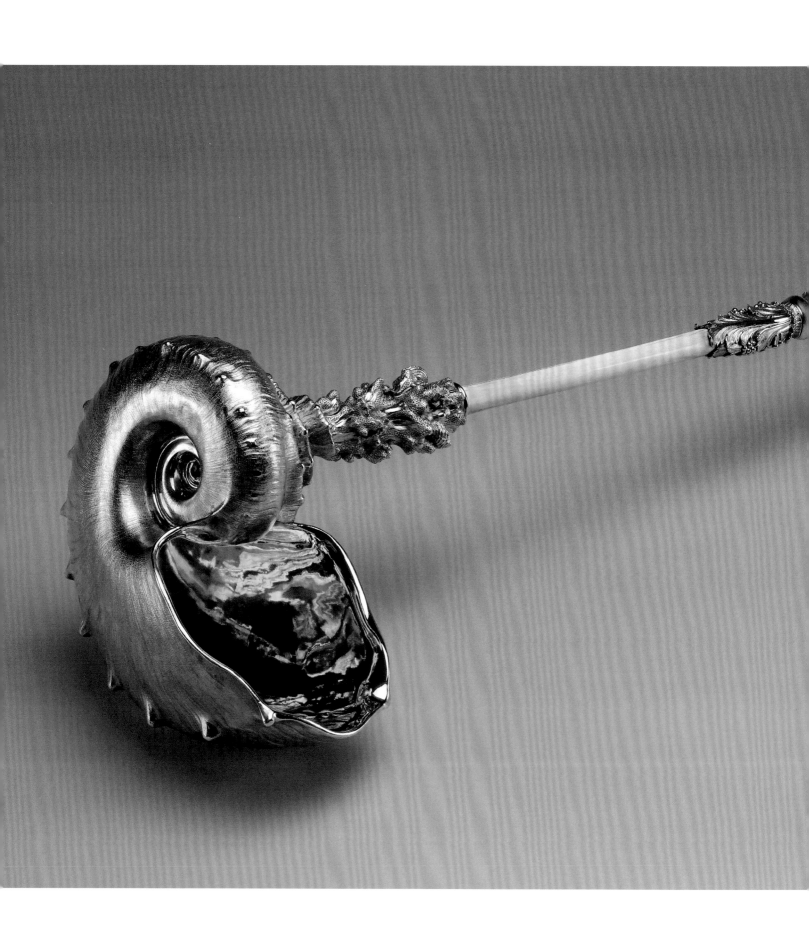

In 1841 Barnard and Sons were asked to provide a spoon so the Punch Bowl could be used for mulled wine, and they created a great ivory-stemmed ladle with its bowl in the shape of an enormous seashell [140]. The handle of the ladle terminates in the Prince of Wales's feathers and an inscription commemorating its use at the christening of Prince Albert Edward in 1842.

As Victoria and Albert carved out a happy domestic existence with their expanding family, trundling between official life in London and their beloved homes on the Isle of Wight and in Scotland, the dominions over which the Queen ruled were dramatically expanding. Nowhere was this more true than on the Indian subcontinent where, having gained control of most of what is now India, the East India Company was extending British power north-west into present-day Pakistan. Here the substantial kingdom of the Punjab, created by the Sikh ruler Ranjit Singh, straddled the north-west border of modern India and Pakistan with its capital at Lahore. Singh was a brilliant military strategist and formidable leader, and while he lived the British had carefully skirted his territories. In 1839 he died and his country descended into chaos. It was only a matter of time before the British intervened. After two short but destructive wars the Punjab was annexed to Britain in 1849 and Ranjit Singh's 11-year-old son, Dalip Singh, signed the Treaty of Lahore. One of the terms, stipulated by the acquisitive Governor-General of India, James Ramsay, the Marquess of Dalhousie, was that the Maharajah should 'surrender' to Queen Victoria the most famous jewel in the Lahore treasury: the Koh-i-nûr diamond [141].

This huge historic diamond was the subject of legend and over the centuries had passed across the mountains and plains of central Asia with the ebb and

Left 140 **LADLE FOR THE GRAND PUNCH BOWL**, *1841.*
This ladle was made for the reception following the christening of the Prince of Wales in January 1842.

flow of dynasties and dominions. Ranjit Singh had himself obtained it from the deposed Emir of Afghanistan, Shah Shuja, one of whose predecessors had acquired it from the Persian emperor Nadir Shah in 1747. The stone had reputedly gained its name – meaning 'Mountain of Light' in Persian – when it had tumbled from the turban of the vanquished Mughal Muhammad Shah into Nadir Shah's hands in 1739. Stories of its beauty and value went back to the first Mughal emperor and earlier, and in the 17th century it had probably belonged to Shah Jahan, who had built the Taj Mahal as a mausoleum for his wife. Lord Dalhousie wrote to the Queen that he hoped she would wear the diamond as 'a trophy of the glory and strength of Your Majesty's Empire in the East'. The stone was brought to England and on 3 July 1850 the Deputy Chairman of the East India Company presented it to Queen Victoria at Buckingham Palace. The news of its arrival caused a sensation: it was one of the star exhibits of the Great Exhibition in 1851 and the diamond was named by Wilkie Collins as the inspiration for his bestselling novel *The Moonstone* (1868).

Although the people poured into the Crystal Palace, many were disappointed by the unfamiliar Indian cut of the Koh-i-nûr – including Prince Albert himself [142]. The decision was soon taken to recut the diamond using modern cutting techniques. The work was carried out by Coster's of Amsterdam and took place in a blaze of publicity. The process lasted thirty-eight days and cost some £8,000, but it did not go smoothly, and the stone lost almost half its weight. Many lips were bitten at the results, doubtless including those of Dalip Singh himself when he was shown the stone by Queen Victoria two years later [143, 145]. But if the Koh-i-nûr had lost some of its exotic appeal as an oval brilliant-cut, its form was much more pleasing to contemporary taste. Although

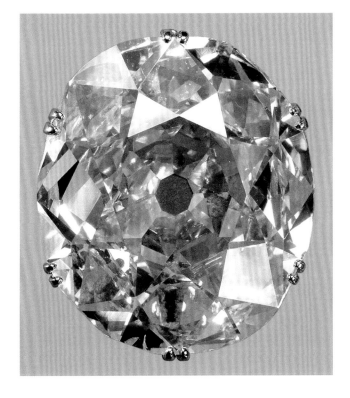

Opposite above 141 *Ranjit Singh's jewels, from Emily Eden's Portraits of the Princes and People of India, 1844. The Koh-i-nûr is shown in profile and on plan in the centre column (top and middle).*

Opposite below 142 **INDIAN SETTING OF THE KOH-I-NÛR**, *1839–43. The enamelled gold armlet in which the Koh-i-nûr came to England was made in Lahore. The armlet is now set with replicas of the stone and its two pendants, showing its form before recutting.*

Above left 143 *The Maharajah Dalip Singh photographed on the Lower Terrace at Osborne House, Queen Victoria's residence on the Isle of Wight, 23 August 1854.*

Above right 144 *Queen Victoria, 1856, by Franz Xaver Winterhalter. The Queen is shown wearing the recut Koh-i-nûr as a brooch; the front cross of the Regal Circlet she wears could also be adapted to hold the diamond.*

Left 145 **THE KOH-I-NÛR DIAMOND**. *It is now set on the Crown of Queen Elizabeth The Queen Mother.*

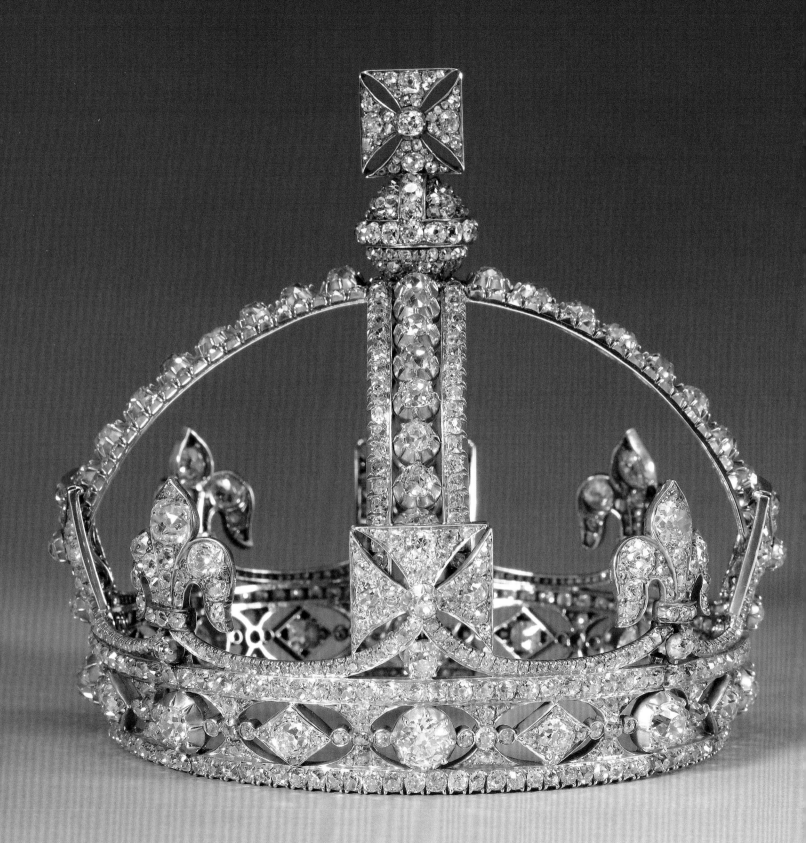

Dalhousie had hoped the diamond would adorn the royal crown, the Queen chose instead to wear it as a personal jewel, occasionally in her Regal Circlet, often as a brooch [144], and sometimes as the centre of the 'Timur Ruby' necklace.

On 14 December 1861 Prince Albert died and Queen Victoria's world collapsed. Her grief was devastating and absolute: as she put it, 'he was my life'. The Queen went into mourning, absenting herself from all official events and adopting the widow's clothing she would wear until her death. When she reluctantly began attending state events again, she did so dressed entirely in black and white, and eschewed the Imperial State Crown with its coloured gems. This created the uncomfortable situation in which the sovereign refused to wear her own crown. The resolution came in 1870, when a tiny new crown was commissioned for Victoria to wear over her white veil. It is a miniature object, weighing little more than 140 gm (5 oz) and measuring less than 10 cm (4 in.) in any direction. Despite its diminutive size, it was set with over 1,000 diamonds, most taken from other pieces of royal jewellery, which, being colourless, were suitable for widowhood [146]. As it was made in the form of a traditional English crown, with arches and alternating crosses and fleur-de-lys, the Small Diamond Crown was

considered appropriate for the Queen to wear on state occasions, with the Imperial State Crown borne alongside her on a cushion. The Queen would go on to wear it with great regularity, both on less formal occasions and for a number of paintings and photographs, and it would become one of her most recognizable possessions [147]. When, after a reign of sixty-three years, Victoria died at Osborne in 1901, the Small Diamond Crown was the object chosen to rest on her coffin.

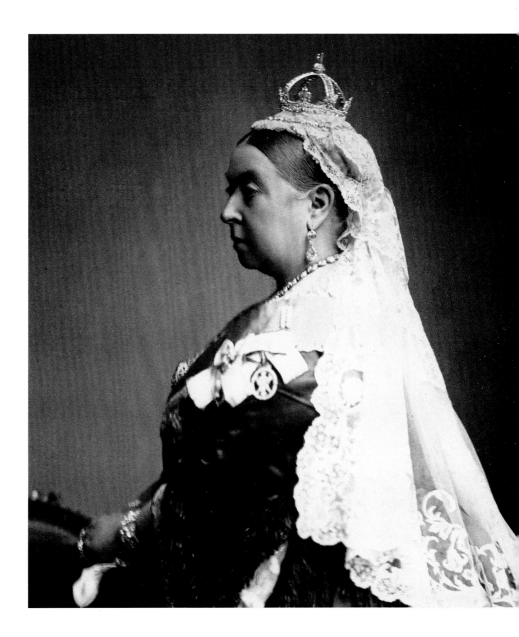

Opposite 146 QUEEN VICTORIA'S SMALL DIAMOND CROWN, 1870. Despite its size, this tiny crown contains over 1,000 diamonds.

Right 147 Queen Victoria, wearing the Small Diamond Crown, photographed by Alexander Bassano in 1882.

9

THE NEW CEREMONIALISM

As the 19th century drew to a close the English regalia lay almost completely unused. St Edward's Crown had not been set on a sovereign's head for well over a century and even the Imperial State Crown had gone unworn for four decades. Albert's death had left Victoria heartbroken and increasingly morbid; she shied away from public events and any sort of state ceremonial, which she regarded as an intrusion on her grief. Only under persistent pressure had she agreed to the public celebration of her Golden and then Diamond Jubilees, and for neither of these had she worn or used the regalia. This was not for want of urging by those about her, but the Queen had flatly refused to use the robes or insignia of state and, to widespread horror, had gone to Westminster Abbey in a bonnet. As the 20th century dawned, public and official frustration at Queen Victoria's reluctance to participate in the pageantry of monarchy was palpable. Sovereigns were expected to be splendid and the Queen was frequently and resolutely dowdy.

The new king, Edward VII, was not an instinctively formal person. He had spent a lifetime as Prince of Wales, which he had passed hunting, travelling and party-going, and the weeks after his accession were marked by a newly relaxed and convivial atmosphere in the royal palaces. However, he loved the theatre and had a strong sense of both drama and romance; these qualities, combined with a general feeling that monarchy needed to be magnificent again, would have far-reaching consequences. On hand to counsel the King was Reginald Brett, Viscount Esher: trusted adviser, recognized ceremonial impresario and, as permanent secretary to the Office of Works, the man responsible for realizing much royal pageantry. The King was initially reluctant to retain various of the ancient aspects of the ceremony, which he regarded as 'tomfoolery', but under Esher's guidance he was persuaded to see that ancientness was precisely what gave the occasion its solemn majesty, and that he should retain, even enhance, 'all the ancient practices and traditions', omitting only those that were actually 'ridiculous'.

This new spirit of historicism extended to the regalia. Mostly significantly the King decided to revive

Opposite 148 The Coronation of King Edward VII, 9 August 1902, 1904, by Laurits Regner Tuxen. The Archbishop of Canterbury, Frederick Temple, can be seen reading the service from deliberately archaic scrolls held by the Bishop of Winchester, Randall Davidson.

the tradition, dormant for two centuries, of using
St Edward's Crown for the act of coronation. The idea
doubtless appealed to the King all the more because he
shared a name with his saintly predecessor. Garrard and
Company, the venerable London firm who since the
1840s had been Crown Jeweller, responsible for making
and managing the Crown Jewels, was asked to refurbish
the crown to fit the King's substantial brow.

As the coronation neared, the King looked less
and less well, and two days before the appointed date
he received an emergency appendectomy on the
Buckingham Palace billiard table. The operation was a
success and the sovereign was sitting up in bed smoking

a cigar the next day – but the great ceremony was
postponed. The King was still weak when the new date,
9 August, came and he had to forego being crowned
with the gold St Edward's Crown and use the lighter
Imperial State Crown instead. In the event, the King's
wish to use his namesake's crown would be fulfilled
only in death, when it adorned his coffin as he lay in
state [149]. Despite various changes to accommodate
a convalescing king, the occasion retained the
archaic atmosphere that Lord Esher had sought:
the lapsed practice of anointing the king's breast was
reintroduced, Anglo-Saxon prayers were spoken and
the Archbishop of Canterbury read the service from

Opposite 149 *The lying-in-state of King Edward VII in the Throne Room at Buckingham Palace, 1910. Although the King was unable to wear St Edward's Crown at his coronation as he had wished, it lay on his coffin along with the Sovereign's Orb. The altar candlesticks were also brought from the Tower for the occasion.*

Right 150 THE PRINCE OF WALES'S CROWN, *1901–02. Made by Garrard and Company, this crown was first worn by the future King George V at the coronation of his father, King Edward VII.*

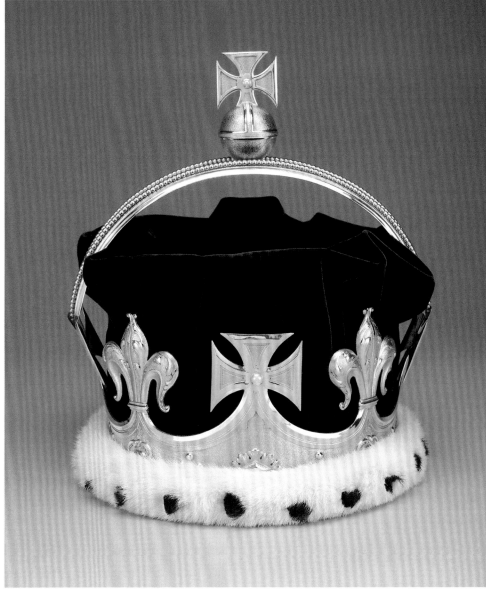

large scrolls designed to evoke 'ancient antiquity' [148].

Some novelty was also involved. When Queen Alexandra was crowned with her husband she was the first queen consort to attend a coronation for eighty years and new crowns were made for her and the Prince of Wales [150, 151]. A Danish princess by birth, Alexandra was, in the words of her sister-in-law, 'outrageously beautiful' and her elegance and stylishness were famous across Europe. She set many trends in clothes and jewellery, including the contemporary fashion for wide, jewelled chokers. The Queen refused to use the Crown Jewellers and instead commissioned a new crown, to be set with over 3,000 diamonds, including the Koh-i-nûr itself, from the Regent Street jeweller Carrington's. Rather than the pair of crossing arches usually found on English crowns, Queen Alexandra's Crown has four intersecting arches in the manner of many continental crowns, including those worn by the kings and queens of her native Denmark. Reports and images of what the Queen wore were reproduced around the world [152]. Even after the stones were removed, the crown would have an influence on the design of all subsequent consort's crowns.

The congregation in 1902 differed vividly from all previous coronations as it included representatives from across the British Empire, notably Canada, Australia and India [153]. Among this legion of colonial delegates were the Boer leaders who only two months earlier had signed the treaty ending the bloody Boer War. This had seen the small south African republics of the Transvaal and the Orange Free State incorporated into the British Empire. The attraction of these tiny states was their recently discovered gold and diamond reserves. Only three years later, at one of these mines on newly British territory just outside Pretoria, the most extraordinary discovery in the history of diamond mining was made.

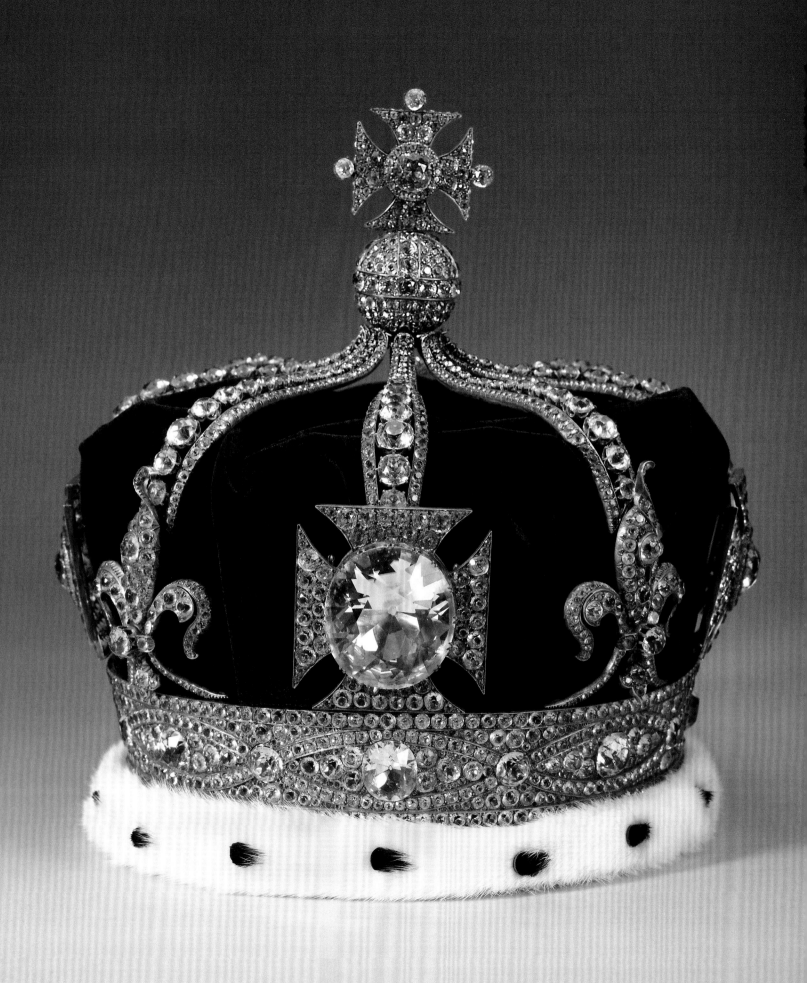

Opposite 151 **QUEEN ALEXANDRA'S CROWN**, 1902. *Now set with paste stones, this elegant crown was the first consort's crown to be adorned with the Koh-i-nûr diamond, setting a precedent that has been followed ever since.*

Above 152 *Queen Alexandra in her coronation robes and wearing her crown, 9 August 1902.*

Right 153 *Indian military representatives who attended the coronation of King Edward VII in 1902, photographed on the terrace of the Palace of Westminster.*

On 26 January 1905 a diamond of gargantuan proportions was prized from the rock-face of the Premier Mine [154]. It weighed a spectacular 3,106 carats, making it over three times the size of the largest diamond ever found, and was swiftly named after the mine's owner, Thomas Cullinan. In 1906–07 the Transvaal and the Orange Free State gained limited self-rule from their British masters, fulfilling one of the terms of the 1902 treaty. The new Transvaal government was keen to mark its inception with a grand gesture, and proceeded to buy the Cullinan diamond from the Premier Mine Company and, 'in commemoration of the grant of responsible government to the colony', presented it to King Edward VII at Sandringham House on 9 November 1907, his sixty-sixth birthday. The stone

Below left 154 *The Cullinan diamond in the rough soon after its discovery in 1905. The uncut stone weighed over 3,000 carats.*

Below right 155 *A replica of the uncut Cullinan diamond (above) and the nine major stones it yielded. These are (middle row, left to right): Cullinan IV, II, I and III. Cullinan III and IV together form the Cullinan Clip Brooch. The bottom row shows the remaining numbered stones, Cullinan IX, VI, V, VII and VIII.*

Bottom 156 *The First Star and the Second Star of Africa (Cullinan I and II) with a 1-carat diamond.*

Opposite left 157 **THE SECOND STAR OF AFRICA** *or* **CULLINAN II**. *This diamond, which weighs 317.4 carats, replaced the Stuart Sapphire in the front of the Imperial State Crown.*

Opposite right 158 **THE SOVEREIGN'S SCEPTRE WITH CROSS**, *1661. The sceptre was remodelled in 1911 to receive the First Star of Africa or Cullinan I, the largest colourless cut diamond in the world.*

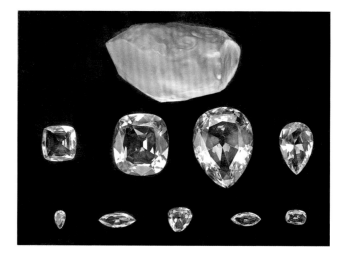

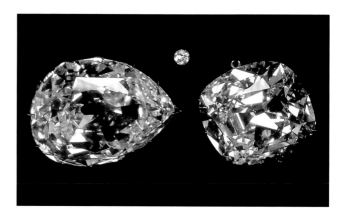

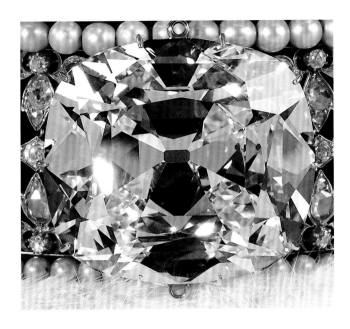

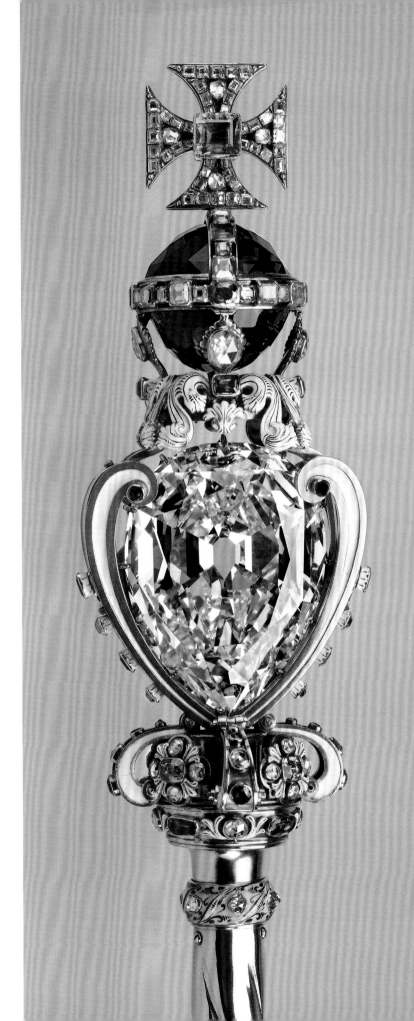

was accepted by the King with the promise that 'this great and unique diamond' would be 'kept and preserved among the historic jewels which form the heirlooms of the Crown'. At this stage the diamond was still in the rough, and the daunting task of cutting it was given to the Dutch firm of Asscher. The operation produced two vast diamonds and a further seven large gems [155]. The two principal stones accounted for over three-quarters of the weight of the cut gems [156], and were to join the Crown Jewels; the rest were given to Asscher's as their fee (but by 1911 all the major stones belonged to the royal family). The King christened the largest, a pear-shaped brilliant weighing an astonishing 530 carats, the 'Great Star of Africa'. It was then and remains today the largest colourless cut diamond in the world.

King Edward VII died in 1910, and it was in preparation for his son's coronation that Garrard altered the Sovereign's Sceptre to receive the First (Great) Star of Africa. To accommodate it the original enamel fleur-de-lys device had to be removed, though its form was evoked in the gold and enamel scrolls that clasp the great diamond in place [158]. The second Cullinan stone, known as the Second Star of Africa or

Cullinan II, was to adorn the Imperial State Crown. The Stuart Sapphire was relegated to the back of the crown to make room at the front of the band for the cushion-shaped brilliant [157].

While these two magnificent diamonds were set on the most prestigious pieces in the English regalia, the royal ladies could not quite bear to lose them from their dressing tables. As a consequence, the settings for the stones were designed to be removable from the regalia, allowing them to be worn together as a stupendous brooch. On at least one occasion Queen Alexandra wore the Koh-i-nûr diamond and both the Stars of Africa at the same time – about as sensational a combination of diamonds as it possible to imagine.

Standing just 1.72 metres (5 ft 6 in.) and weighing barely 63 kg (10 stone), the slight King George V struck a contrasting figure to his corpulent father [159]. While the expansive Edward VII had enjoyed the company of entertainers and actresses, his son's court was formal, sober and verging on the autocratic. But George V was not without imagination and as early as November 1910 he announced his passionate desire to be personally inaugurated as Emperor of India. Great ceremonial events had been staged outside Delhi in 1877 and 1903 to mark the 'imperial' accession of Queen Victoria and King Edward VII, but neither sovereign had attended in person. George V, however, had been greatly impressed by his own visit to India in 1905 and was determined to attend.

The King's original scheme for a full coronation was soon abandoned when the difficulties of holding a Christian ceremony in a largely Hindu country were considered. Instead, therefore, the event was to involve the already crowned King receiving the homage of the princes of India. Any suggestion that the Imperial State Crown should be taken out of England was immediately deemed 'illegal'. Garrard was therefore asked to provide designs and an estimate for a new Imperial Crown. The crown was to be both English and somehow Indian in its design and composition. The traditional fleur-de-lys and crosses were retained, but the object was given an exotic air by the double arches – influenced by Queen Alexandra's crown of 1902 [see 151]. Similarly, while the usual range of precious stones were to feature, these were (in theory at least) to come from India, and the principal stone would be a large polished emerald evocative of the ancient gems of the East. When completed, the new crown was set with 6,000 diamonds, 22 emeralds, 4 rubies and 4 sapphires [160]. The cost was met by the state, but paid for with revenues from British India.

King George V and Queen Mary set sail from England on 11 November 1911 and landed in Bombay

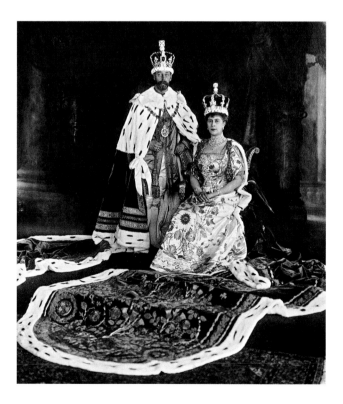

Left 159 *King George V and Queen Mary in their coronation robes, 22 June 1911. This was the last coronation for which Queen Victoria's state crown was worn.*

Opposite 160 **THE IMPERIAL CROWN OF INDIA**, *1911. This magnificent crown was made for King George V's inauguration as Emperor of India, and has been worn only once.*

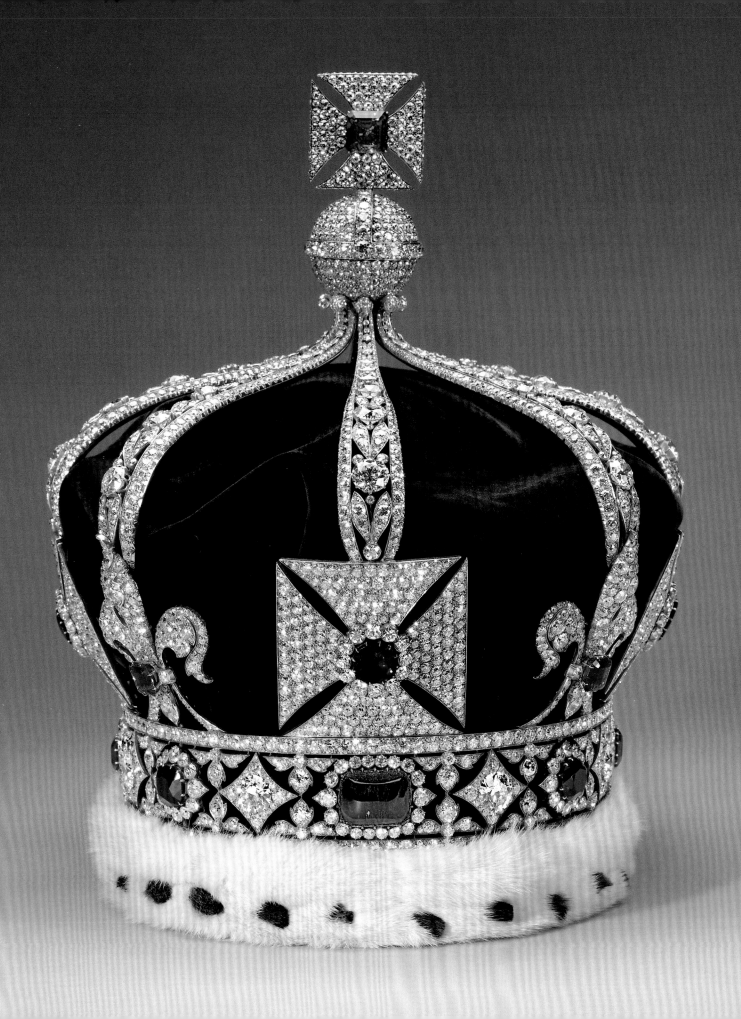

Left 161 George V and Queen Mary at the Delhi Durbar, *1912, by George Percy Jacomb-Hood. The royal couple are shown receiving the homage of the princes of India at the great ceremonial court known as the 'Delhi Durbar' in 1911.*

Below 162 The Coronation of King George V; Edward, Prince of Wales, Doing Homage, *1911–13, by Laurits Regner Tuxen. This part of the ceremony was remembered with emotion by father and son.*

Opposite 163 *The future King Edward VIII dressed for his ceremonial investiture as Prince of Wales at Caernarvon Castle in 1911.*

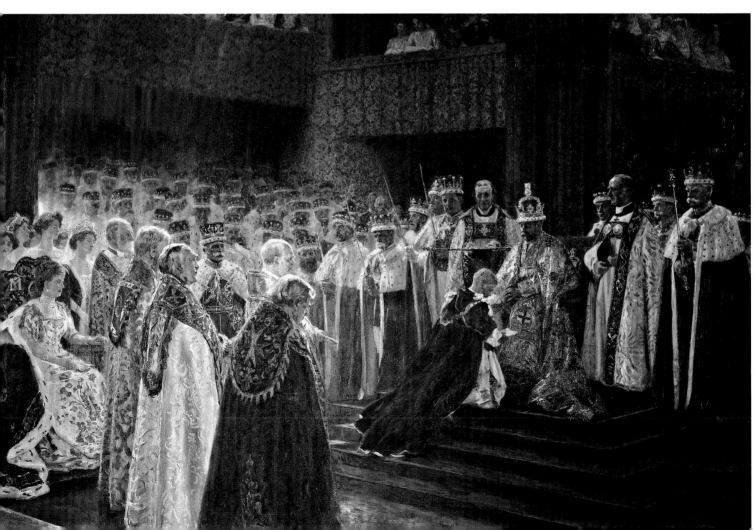

three weeks later. The ceremony, called a 'Durbar' after the courts of the Mughal emperors, was to take place in an enormous open plain outside the ancient capital of Delhi. Here, a vast shaded amphitheatre stood behind a throne platform, facing out towards a much larger curving mound on which some 50,000 spectators gathered from all over India to watch the great occasion. On the amphitheatre sat the princes and officers of British India, draped in gold and crimson finery or wearing magnificent uniforms, and dripping with enamelled swords, pearls and gems. King George V and Queen Mary arrived in a carriage dressed in furred robes of state despite the heat. Having first taken their seats beneath a canopied dome [161], the King and Queen received each of the princes of India in turn, starting with the 30-year-old Nizam of Hyderabad – dressed entirely in black but for a brilliant yellow headdress –

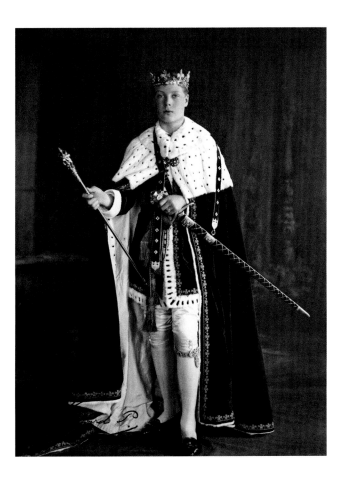

whose territories alone were as large as Great Britain and inhabited by over 15 million people. The whole occasion was on an astounding scale, and though the crown hurt the King's head and 'the heat was simply awful', George V described it simply as 'the most beautiful and wonderful sight I ever saw'.

When the King and Queen set sail for India in 1911, they were waved off from the Portsmouth docks by their eldest son, Edward, Prince of Wales. As a Naval officer and keen traveller, the Prince was disappointed to be left behind; but the year of his father's accession gave him a vivid taste of the ceremonial of sovereignty. He had played a significant role at the coronation, and as he had removed the Prince of Wales's crown [see 150] and knelt before the King in homage, the eyes of both father and son had filled with tears [162]. Several months later further ceremonies were held outside London in the rest of the kingdom, and Edward was formally invested as Prince of Wales in a new ceremony dreamt up by the Chancellor of the Exchequer, David Lloyd George, a native of Caernarvonshire [163]. But Prince Edward was a modern man, fashionable, urbane and uncomfortable with the ceremoniousness of kingship – and the investiture caused him to make the painful discovery that 'I recoiled from anything that tended to set me up as a person requiring homage'. When he acceded to the throne in 1936 the uneasiness remained, as he found that 'the King, more than most men, is a prisoner of the past'. Less than a year into his reign Edward VIII abdicated the throne to marry the divorcee Wallis Simspon. At 2 a.m. on a freezing December morning in 1936 he sailed into exile, leaving behind on the foggy shores everything to which he had been born.

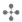

King Edward VIII's abdication had a colossal impact on the British royal family. As he signed the 'instrument' of abdication, the throne passed immediately to his

brother, the ill-prepared Duke of York. The Duke's wife, better known as Queen Elizabeth The Queen Mother, later recalled that 'the shock of those terrible days in December was literally stunning'. Though the impact was indeed profound, it was mixed in some quarters with a sense of relief. Edward VIII had seemed set to steer the monarchy on a new course. Unhappy simply to continue the dutiful conservatism of his father, he

insisted on changes to time-honoured practices and on occasion refused to carry out engagements altogether; his attitude was to some extent born of restlessness, but it was also inspired by a genuinely different view of the role of the sovereign.

If King Edward VIII was a modernizer, his brother was a traditionalist [164]. The Duke of York did not become King Albert – his Christian name – but King George VI, to emphasize the continuity with the reign of his father. The Archbishop of Canterbury, who had been dreading the coronation of Edward VIII because of his 'strained and wilful ways', was relieved to be dealing instead with the coronation of George VI in an 'atmosphere of intimate friendship'.

The original coronation date of 12 May 1937 was kept for King George VI and Queen Elizabeth so no time could be wasted in concluding the arrangements. Although Edward VII had been unable to use St Edward's Crown in 1902, his wish was realized by his successors, and the gold crown has been used at every coronation since. As intended in 1660, that crown served only for the act of coronation itself, and the Imperial State Crown was worn for the remainder of the ceremony. By 1937 the state crown made for Queen Victoria [see 132] was a hundred years old and the decision was taken to have it completely remade for the coronation of George VI. The new frame created by Garrard was essentially a replica of Queen Victoria's crown, though the jewellers managed to reduce the overall weight by 283 gm (10 oz). The 1937 coronation was in many respects a self-conscious rerun of that of 1911. Many elements, from the X-framed thrones on which the royal couple sat to the King's purple satin surcoat, were identical to those used by George V. The coronation robes with which the King was invested were also those his father had worn, including the George IV Mantle [see 118] and the gorgeous cloth-of-gold belted robe known as the Supertunica, made new for George V in 1911 [165].

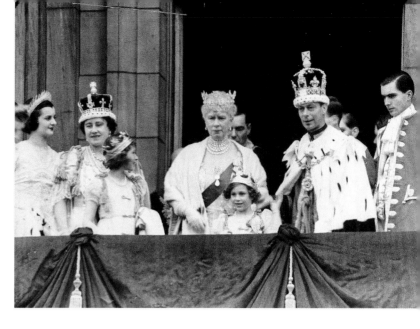

Opposite 164 *King George VI, 1938–45, by Sir Gerald Kelly. The new Imperial State Crown is shown on the table to the King's left.*

Below 165 **THE SUPERTUNICA**, *1911. This robe was made for King George V by Wilkinson and Son of Hanover Square, and used by his son King George VI in 1937.*

Right 166 *King George VI, Queen Elizabeth, Queen Mary and Princesses Elizabeth and Margaret Rose on the balcony of Buckingham Palace on coronation day, 12 May 1937. The King and Queen are wearing the new crowns made for the occasion and Queen Mary is wearing her crown of 1911 without the arches.*

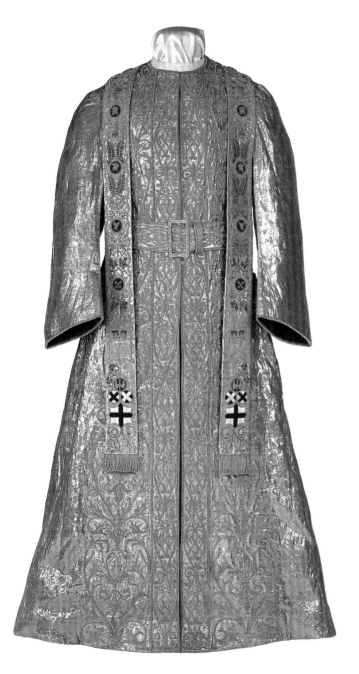

One of the new King's staunchest supporters through the difficult days of 1937 was his mother, Queen Mary. The dowager queen knew only too well how much pressure the course of events had put on her shy second son – she had witnessed his open sobs when he realized the certainty of his brother's abdication. In a break with usual practice, Queen Mary attended her son's coronation to give a public show of family unity; so raising the unusual question of what to do when there was more than one queen present.

Queen Mary was no trendsetter, but she loved jewellery. The slender-limbed silver crown made for her coronation in 1911 by Garrard was very much in the tradition of Queen Alexandra's crown, though realized with a new Art Deco elegance [167]. It was Queen Mary's intention that this crown, which she paid for from her private income, should serve as the permanent consort's crown for future coronations. However, when she announced her intention to attend her son's coronation in 1937, it was clear that she meant to wear the crown, albeit without the arches which could be detached, and with the Koh-i-nûr replaced by Cullinan V. The new Queen Consort would need another crown, therefore, and Garrard and Company were again engaged to make one. The object created for Queen Elizabeth was very similar to that made for Queen Mary, though the double arches introduced by

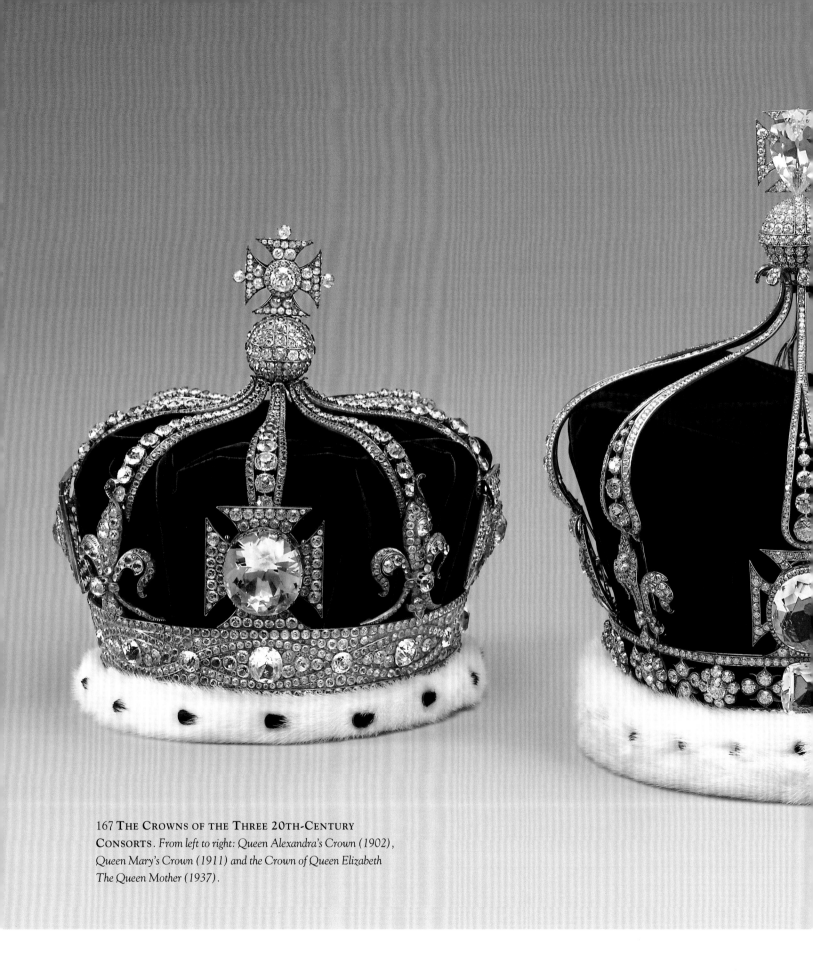

167 **THE CROWNS OF THE THREE 20TH-CENTURY CONSORTS**. *From left to right: Queen Alexandra's Crown (1902), Queen Mary's Crown (1911) and the Crown of Queen Elizabeth The Queen Mother (1937).*

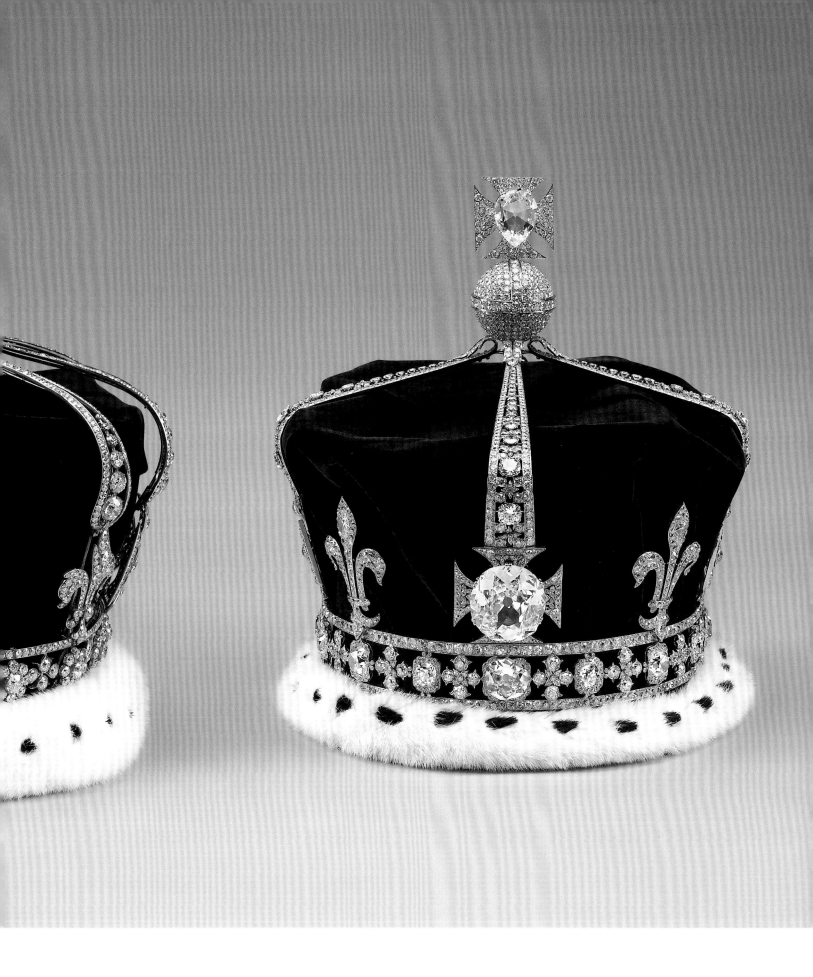

Queen Alexandra were dispensed with. The result was again extremely elegant: a platinum frame set entirely with diamonds, with the Koh-i-nûr dominating the front [169]. The King and Queen's daughters, Princess Elizabeth and Princess Margaret Rose, joined their parents for the occasion, dressed in miniature versions of their mother's coronation gown and wearing gilt-metal coronets [166].

The 1937 coronation went off very smoothly despite pouring rain and the stormy constitutional conditions that had preceded it [168]. For the first time parts of the service were televised and the ceremony was relayed across the world in radio broadcasts. Among the many millions gathered around the wireless was a party at the Chateau de Candé in the Loire valley of France. There, the Duke of Windsor, as King Edward VIII was now called, listened to the broadcast with Wallis beside him. He showed no emotion, but when their friends had gone, the Duke turned to her and said simply, 'You must

Above 168 *Coronation street party in Flint Street, Cardiff, 1937. King George VI's coronation was the first to be televised, and thousands of people participated through street parties, which had become popular forms of public celebration after the First World War.*

Opposite 169 **DETAIL OF THE CROWN OF QUEEN ELIZABETH THE QUEEN MOTHER**, *1937. The continental-style double arches introduced by Queen Alexandra were dropped from the design of the new consort's crown of 1937. The Koh-i-nûr diamond is in the front cross.*

have no regrets – I have none. This much I know: what I know of happiness is for ever associated with you.' But despite his reassurances the Duke still hankered for the world he had relinquished and among the objects he chose to take into exile was the crown that he had worn at his father's coronation [see 150]. He kept it with him for the rest of his life, and only on his death in 1972 would it quietly rejoin the regalia at the Tower of London.

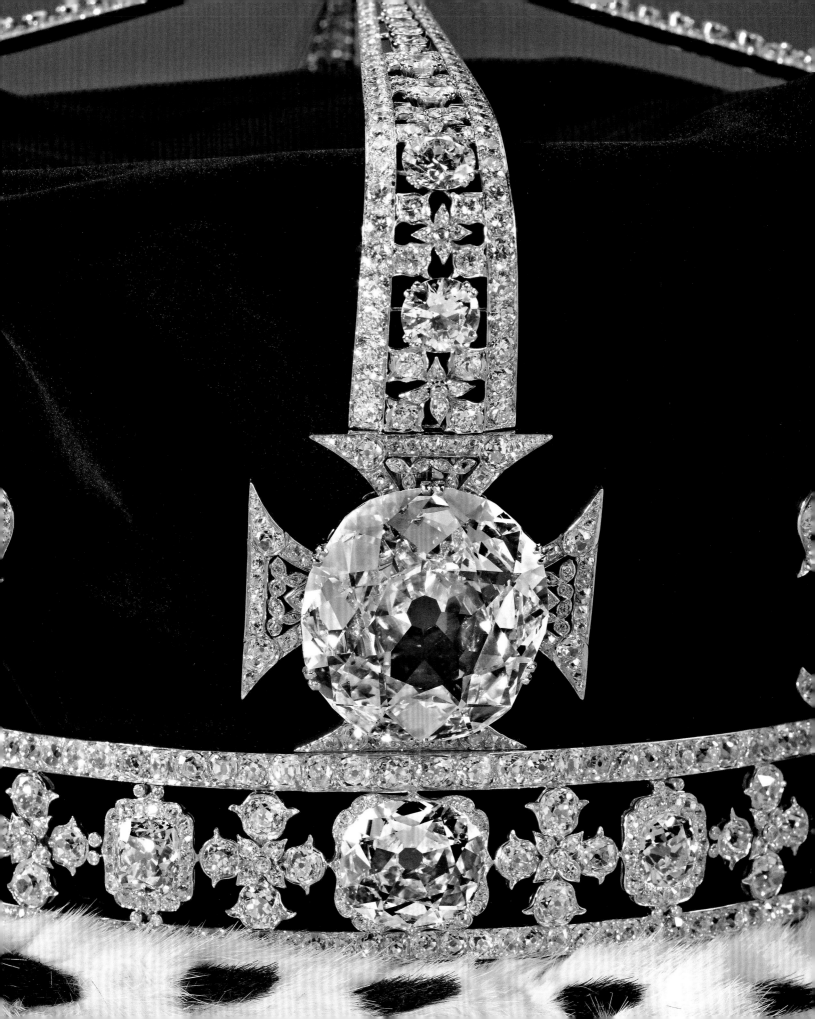

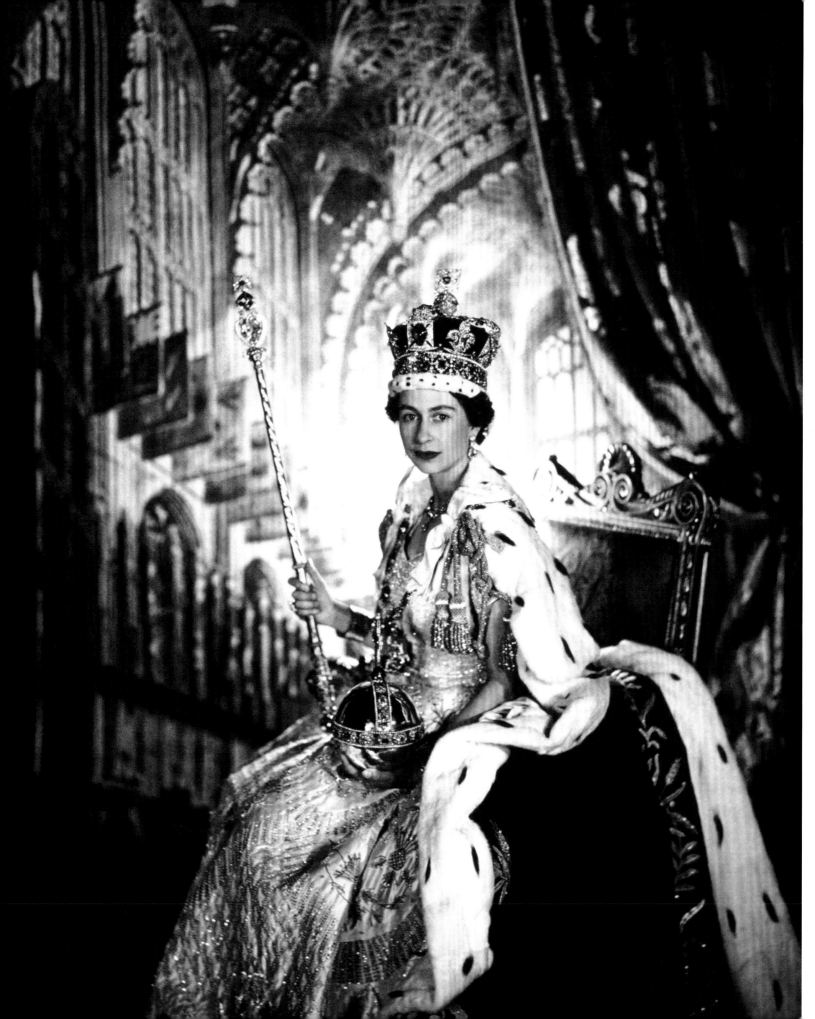

10

THE MODERN AGE

The Second World War left the people, landscape and infrastructure of the United Kingdom battered and bruised, and brought the nation to the brink of bankruptcy. The bloodshed and upheaval also accelerated the disintegration of the British Empire: India and Pakistan gained independence in 1947, Sri Lanka and Burma in 1948, blazing trails that most of the rest of the empire would soon follow. So it was that despite the victory in war, Britain in the early 1950s was a bleak and dreary place, a backdrop against which the death of King George VI at 56 seemed yet another cause for regret.

The passing of the King meant that his 25-year-old daughter Princess Elizabeth, now married and the mother of two young children, inherited the throne. In these circumstances it was decided that the coronation provided the perfect opportunity, in the words of one of its organizers, 'to lift people out of the bleakness of a post-

war era where meat, eggs and sweets were still rationed and where the bomb sites in London were still showing the broken teeth of bricks and rubble'. This was to be a new Elizabethan age, and from the ashes and debris of the war the coronation would rise as a glorious phoenix bringing pageantry, pride and new possibility. The occasion was to be a vivid celebration of the country's glorious ancient past, but also a reassertion of Britain's world role, no longer as imperial master, but as convener of a new collaborative club, the Commonwealth.

So great was the challenge of creating the desired level of magnificence that sixteen months were to pass between the accession of the Queen and the great ceremony in June 1953. During these months London was teeming with preparation. Everything was to be done in such a way as to bring maximum spectacle while also supporting the work of national reconstruction. The timbers for the platforms within Westminster Abbey were cut to lengths that could be reused in the building trade, and the acres of blue carpet were later to be cut up to cover the floors of Anglican churches across the world.

In 1952 Queen Elizabeth II was proclaimed 'Head of the Commonwealth' and this notion of Queen and Commonwealth would be ubiquitous at the coronation. In the procession to the Abbey the 'Rulers of States

Opposite 170 Cecil Beaton's official coronation portrait of Queen Elizabeth II, 2 June 1953. The Queen wears the Imperial State Crown made for her father in 1937, and holds the Sovereign's Sceptre with Cross and the Sovereign's Orb. The new gold Armills can be seen on her wrists.

under Her Majesty's Protection', led by the magnificent figure of Queen Salote of Tonga, and the Commonwealth prime ministers travelled immediately before the royal party. Constance Spry filled the Abbey with flowers from the Commonwealth countries, while images of their national plants adorned the Queen's own dress and the cloth-of-gold Stole [170, 171]. The glazing of the steel-framed annexe erected against the Abbey was etched with emblems of the Commonwealth.

While Edward VIII's desire for change had caused the Archbishop of Canterbury to dread his approaching coronation as a sort of 'nightmare', Queen Elizabeth II, like her father, was not 'steamed up on reforms'. The Queen's views chimed with those of the Archbishop of Canterbury, Geoffrey Fisher, and set the occasion squarely in the tradition of the coronations of her father and grandfather. More than this, those involved in the ceremony were determined to use every opportunity to emphasize the glorious, pride-inspiring lineage of the monarchy. As the Prime Minister Sir Winston Churchill put it, 'Let it not be thought that the age of chivalry belongs to the past.' The architect eagerly explained how the stage in the Abbey was almost identical to that erected for Queen Elizabeth I, and officials thumbed through copies of the 14th-century *Liber regalis* for additional medieval touches. While almost all the participants in the 1937 coronation had travelled to the Abbey

Left 171 **THE STOLE**, *1953. Like the Queen's coronation dress, the Stole incorporated images of the flowers of the nations of the United Kingdom, and emblematic plants of the Commonwealth nations, Canada, Australia, New Zealand, India and Sri Lanka.*

Opposite 172 **THE ARMILLS OF QUEEN ELIZABETH II**, *1952–53. Made for Queen Elizabeth II by Garrard and Company as a gift from the Commonwealth nations.*

by car, in 1953 anyone who possibly could came by horse and carriage – to the extent that the royal household had to borrow seven additional coaches from a film company.

It was in this atmosphere that the decision was taken to provide a completely new piece of regalia: the Armills of Queen Elizabeth II [172]. A pair of 'coronation bracelets' had been melted down in 1649 and in 1661 new armlets, or 'Armills' were created for Charles II [*see* 51]. However, the 1661 Armills may never have been used, and certainly played no part in a coronation from the early 18th century. In a significant act of historical revivalism, which had the added advantage of creating a 'Commonwealth' piece of regalia, Garrard and Company were commissioned by the Commonwealth Relations Office to make new Armills. Gold with red velvet linings, the Armills – like so many of the pieces made in 1660–61 – were made to a self-consciously 'medieval' design and bestowed on the Queen by the Archbishop with the rest of the regalia. All the other principal pieces were cleaned and repaired for the coronation. St Edward's Crown was to be used unaltered for the act of coronation but the Imperial State Crown, which had to be worn for much longer, was thought to need work. The frame was considered too tall for the 1.62 metre (5 ft 4 in.) Queen, and was reduced by lowering the arches 2.5 cm (1 in.) and altering the band [173, 174].

Coronation day 1953 was one of the coldest June days of the 20th century with the afternoon temperature in London barely 11°C. Thin rain fell and the crowds shivered. Despite the dark skies, the pageant that unfolded was technicoloured. The man responsible for its appearance was the elegant and energetic Minister of Works and Public Buildings, David Eccles, nicknamed the 'abominable showman'. It was his intention that the occasion should bring about a national 'return to gaiety in colour'. The success of Eccles's undertaking was due in large part to the representation of the event on film. Overcoming her initial reluctance, the Queen agreed that the coronation could be televised 'as live' by the BBC. Half of the adult population of Britain was glued to a screen, the number of licence holders having doubled in the months running up to the event. The result, a six-hour forty-five minute broadcast with commentary by Richard Dimbleby, was considered a triumph, 'television's finest hour', according to the *Sunday Times* [175]. In just four days J. Arthur Rank's

feature-length colour documentary, *A Queen is Crowned*, was showing at cinemas on both sides of the Atlantic [176]. Hailed as a cinematic masterpiece, the film, narrated in sparse and stirring tones by Sir Laurence Olivier, became an instant box-office hit. The BBC commentary and the Rank film shared a reverential air and over-powering sense of the nation's glorious heritage. While Olivier read John of Gaunt's 'other Eden' speech from *Richard II*, Dimbleby described the historic gems in the Imperial State Crown in similarly spine-tingling, almost Shakespearan, language. The effect of the pageantry itself and its brilliant presentation through film and television was almost universally agreed to be an unprecedented ceremonial success. The *Herald Tribune* journalist could find no higher praise

Above 173 *The Imperial State Crown lies dismantled on the jewellers' workbench, in the process of being altered for the coronation of Queen Elizabeth II in 1953.*

Opposite 174 **THE IMPERIAL STATE CROWN**, *1937. Made for King George VI, the crown was reduced in height for the coronation of his daughter Queen Elizabeth II, and remains in regular use today.*

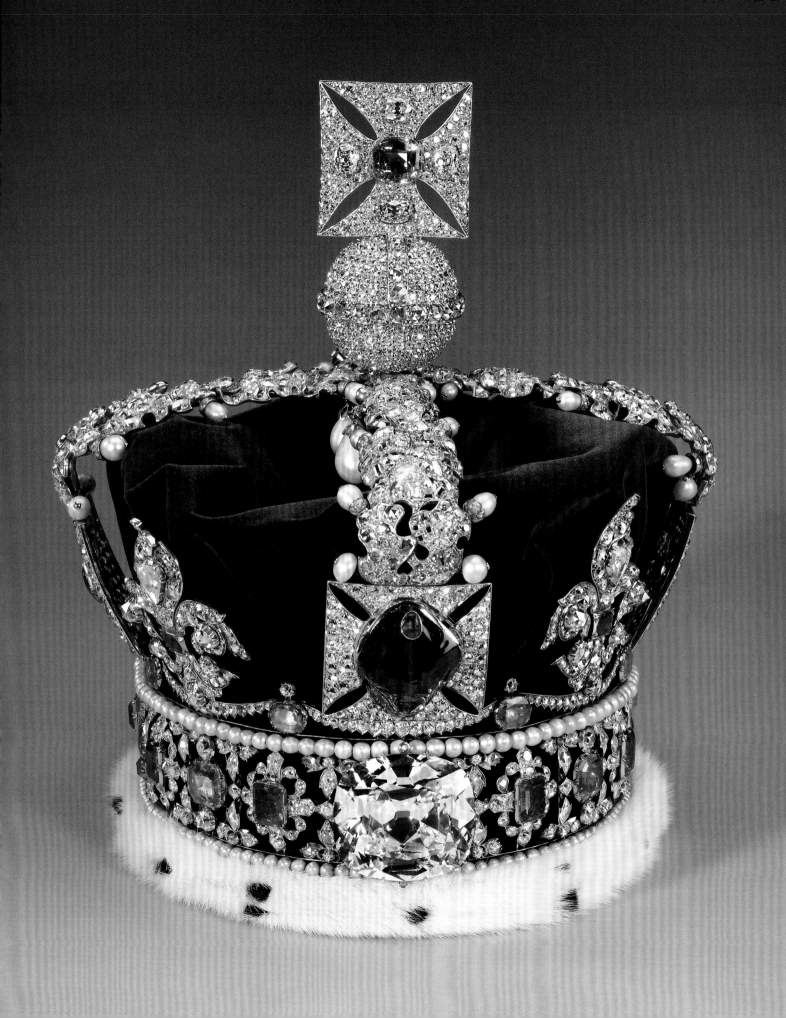

Right 175 *The television coverage of the 1953 coronation was the BBC's biggest outside broadcast up to that date.*

Below 176 *A* Qeen *[sic]* is Crowned *showing at the Tivoli Theatre on the Strand in London, June 1953. The full-length Technicolor film of the coronation was an international box-office hit.*

Opposite 177 *Queen Elizabeth II enthroned, Westminster Abbey, 2 June 1953. The Queen is seated on the Chair of Estate and is wearing St Edward's Crown, the coronation robes, the Armills and the Sovereign's Ring. She holds the two Sovereign's Sceptres.*

than to describe the coronation as featuring 'more soldiers than in *Birth of a Nation* and more celebrities than in a month of newsreels', amounting to nothing less than 'a Cecil B. De Mille dream'.

The coronation of 1953 saw the Crown Jewels out in force [177]. While some items remained in the Jewel House – the fonts had no role, various crowns were not required, and much of the dining plate had ceased to be used as the coronation banquet no longer took place – the core regalia was all in use. The Archbishop of Canterbury poured the oil from the Charles II Ampulla into 12th-century spoon to anoint the Queen. At the investiture that followed she received the full range of sovereign's regalia: the Supertunica, the Mantle, the new Stole and Armills, the Spurs, the jewelled Sword of Offering, the Sovereign's Orb, the Sovereign's Ring, the two Sovereign's Sceptres and St Edward's Crown – the last then exchanged for the Imperial State Crown. The maces, Sword of State and other swords were carried in the procession by royal officials. Much of the Jewel House altar plate was laid out in the Abbey, including the feathered flagons and Last Supper altar dishes, and when the Queen knelt to take Holy Communion, she received it from the 17th-century Chalice and Paten.

The year of Elizabeth II's accession had seen the opening of the world's first electricity-generating nuclear power plant, the introduction of ultrasound technology into medical science and the invention of the computer game, and yet the dominant image of the age was of a young woman enthroned in medieval splendour at Westminster Abbey. The antiquity of the collection

in the Jewel House is certainly remarkable but what it reflects is even more so: the enduring power of royal ritual, from the Iron Age to the age of the Internet. While the Crown Jewels are unquestionably impressive in their own right – as any visitor to the Tower of London can attest – it is their use at great ceremonial occasions that gives them their real power. The objects in the collection were not designed to be viewed in the solitary splendour of a glass case, but to play in the ensemble orchestra of royal ritual. In 2002 a quarter of a million people stood in queues four miles long to see the lying-in-state of Queen Elizabeth The Queen Mother; on her coffin lay her diamond crown, with the Koh-i-nûr dazzling brilliantly in the gloom of Westminster Hall [178]. The continuing appeal and authority of royal rituals lies essentially in their ability to move the spirit. Heart-stopping historic buildings, magnificent music that lifts the soul, iridescent royal insignia and crowds of adoring spectators all combine, in the 21st century as in the 12th, to provoke a profoundly emotional response.

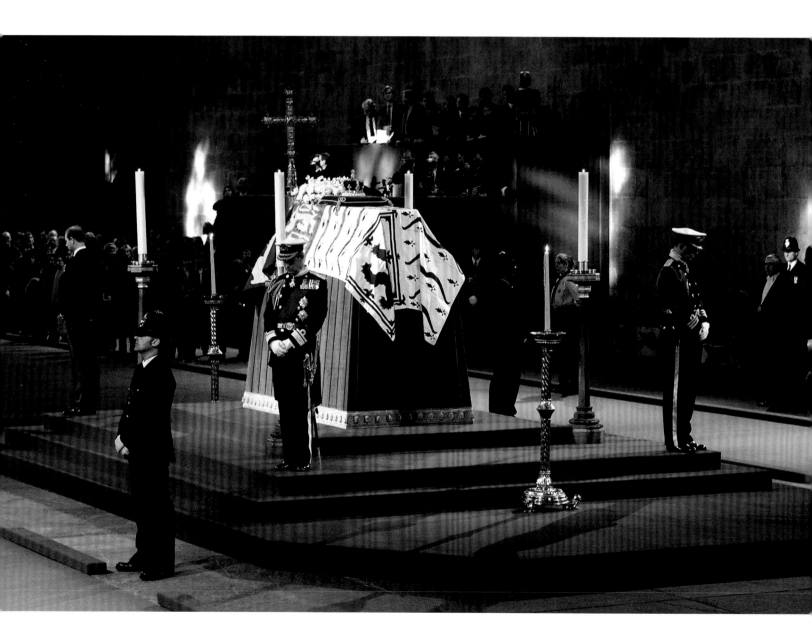

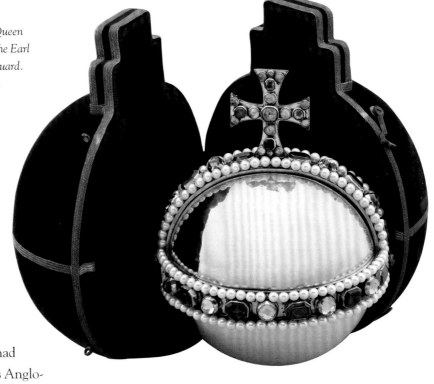

Opposite 178 *The lying-in-state of Queen Elizabeth The Queen Mother, Westminster Hall, April 2002. From left to right, the Earl of Wessex, the Prince of Wales and the Duke of York stand guard. The Crown of Queen Elizabeth The Queen Mother rests on the catafalque.*

Right 179 QUEEN MARY'S ORB, *1689. While this piece is not now used, the principal items in the Jewel House all have purpose-made travelling cases.*

The antiquity of royal rituals – actual or perceived – has been a crucial aspect of their potency from the earliest times. In their desire to emphasize the ancientness of the coronation, royal officials of the 20th century were simply following the practice of a thousand years. From the 13th century English kings had had themselves crowned with what they claimed was Anglo-Saxon regalia; the Coronation Spoon was being revered as an object of 'antique forme' from at least the 14th century and at the Restoration Charles II religiously replicated the entire ancient assemblage that the republicans had melted down.

The Crown Jewels, more than any other tangible objects, embody the continuity of the English appetite for royal ceremony. While the volume might have abated and the vehicles have certainly changed, the same regular traffic passes to and from the Jewel House as in Henry VIII's reign. In March 2008 five of the 17th-century altar plates were taken to Armagh in Northern Ireland to carry the purses that the Queen distributed on Maundy Thursday. The following month the Lily Font and the 18th-century Christening Ewer were taken to Windsor Castle for the baptism of Viscount Severn, the Queen's eighth grandchild. In July the great Charles II banqueting dishes chased with writhing fishes were dispatched to St James's Palace for the wedding of Lady Rose Windsor, the daughter of the Duke of Gloucester

and great-granddaughter of George V. On 3 December, at the State Opening of Parliament, the Queen, wearing the Imperial State Crown and with the Sword of State held aloft beside her, announced the government's plans to prevent the collapse in the British banking system.

While the completeness of the collection, the antiquity of various items, the size and value of the gems are all remarkable aspects of the Crown Jewels, it is these almost mundane comings and goings from the Tower of London that set these objects apart from all other comparable collections [179]. No other European monarchy still receives its regalia in a full-scale medieval coronation, and no royal collection is in such regular use for its original purpose.

When the Crown Jewels were moved to more spacious accommodation within the Tower of London in 1994 new labels were made for the display. As well as those describing each object, half a dozen additional labels were required; these read, simply, 'In Use'.

GLOSSARY

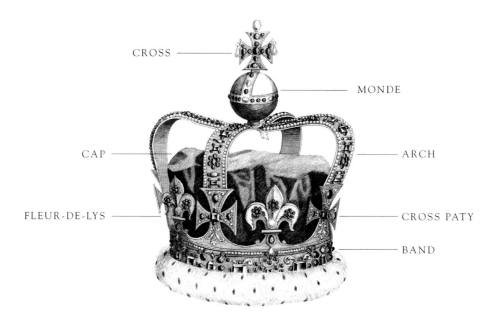

CROSS

MONDE

CAP

ARCH

FLEUR-DE-LYS

CROSS PATY

BAND

AMPULLA
Vessel used for holding the anointing oil.

ARCH
The raised bands of metal on a crown that cross the head of the wearer.

ARMILLS
Broad gold bracelets given to the sovereign during the coronation ceremony.

BAND
The part of the crown that encircles the wearer's brow.

CADDINET
A piece of high-status tableware used in the 17th and 18th centuries to hold the bread and seasoning for a single diner.

CARAT
A measurement of the weight of diamonds, equivalent to one fifth of a gram.

CHALICE
The cup from which the communicant receives the consecrated wine during the communion service.

CORONATION CROWN
The crown with which the sovereign is invested during the coronation service. In the Middle Ages this was considered to be a holy relic of Edward the Confesssor, and was kept in Westminster Abbey.

CORONATION ORDER
The order of service for the coronation ceremony.

CROWN JEWELS
The collection of regalia, plate and precious objects belonging to the sovereign kept in the Tower of London and used for royal ceremonies.

DALMATIC
A long cloak-like vestment with which the sovereign is invested at the coronation. The term also refers to an item of ecclesiastical dress.

DIADEM
A form of princely headdress, usually without arches.

FLEUR-DE-LYS
A three-leafed floral emblem, found on English crowns and other regalia. While the fleur-de-lys sometimes referred to the English claim to the kingdom of France, the use of the emblem on the crown was actually from long before.

MONDE
A small metal or jewelled ball, often representing the world (*monde*), found on the top of crowns and other items of regalia.

ORB
A large metal ball representing the world, which forms part of the English regalia.

SCEPTRE
A long staff representing royal authority.

PATEN
The small dish used to hold the consecrated bread in the communion service.

REGALIA
The precious objects worn or carried by a ruler which signify his or her royal status. In the Middle Ages divided into the 'coronation regalia', with which the king and queen were invested at the coronation, and 'state regalia', used on all other occasions.

ROYAL MAUNDY
The traditional ceremonies performed by the sovereign on the Thursday before Easter, historically including the washing of paupers' feet (no longer performed) and the presentation of alms.

SILVER GILT
Silver covered with a thin coating of gold.

STATE CROWN
One or more crowns used by the sovereign for the most formal occasions but not for the act of investiture.

SUPERTUNICA
A long cloth of gold robe with which the sovereign is invested at the coronation.

FURTHER READING

Age of Chivalry: Art in Plantagenet England 1200–1400, edited by Jonathan Alexander and Paul Binski, catalogue of an exhibition at the Royal Academy of Arts, 1987–88. London, 1987

Balfour, Ian, *Famous Diamonds*. London, 1987; 3rd edn, 1997

Barclay, Andrew, 'The 1661 St Edward's Crown – refurbished, recycled or replaced?', in *Court Historian*, 13:2 (December 2008), pp. 149–70

Barker, Brian, *When the Queen was Crowned*. London, 1976

Blair, Claude (ed.), *The Crown Jewels: The History of the Coronation Regalia in the Jewel House of the Tower of London*, 2 vols. London, 1998

Brett, Maurice V. (ed.), *Journals and Letters of Reginald, Viscount Esher*, 2 vols. London, 1934

Bruce-Mitford, Rupert, *The Sutton Hoo Ship-Burial*. Vol. 2, *Arms, Armour and Regalia*. London, 1978

Cannadine, David, 'Splendor out of court: royal spectacle and pageantry in modern Britain, c.1820–1977', in *Rites of Power: Symbolism, Ritual, and Politics since the Middle Ages*, edited by Sean Wilentz, pp. 206–43. Philadelphia, 1985

Collins, A. Jefferies, *Jewels and Plate of Queen Elizabeth 1: The inventory of 1574 edited from Harley MS. 1650 and Stowe MS. 555 in the British Museum*. London, 1955

'The coronation of King Edward VII, 9 August 1902, as recorded by Lady Mary Lygon', *Court Historian*, 7:1 (May 2002), p. 65

'The coronation of King George V, 22 June 1911, as recorded in his diary for that day', *Court Historian*, 7:1 (May 2002), p. 66

The Coronation of Richard III: The Extant Documents, edited by Anne F. Sutton and P. W. Hammond. Gloucester, 1983

The Coronation in Pictures: Complete Camera Record of the Mighty Pageant. London, 1937

The Diary of Samuel Pepys, edited by Robert Latham and William Matthews, 11 vols. London, 1970–83

Elizabeth Crowned Queen: The Pictorial Record of the Coronation. London, 1953; reprinted 2006

English Coronation Records, edited by Leopold G. Wickham Legg. London and New York, 1901

Gere, Charlotte, John Culme and William Summers, *Garrard: the Crown Jewellers for 150 Years, 1843–1993*. London, 1993

The Girlhood of Queen Victoria: A Selection from Her Majesty's Diaries between the Years 1832 and 1840, edited by Reginald Brett, Viscount Esher, 2 vols. London, 1912

Glanville, Philippa, *Silver in England*. London and New York, 1987

Halls, Zillah, *Coronation Costume and Accessories, 1685–1953*. London, 1973

Hoak, Dale, 'The coronations of Edward VI, Mary I, and Elizabeth I, and the transformation of the Tudor monarchy', in *Westminster Abbey Reformed, 1540–1640*, edited by C. S. Knighton and Richard Mortimer, pp. 114–51. Aldershot, 2003

Impey, Edward (ed.), *The White Tower*. London and New Haven, 2008

Keay, Anna, *The Elizabethan Tower of London: The Haiward and Gascoyne Plan of 1597*. London, 2001

—, *The Magnificent Monarch: Charles II and the Ceremonies of Power*. London, 2008

Keay, John, *India: A History*. London, 2000

Kuhn, William M., *Democratic Royalism: The Transformation of the British Monarchy, 1861–1914*. Basingstoke and New York, 1996

Lacey, Robert, *Royal: Her Majesty Queen Elizabeth II*. London, 2002

Lee, Sir Sidney, *King Edward VII: A Biography*, 2 vols. London, 1927

The Letters of King George IV, 1812–1830, edited by A. Aspinall, 3 vols. Cambridge, 1938

Lightbown, Ronald, 'The king's regalia, insignia and jewellery', in *The Late King's Goods, Collections, Possessions and Patronage of Charles I in the light of the Commonwealth Sale Inventories*, edited by Arthur MacGregor, pp. 257–75. Oxford, 1989

Longford, Elizabeth, *Elizabeth R: A Biography*. London, 1984

Longford, Elizabeth, *Victoria R.I.* London, 1964; 2nd edn, 1987

Madway, Lorraine, 'The most conspicuous solemnity: the coronation of Charles II', in *The Stuart Courts*, edited by Eveline Cruickshanks, pp. 141–58. Stroud, 2000

Magnus, Philip, *King Edward the Seventh*. London, 1964

Millar, Oliver (ed.), *The Inventories and Valuations of the King's Goods, 1649–51*, Walpole Society, 43 (1970–72). Glasgow, 1972

Myers, A. R. (ed.), *The Household of Edward IV: The Black Book and the Ordinance of 1478*. Manchester, 1959

Nelson, Janet L., 'The earliest surviving royal *ordo*: some liturgical and historical aspects', in Nelson, *Politics and Ritual in Early Medieval Europe*, pp. 341–60. London, 1986

Parfitt, Keith, *Iron Age Burials from Mill Hill, Deal*. London, 1995

Piacenti, Kirsten Aschengreen and John Boardman, *Ancient and Modern Gems and Jewels in the Collection of Her Majesty the Queen*. London, 2008

Princely Magnificence: Court Jewels of the Renaissance 1500–1630, catalogue of an exhibition at the Victoria & Albert Museum, London, 1980–81. London, 1980

Rose, Kenneth, *King George V*. London, 1983

Royal Goldsmiths: The Art of Rundell and Bridge 1797–1843, edited by Christopher Hartop. Cambridge, 2005

Scarisbrick, Diana, *Jewellery in Britain 1066–1837: A Documentary, Social, Literary and Artistic Survey*. Norwich, 1994

Schramm, Percy Ernst, *A History of the English Coronation*, trans. by Leopold G. Wickham Legg. Oxford, 1937

Scott, Walter, *Description of the Regalia of Scotland*. Edinburgh, 1819

Shawcross, William, *Queen Elizabeth The Queen Mother: The Official Biography*. London, 2009

Sitwell, H. D. W., 'Royal sergeants-at-arms and the royal maces', *Archaeologia*, 102 (1969), pp. 203–50

Smith, E. A., *George IV*. London and New Haven, 1999

Strong, Roy, *Coronation: A History of Kingship and the British Monarchy*. London, 2005

Stronge, Susan (ed.), *The Arts of the Sikh Kingdoms*. London, 1999

Twining, Edward Francis, Baron, *European Regalia*. London, 1967

Vickers, Hugo, *Elizabeth, The Queen Mother*. London, 2005

Welander, Richard, David J. Breeze and Thomas Owen Clancy (eds), *The Stone of Destiny: Artefact and Icon*. Edinburgh, 2003

Windsor, Edward, Duke of, *A King's Story: The Memoirs of H.R.H. the Duke of Windsor K.G.* London, 1951

Windsor, Wallis, Duchess of, *The Heart has its Reasons: The Memoirs of the Duchess of Windsor*. London, 1957

Younghusband, George, *The Jewel House: An account of the many romances connected with the royal regalia, together with Sir Gilbert Talbot's account of Colonel Blood's plot here reproduced for the first time*. London, 1921

Ziegler, Philip, *King William IV*. London, 1971

PICTURE CREDITS

All illustrations are from The Royal Collection © 2012 Her Majesty Queen Elizabeth II except those listed below.

Palazzo Vecchio, Florence. akg-images/Nimatallah 32; © Angelo Hornak/Alamy 28; © Museum of London/The Art Archive 36, 53, 83; Ashmolean Museum, University of Oxford 6, 7; The Bodleian Libraries, University of Oxford (MS Bodl. 579, fol. 1r) 5; Kenwood House, London. English Heritage Photo Library/ Bridgeman Art Library 74; Photo James Brittain/Bridgeman Art Library 97; Photo John Bethell/Bridgeman Art Library 24; Society of Antiquaries of London/Bridgeman Art Library 20; British Library (MS 17019, fol. 43v) 86; The Trustees of the British Museum 1, 3, 4, 86; BBC/Corbis 175; Courtesy of Cromwell Coins 31; Crown Copyright: Historic Royal Palaces 17, 46, 78, 94, p. 172; Crown Copyright, Courtesy of Historic Scotland www.historicscotlandimages.gov.uk 122; Crown Copyright/The Royal Collection © Her Majesty Queen Elizabeth II 93; The Gallery Collection/Corbis 8; Photo The Danish Royal Collection at Rosenborg Castle 47; Copyright The Gemmologists/E. Alan Jobbins 156; Express/Getty Images 176; Fox Photos/Getty Images 154, 173; Hulton Archive/Getty Images 177; Pool Photo/Getty Images 178; Popperfoto/Getty Images 16, 80; Science & Society Picture Library/Getty Images 168; Photograph by Benjamin Stone/Getty Images 153; Time & Life Pictures/Getty Images 166; Musée de la Tapisserie, Bayeux, France 21; The National Archives, UK (MPH1/214) 25, (SP14/80) 27; National Museum, Belgrade 2; National Portrait Gallery, London 84, 85, 116, Photo Ann Ronan/Heritage Images/Scala, Florence 23; Private collection 114, photo Derek Adlam 126; Collection Rijksmuseum, Amsterdam 37; © reserved/The Royal Collection 155; Scottish National Portrait Gallery, Edinburgh, on loan from the Earl of Rosebery 30; State Museums of the Moscow Kremlin 29; Stedelijke Musea Bruges. Lukas – Art in Flanders VZW 60; Treasury, Aachen Cathedral 10, 12, 13; Treasury, Munich Residence, Munich 11; Courtesy the Master and Fellows of Trinity College, Cambridge (MS O.3.59) 18; V&A images/ Victoria & Albert Museum, London 109, 170; George Younghusband, *The Jewel House*, London, 1921 100.

Inventory numbers for items from the Royal Collection (excluding the Crown Jewels which are given in the separate list below) are as follows: 19 RCIN 250090; 26 RCIN 404430; 33 RCIN 404951; 54 RCIN 805164; 61 RCIN 802368; 88 RCIN 750182; 101 RCIN 913015; 102 RCIN 405677; 105 RCIN 405741; 107 RCIN 31702; 111 RCIN 405918; 115 RCIN 404540; 119 RCIN 913630; 121 RCIN 50435; 123 RCIN 404931; 124 RCIN 405418; 125 RCIN 441925; 130 RCIN 401213; 131 RCIN 405409; 133 RCIN 404388; 137 RCIN 403501; 141 RCIN 1070252; 143 RCIN 2906149; 144 RCIN 406698; 147 RCIN 2105758; 148 RCIN 404487; 149 RCIN 2109808; 152 RCIN 2106310; 159 RCIN 2917123; 161 RCIN 452381; 162 RCIN 404478; 163 RCIN 2806535; 164 RCIN 403422

Media and dimensions for the Crown Jewels in the Tower of London illustrated in this book. Key: d = diameter; h = height; l = length; w = width. RCIN = Royal Collection Inventory Number

14 The Coronation Spoon, 12th century. Silver gilt, l. 26.7 cm (10½ in.). RCIN 31733

17 Left to right: The Sword of Temporal Justice, early 17th century. Steel, silver gilt and gilt iron, l. 114 cm (44¾ in.). RCIN 31731; The Sword of Spiritual Justice, early 17th century. Steel, silver gilt and gilt iron, l. 116 cm (45⅝ in.). RCIN 31729; The Sword of Mercy, early 17th century. Steel, silver gilt and gilt iron, l. 96.5 cm (38 in.). RCIN 31730

35 St Edward's Crown, 1661. Gold with enamel mounts and gems, h. 30.2 cm (11⅞ in.). RCIN 31700

39 The Ampulla, 1661. Gold, h. 20.6 cm (8⅛ in.). RCIN 31732

40 The Sovereign's Orb, 1661. Gold with enamel and gems, h. 27.3 cm (10¾ in.). RCIN 31718

42 Left: The Sovereign's Sceptre with Cross, 1661. Gold with enamel and gems, l. 92.7 cm (36½ in.). RCIN 31712; right: The Sovereign's Sceptre with Dove, 1661. Gold with enamel and gems, l. 110.5 cm (43½ in.). RCIN 31713

48 St Edward's Staff, 1661. Gold and steel, l. 142 cm (55⅞ in.). RCIN 31717

49 The Spurs, 1660–61. Gold, l. (excluding buckle) 13.2 cm (5¼ in.). RCIN 31725

51 The Sovereign's Armills, 1661. Enamelled gold, w. 6.6 cm (2⅝ in.). RCIN 31723

55 The Salt of State, c.1630. Silver gilt set with gems, h. 45.7 cm (18 in.). RCIN 31772

59 The Plymouth Fountain, mid-17th century. Silver gilt, h. 77.5 cm (30½ in.). RCIN 31742

62 Queen Elizabeth's Salt, 1572. Silver gilt, h. 35 cm (13¾ in.). RCIN 31773

63 St George's Salts 1660–61. Silver gilt. Left to right: RCIN 31775, 31778, 31777

64 Two Caddinets, 1683 (below) RCIN 31735 and 1688 (above) RCIN 31736. Silver gilt, l. 39.4 cm (15½ in.).

65 Chalice and Paten, c.1661. Gold, h. (chalice) 27 cm (10⅝ in.), d. (paten) 18.7 cm (7⅜ in.). RCIN 31766.a–b

66 Feathered Flagon, 1660. Silver gilt, h. 52 cm (20½ in.). RCIN 31756

68 Flagons. Left to right: 1660. Silver gilt, h. 37.5 cm (14¾ in.) RCIN 31753; c.1661. Silver gilt, h. 40 cm (15¾ in.). RCIN 31749

69 Altar Candlesticks, c.1661. Silver gilt, h. 95.9 cm (37¾ in.). RCIN 31758

70 Altar Dish, 1660. Silver gilt, d. 60.7 cm (23⅞ in.). RCIN 31748

71 Pair of Altar Dishes, c.1661. Silver gilt, d. 60.3 cm (23¾ in.). RCIN 31743.1–2

72 Charles II plate. Back row: Pair of Altar Candlesticks, c.1661. RCIN 31758; pair of Altar Dishes, c.1661. RCIN 31743.1–2; (centre) Maundy Dish, 1660. Silver gilt, d. 65.4 cm (25¾ in.). RCIN 31747; front row: Two Feathered Flagons (straight sided), 1660. RCIN 31753.1–2; two Flagons, c.1661. RCIN 31749 and 31750; two Feathered Flagons (pear shaped), 1660. RCIN 31756.1–2; Chalice and Paten, c.1661. RCIN 31766.a–b

73 James, Duke of York, plate. Back row: 'Last Supper' Altar Dish, 1664. RCIN 31745; Altar Dish, 1660. Silver gilt, d. 46.4 cm (18¼ in.). RCIN 31746; front row: Two Flagons, 1664. Silver gilt, h. 35.5 cm (14 in.). RCIN 31754.1–2; two Feathered Flagons, 1664. Silver gilt, h. 52 cm (20½ in.). RCIN 31755.1–2; (left) Chalice and Paten, c.1661. Silver gilt, h. (chalice) 25.1 cm (9⅞ in.), d. (paten) 15.2 cm (6 in.). RCIN 47835.4.a–b; (right) Chalice and Paten, c.1661. Silver gilt, h.(chalice) 20.4 cm (8 in.), d. (paten) 13.6 cm (5⅜ in.). RCIN 31765.a–b; (centre) Chalice and Paten, by 1688. Gold, h. (chalice) 25.7 cm (10⅛ in.), d. (paten) 17.8 cm (7 in.). RCIN 31767.a–b

76 Baptismal Font and Basin, 1660. Silver gilt, h. (font) 95.2 cm (37½ in.). RCIN 31739.a–c

77 The 'Last Supper' Altar Dish, 1664. Silver gilt, h. 94.6 cm (37¼ in.). RCIN 31745

79 Mace, 1660. Silver gilt. RCIN 31781

80 The Sword of State, 1678. Steel and silver gilt, l. 119 cm (46⅞ in.). RCIN 31727

82 The State Crown of Mary of Modena, 1685. Gold with rock crystals, h. 19 cm (7½ in.). RCIN 31707

89 Mary of Modena's Diadem, 1685. Gold with rock crystals, h. of frame 8 cm (3⅛ in.). RCIN 31708

91 The Queen Consort's Sceptre with Cross, 1685. Gold and silver with rock crystals, l. 85.3 cm (33⅝ in.). RCIN 31715

92 The Queen Consort's Ivory Rod with Dove, 1685. Ivory with gold and enamel, l. 95 cm (37⅜ in.). RCIN 31716

93 James II's Monde, 1685. Silver and gold with paste and quartz, h. 8.5 cm (3⅜ in.). RCIN 31711

95 The Black Prince's Ruby. Red spinel, irregular cabochon set with a small ruby, h. 43 mm (1⅝ in.), 170 carats. Set in the Imperial State Crown

96 Above: Queen Mary II's Orb, 1689. Gold with rock crystals and imitation stones, h. 20.6 cm (8⅛ in.). RCIN 31719; below: Queen Mary II's Sceptre with Dove, 1689. Gold and silver with enamel and gems, l. 100.4 cm (39½ in.). RCIN 31714

103 The Crown of Frederick, Prince of Wales, 1728. Gold with enamel and gems, h. 20.3 cm (8 in.). RCIN 31709

104 George I's State Crown, Frame, 1714. Gold, h. 20.4 cm (8 in.). RCIN 50412

106 Christening Basin and Ewer, c.1735. Silver gilt, h. (ewer) 45.7 cm (18 in.). RCIN 31740.a–b

108 George IV's Crown, Frame, 1820. Gold and silver, h. 37.5 cm (14¾ in.). RCIN 50411

110 St Edward's Sapphire. Octagonal rose-cut, h. 16 mm (⅝ in.). Set in the Imperial State Crown

112 The Sword of Offering, 1820. Steel, gold and precious stones, h. 96.5 cm (38 in.). RCIN 31726

117 The Stuart Sapphire. Ovoid table-cut. Length 49 mm (1⅞ in.), c.104 carats. Set in the Imperial State Crown

118 The Mantle, 1821. Cloth of gold, l. 2.29 m (7½ ft). RCIN 31794

120 The Salt Spoons, 1820. Silver gilt, l. 10.5 cm (4⅛ in.). RCIN 31779.1–12

127 Left: The Sovereign's Ring, 1831. Gold with sapphire, rubies and diamonds, w. 2.8 cm (1⅛ in.). RCIN 31720; right: The Queen Consort's Coronation Ring, 1831. Gold with rubies and diamonds, w. 2 cm (¾ in.). RCIN 31721

128 Queen Adelaide's Crown, Frame, 1831. Silver, h. 23.3 cm (9⅛ in.). RCIN 50410

129 Queen Victoria's Crown, Frame, 1838. Gold, h. 19 cm (7½ in.). RCIN 75002

134 Left: Queen Victoria's Coronation Ring, 1838. Gold with sapphire, rubies and diamonds, w. 2 cm (¾ in.). RCIN 31709

136 The Lily Font, 1840. Silver gilt, h. 43.2 cm (17 in.). RCIN 31741

138 The Wine Cistern or Grand Punch Bowl, 1829. Silver gilt, h. 76.2 cm (30 in.), w. 101 cm (39¾ in.). RCIN 31768

140 Ladle for the Grand Punch Bowl, 1841. Silver gilt and ivory, l. 105.4 cm (41½ in.). RCIN 31769

142 Indian setting of the Koh-i-nûr, 1839–43. Enamelled gold with rock crystals, l. 12.9 cm (5 in.). RCIN 31734

145 The Koh-i-nûr Diamond. Cushion-shaped brilliant, d. 36 mm max. (1⅜ in.), 105.6 carats. Set in the Crown of Queen Elizabeth The Queen Mother

146 Queen Victoria's Small Diamond Crown, 1870. Silver and gold with diamonds, h. 9.4 cm (3¾ in.). RCIN 31705

150 The Prince of Wales's Crown, 1901–02. Silver gilt, h. 22.8 cm (9 in.). RCIN 31710

157 Cullinan II or the Second Star of Africa. Cushion-shaped brilliant, d. 45 mm (1¾ in.), 317.4 carats. Set in the Imperial State Crown

158 Cullinan I or the First Star of Africa. Pear-shaped brilliant, h. 58.9 mm (2⅜ in.), w. 45.5 mm (1¾ in.), 530.2 carats. Set in the Sovereign's Sceptre with Cross

160 The Imperial Crown of India, 1911. Silver and gold with gems, h. 27.5 cm (10¾ in.). RCIN 31706

165 The Supertunica, 1911. Cloth of gold, l. 1.39 m (4½ ft). RCIN 31793

167 Left to right: Queen Alexandra's Crown, 1902. Silver and gold with paste diamonds, h. 22.5 cm (8⅞ in.). RCIN 75008; Queen Mary's Crown, 1911, Silver and gold with diamonds, h. 25 cm (9⅞ in.). RCIN 31704; The Crown of Queen Elizabeth The Queen Mother, 1937. Platinum with diamonds, h. 20.7 cm (8⅛ in.). RCIN 31703

171 The Stole, 1953. Cloth of gold, l. 2.16 m (7 ft). RCIN 31795

172 The Armills of Queen Elizabeth II, 1952–53. Gold, w. 7.4 cm (2⅞ in.). RCIN 31724

174 The Imperial State Crown, 1937. Gold and silver with gems, h. 31.5 cm (12⅜ in.). RCIN 31701